WHITNEY BIENNIAL 2017

Whitney Museum of American Art, New York
Distributed by Yale University Press,
New Haven and London

This publication was produced by the publications department at the Whitney Museum of American Art, New York: Beth A. Huseman, director of publications; Jennifer MacNair Stitt, editor; Beth Turk, editor; Anita Duquette, manager, rights and reproductions; and Jacob Horn, editorial coordinator.

PROJECT MANAGER:
Elizabeth Levy

EDITORS:
Jason Best with
Domenick Ammirati and Deirdre O'Dwyer

DESIGN:
Olga Casellas Badillo and
Luis "Tuto" González, Tiguere Corp.

PRODUCTION:
Nerissa Dominguez Vales and Sue Medlicott,
The Production Department

PROOFREADER:
Kate Norment

PRINTING AND BINDING:
GHP, West Haven, CT

TYPESET IN
Suisse Int'l, Tiempos Text, and Trasandina

PRINTED ON
80 lb. Accent Opaque white text, vellum finish

SINCERELY YOURS:
A CONVERSATION WITH
CHRISTOPHER Y. LEW AND MIA LOCKS

Rothkopf, Scott

FOREWORD

Artists are often prognosticators. They are sensitive to the signals—and not afraid to face the realities—of the present-day culture that they refine, transform, fortify, and retransmit. Accordingly, given the anxious and deeply unsettled nature of social and political affairs in the United States leading up to the most recent presidential election, the 2017 Whitney Biennial not only reflects but foreshadows the uncertain, bitter, and divided state of the nation. For artists pay attention, worry, contemplate, speculate, advance, provoke, contest, and protest. They are strident; they offer dissenting and often surprising propositions, alternative points of view, and idealistic dreams—all of which are much needed at this moment.

I am writing this foreword just a few weeks after the 2016 election. Curators Christopher Y. Lew and Mia Locks, aided by an excellent group of advisors in the field, have selected the artists and collectives—sixty-three in all—for the Biennial. The works have largely been chosen and proposals for commissioned projects are under way. The list of artists has been released and the press is busy parsing the significance of both the choices and the mix of artists. Dealers whose artists will be in the show are touting the Museum's wisdom, while other interested parties are no doubt disappointed by who has not been included. It has been many years since the Whitney believed in the notion of, or attempted to produce, a comprehensive exhibition representing contemporary American art. Even decades ago, that was an impossible task. Each Biennial is therefore but a snapshot, a barometer—one measurement of many—of the times as experienced through art.

The process of organizing a Biennial is largely intuitive, albeit based on extensive experience and study. The curators are detectives in search of multiple, leading suspects as much as singular perpetrators. They look carefully, listen attentively, and travel extensively in the hopes of discerning the zeitgeist—understanding, of course, that such an assessment is impressionistic, to some degree subjective, and results in a gathering of artist visions as dissimilar from one another in appearance as they are in intent.

From the beginning, though, the Whitney Museum of American Art has been awash in the social and artistic currents of its day, particularly through its Biennials and concurrent acquisitions. While founder Gertrude Vanderbilt Whitney played a critical role in supporting the artistically and politically radical practitioners of realism—among them John Sloan, Robert Henri, and George Bellows, who portrayed the dismaying social conditions of immigrant life in American cities—she also recognized the importance of presenting advanced strains of utopian, modernist art. Thus, in keeping with this democratic spirit, in the first Biennial (1932) we find works not only by the aforementioned realists but also by Arthur Dove, Georgia O'Keeffe, and Marsden Hartley, whose art differed considerably from Mrs. Whitney's own sculpture and personal taste. This notion of pushing beyond what is comfortable, of presenting diverse approaches to artmaking, and above all of understanding that art can never be severed from the world at large, has always been in the Whitney's DNA.

For example, realizing that art had become an event in the environment, the 1970 Sculpture Annual presented site-specific works outside the Museum, including Keith Sonnier's *Untitled* sound work on the roof of his studio in SoHo. Richard Serra's *To Encircle Base Plate Hexagram, Right Angles Inverted* in the Bronx and Robert Smithson's *Spiral Jetty* in Great Salt Lake, Utah, were also part of the exhibition. The 1993 Biennial pointed beyond the social confines of the Museum, from Pat Ward Williams's photomural of five black men with the spray-painted statement "What you lookn at" scrawled over it visible in the Whitney's windows from the street, to Daniel J. Martinez's

FOREWORD

study for *Museum Tags*, which declared on visitors' entrance badges, "I can't imagine ever wanting to be white." The 2000 Biennial included Franco Mondini-Ruiz's *Infinito Botanica*, a table placed in front of the Whitney on Madison Avenue where the artist sold Tex-Mex objets d'art. The 2002 Biennial featured works in and around Central Park, such as Keith Edmier's *Emil Dobbelstein and Henry Drope, 1944*, bronze figures that memorialized the World War II service of his grandfathers. And the 2008 Biennial presented performances by Coco Fusco and Matt Mullican, among others, at the Seventh Regiment Armory on Park Avenue. These Biennial works and many, many others, especially over the last decades, had an explicit sociopolitical dimension that connected the Museum to the world. Art is more than politics, but politics informs art. As our mission statement declares, "We foster the work of living artists at critical moments in their careers." So too do we encourage, reinforce, and defend artists' voices at critical moments in history.

But artists also feel vulnerable psychically and financially. As Chris Lew recounts herein, "We want to acknowledge artists as people, as humans—to not just treat an artist as an abstraction, saying, 'We want your work, but we're not going to deal with you as a person.'" Indeed, this was Mrs. Whitney's philosophy even before the inception of the Museum in 1931. She believed in providing for artists' human needs (housing, medical, social, and educational) and artistic needs as much as amassing a collection. "It is not as a repository of what American artists have done in the past that the museum expects to find its greatest usefulness," she wrote, believing that the Whitney should participate in the present by actively supporting artists in their endeavors to make history as well as reflect it.

As the Whitney's next chapter begins in our downtown home, we recommit ourselves to following the lead of artists, to trusting in their

visions, which, at this moment, are greatly affected by the sociopolitical realm. Mia Locks notes in the curatorial interview that follows, "Every time we entered a studio, issues of inequality or racism or violence were being brought up in one way or another without our prompting." This is evident in Frances Stark's series of *Censorship Now* paintings, Jordan Wolfson's address of brutality in our culture, Aliza Nisenbaum's reflections on the immigrant experience, Lyle Ashton Harris's personal consideration of race and gay identity, and Postcommodity's focus on more nuanced understandings of community beyond national borders, among many other urgent projects.

While the new Whitney building wonderfully showcases art, it has never constituted our purpose or mission. It is a vehicle, not a temple or an end in itself. It is an aspirational space for artists to do their work not ours, a space for connecting to and with the world. Designed with transparency as part of its ethos, the building can be seen from and looks out 360 degrees. Consequently, artists in the 2017 Biennial are using it and what it offers to create their work, work that is unruly and sometimes subversive, such as Rafa Esparza's room-size installation made of adobe bricks that literally creates space in the lobby gallery for the work of other artists invited by Esparza; Park McArthur's no-information signage pieces, one of which greets visitors above the admissions desk; Ajay Kurian's exciting but troubling work, in the central staircase, that comments on the notion of upward mobility; Larry Bell's site-specific commission for the fifth-floor outdoor gallery, itself a metaphor for interior/exterior space; Zarouhie Abdalian's sound work that addresses visitors from the east-facing terraces on the sixth and seventh floors, uttering a list of tools that evokes the legacies of manual labor; Raúl de Nieves's vibrant stained-glass installation along the fifth-floor windows on the building's east side, which casts a colorful glow

visible both inside and out; and Samara Golden's disorienting and disquieting mirrored built environment that engages the Hudson River. Moreover, the building itself encourages a reciprocal relationship with the exterior world, from the billboard across the street from the Whitney that will be utilized by Puppies Puppies to Chemi Rosado-Seijo's work in which a fifth-floor gallery will serve as a high school classroom for Lower Manhattan Arts Academy while the school classroom will become a gallery.

This has not been an easy time in American history to assess, no less comprehend and present, a Biennial. In the maelstrom of the moment, however, the curators, together with the excellent guidance and insights of the Whitney's deputy director for programs and Nancy and Steve Crown Family Chief Curator, Scott Rothkopf, have given their all to the intractable situation at hand. With sensitivity, honesty, deep probing, and clarity of purpose they have been unafraid to take a stand and commit to a selection of voices that they believe are among the most salient and emblematic at this time. They have demonstrated how, as described in this volume, "an exhibition is a social space for aesthetic experience as well as an aesthetic space for social experience." For all of this, I wish to express my profound thanks and greatest admiration to exhibition curators Christopher Y. Lew and Mia Locks. They would also be the first to acknowledge Biennial advisors Negar Azimi, Gean Moreno, Aily Nash, and Wendy Yao for brainstorming, critiquing, and providing reality checks during marathon retreats and informal consultations; I extend my gratitude as well for their expertise.

The Museum could never realize ambitious undertakings such as the Whitney Biennial without many institutional and individual donors. I am most grateful to Tiffany & Co. for recognizing the significance of the Biennial and for its steadfast commitment to the presentation of the exhibition. J.P. Morgan Private Bank and Sotheby's both provided crucial support of the exhibition. My great thanks are also due to the Brown Foundation, Inc., of Houston and the National Committee of the Whitney Museum of American Art. I acknowledge the important support provided by the Philip and Janice Levin Foundation. My appreciation also goes to 2017 Biennial Committee Co-Chairs Leslie Bluhm, Beth Rudin DeWoody, Bob Gersh, and Miyoung Lee; Biennial Committee members Diane and Adam E. Max, Teresa Tsai, Suzanne and Bob Cochran, Rebecca and Martin Eisenberg, Amanda and Glenn Fuhrman, Barbara and Michael Gamson, Kourosh Larizadeh and Luis Pardo, and Jackson Tang; as well as the Henry Peterson Foundation and anonymous donors. I gratefully recognize the Austrian Federal Chancellery and Phileas — A Fund for Contemporary Art as well as the Cultural Services of the French Embassy in the United States for their support. Funding from special Biennial endowments created by Melva Bucksbaum, Emily Fisher Landau, Leonard A. Lauder, and Fern and Lenard Tessler was essential, as was additional endowment support from the Keith Haring Foundation Exhibition Fund, Donna Perret Rosen and Benjamin M. Rosen, and the Jon and Mary Shirley Foundation. I am also appreciative of Rosina Lee Yue and Bert A. Lies, Jr., whose endowment funded the curators' travel and research.

This is an exhibition that the curators acknowledge has "very dark overtones," but it also "shows that artists can envision a future that *is* different." Indeed, the artists included are creating challenging art for challenging times—a hallmark of the Whitney Biennial.

—ADAM D. WEINBERG
ALICE PRATT BROWN DIRECTOR

ACKNOWLEDGMENTS

The process of organizing the 2017 Whitney Biennial has been an inspiring, challenging, exhilarating, and humbling experience that is difficult to put into words. The world feels like a truly different place than it did when we first embarked on this project in the fall of 2015. To have been able to travel across the United States and beyond during this time, to have met with as many incredible artists as we did, and to have engaged in some of the most honest and raw and heartfelt discussions about the power and the possibility of art has been a privilege beyond our wildest dreams. We are exceptionally thankful for this unique experience, which we will no doubt carry with us for the rest of our lives.

The exhibition comprises the work of sixty-three artists, collectives, and filmmakers; every ounce of our gratitude goes first and foremost to them. Their work has made our work possible, and we are honored and humbled by this opportunity to have collaborated with each and every one of them.

We extend a very special thank-you to Adam D. Weinberg, the Whitney's Alice Pratt Brown Director, for supporting this project from start to finish. We are also extremely grateful to Scott Rothkopf, deputy director for programs and Nancy and Steve Crown Family Chief Curator, for inviting us to organize the Biennial. Scott led the Biennial advisory team, which included Negar Azimi, Gean Moreno, Aily Nash, and Wendy Yao, all of whom we thank for listening closely, engaging deeply, and providing critical feedback during each step of our process. We further acknowledge Aily, who co-organized the Biennial film program. We salute the staff at Tiffany & Co. for their steadfast partnership, in particular Ashley Barrett, Anna Edwards-Wagoner, Jessica Tullman Levine, and Tenley Zinke. And we express our gratitude to the Whitney's trustees, as well as to the members of the 2017 Biennial Committee, co-chaired by Leslie Bluhm, Beth Rudin DeWoody, Bob Gersh, and Miyoung Lee.

We gratefully acknowledge our exceptional and tireless Biennial team: Maura Heffner, assistant director of exhibitions management, oversaw all aspects of the show with professional grace and attention; Emily Guzman Sufrin, curatorial assistant, has been the ever cheerful connector of everyone and everything; and Lindsey O'Connor, Biennial assistant coordinator, brought her meticulous eye to the exhibition and film program. We are deeply grateful to others on the curatorial team who pitched in at various points along the way: curatorial assistants Melinda Lang and Clémence White, curatorial project assistant Anna Blum, curatorial fellow Michelle Donnolly, and curatorial interns Katie Lee, Saxton Randolph, Daphne Takahashi, and Emily Wang.

Our thanks also go to our colleagues in the curatorial department. Jay Sanders, Engell Speyer Family Curator and curator of performance; Elisabeth Sussman, curator and Sondra Gilman Curator of Photography; and Chrissie Iles, Anne and Joel Ehrenkranz Curator, in particular, shared their indispensable knowledge and insight. Emily Russell, director of curatorial affairs, was a reliable and steadfast ally and advocate. For their collegial support, we also extend our thanks to: David Breslin, DeMartini Family Curator and director of the collection; Donna De Salvo, deputy director for international initiatives and senior curator; Carter Foster, former Steven and Ann Ames Curator of Drawing; Jennie Goldstein, assistant curator; Barbara Haskell, curator; Claire Henry, assistant curator, Warhol Film Project; David Kiehl, curator emeritus; Dana Miller, former Richard DeMartini Family Curator and director of the collection; Christiane Paul, adjunct curator of new media arts; and Carrie Springer, assistant curator. We also acknowledge the contemporary working group for its input: Jane Panetta, associate curator; Laura Phipps, assistant curator; Elisabeth Sherman, assistant curator; Margaret Kross, curatorial assistant; and Megan Heuer, director of public programs and public engagement.

⚅⚅ O

ACKNOWLEDGMENTS

This publication is an indispensable element of the Biennial, one we hope will ensure that the ideas and discourses surrounding the exhibition live on long after it has closed. We thank Olga Casellas Badillo and Luis "Tuto" González, designers, and their team at Tiguere Corp. in San Juan, Puerto Rico, for this elegant book; Beth Huseman, director of publications, for her expert guidance; Elizabeth Levy, for her peerless management of the project; Jennifer MacNair Stitt, editor, Beth Turk, editor, and Jacob Horn, editorial coordinator, for their help along the way; as well as editors Domenick Ammirati, Jason Best, and Deirdre O'Dwyer. We also extend our deepest thanks to the authors of the artist entries: Erika Balsom, Claire Barliant, Erica Cooke, Nicole Demby, Jeanne Dreskin, Matthew Evans, Julia Pelta Feldman, Christopher Glazek, Leo Goldsmith, Irena Haiduk, Charlotte Ickes, Frances Jacobus-Parker, Park McArthur, Nicholas Robbins, Cameron Rowland, and Rachel Wetzler.

An exhibition as large in scale as a Biennial requires the support and attention of every department at the Museum. We thank the Whitney's incredible staff in its entirety, especially the following: Jehad Abu-Hamda, projectionist; Stephanie Adams, director of individual and planned giving; Sofie Andersen, director of digital media; Marilou Aquino, director of philanthropy; I. D. Aruede, chief financial officer; Wendy Barbee-Lowell, manager of visitor services; Jeffrey Bergstrom, projectionist; Peter Berson, temporary senior AV technician; Richard Bloes, senior AV technician; Anne Byrd, director of interpretation and research; Rosana Chang, AV technician; Max Chester, assistant theater manager; Amanda Davis, performance coordinator; Anita Duquette, manager of rights and reproductions; Reid Farrington, audio visual manager; Lily Foster, manager of public programs; Lauri Freedman, retail product development manager; Hilary Greenbaum, director of graphic design; Peter Guss, director of information technology; Adrian Hardwicke, director of visitor experience; Lola Harney, production assistant; Greta Hartenstein, senior curatorial assistant; Peter Henderson, former senior manager, special events; Jennifer Heslin, director of retail operations; Nicholas S. Holmes, general counsel; Caroline Ingalls, director of finance and treasury; Zoe Jackson, director of marketing; Eunice Lee, director of corporate partnerships; Sang Lee, manager of information technology; Jen Leventhal, chief of staff; Jeff Levine, former chief marketing and communications officer; Elyse Mallouk, senior manager, digital content; Carol Mancusi-Ungaro, Melva Bucksbaum Associate Director for Conservation and Research; Anna Martin, exhibition design and construction associate designer; Sarah Meller, senior marketing manager; Graham Miles, assistant head preparator; Lana Mione, theater manager; Kathryn Potts, associate director, Helena Rubinstein Chair of Education; Christy Putnam, associate director for exhibitions and collections management; Shama Rahman, senior marketing coordinator; Gina Rogak, director of special events; Justin Romeo, executive coordinator, director's office; Joshua Rosenblatt, head preparator; Amy Roth, chief planning officer; Peter Scott, director of facilities; David Selimoski, engineering manager; Matthew Skopek, associate conservator; Michele Snyder, assistant director of leadership gifts; Stephen Soba, director of communications; John S. Stanley, chief operating officer; Mark Steigelman, exhibition design and construction manager; Hillary Strong, former director of institutional relations; Alexandra Wheeler, deputy director for advancement; and Sasha Wortzel, director of access and community programs.

The 2017 Biennial featured a couple of projects that extended beyond the Museum's galleries. We would like to thank Heather Maxson, the Whitney's director of school, youth, and family programs, who helped realize our public school collaboration along with Julianne Newman at

the New York City Department of Education and the staff of the Lower Manhattan Arts Academy, especially John Wenk, Julie Roinos, and Renae Despointes; and Union Square Hospitality Group, Michael Anthony, and the rest of the staff at Untitled and Studio Café.

Throughout the process of developing the exhibition we benefited from the tremendous generosity of friends and colleagues who supported us in a variety of ways. In this regard, we acknowledge and thank: Burt Aaron, Banch Abegaze, Jennifer Allora and Guillermo Calzadilla, Sophia Al-Maria, Rhea Anastas, Kevin Beasley, Biba Bell, Klaus Biesenbach, Adriana Blidaru, Elysia Borowy-Reeder and Scott Reeder, Lauren Boyle and Marco Rosso, Dan Byers, Victoria Camblin, Valerie Cassel Oliver, Solomon Chase, Elizabeth Chodos, Ted Chung, Michael Connor, Rachel Cook, Francisco Cordero-Oceguera, Douglas Crimp, Dean Daderko, Kenturah Davis, Angela Dimayuga, Anthony Elms, Justin Falvey, Jason Faumberg, Eve Fowler, Eric Friedericksen, Daniel Fuller and Myleik Teele, Gaylen Gerber, Romeo Giron, Marc Glimcher, Thelma Golden, Christopher Grunden, Elizabeth Hamilton, Calla Henkel and Max Pitegoff, José Hernández Castrodad, Donna Huanca, Anthony Huberman, Jamillah James, Kahlil Joseph, JPW3, Toby Kamps, Adam Katz, Veronica Kessenich, Nora N. Khan, Kate Kraczon, Lilly Lampe and Alex Robbins, Thomas J. Lax, Young Jean Lee, Sarah Lehrer-Graiwer, Nacho Lopez and Laura Guerra, Michael Lynne, Bartomeu Marí, Emmett McCann, Franklin Melendez, Polly Morris, Aram Moshayedi, Michael Moskowitz, Daisy Nam, Jay Ezra Naysan, Jon Neidich, María Elena Ortiz, Solveig Øvstebø, Clifford Owens, Manuela Paz and Christopher Rivera, Jordan Poole, Cay-Sophie Rabinowitz, Eva Respini, Carlos and Mima Reyes, Marina Reyes, Michael Rooks, Paul Schimmel, Bennett Simpson, Charlie Smith, Jason Sneed, Robert Snowden, Paul Soto, Pascal Spengemann, John Spiak, Graham Steele, A. L. Steiner, Jamie Stevens, Lanka Tattersall, Alesse Thompson, Lynne Tillman,

David Toro, Janice Wang, Jocko Weyland, Michelle White, and Daniel Wichelhaus.

We are deeply thankful to the following galleries for their support and kindness: 47 Canal, New York; Air de Paris, Paris; Altman Siegel, San Francisco; Annka Kultys Gallery, London; Blum & Poe, Los Angeles, New York, and Tokyo; Bridget Donahue, New York; Cabinet Gallery, London; Callicoon Fine Arts, New York; CANADA, New York; Catherine Bastide, Brussels; Company Gallery, New York; Corbett vs. Dempsey, Chicago; David Castillo Gallery, Miami; David Kordansky Gallery, Los Angeles; David Zwirner, New York and London; DC Moore Gallery, New York; Deborah Schamoni Galerie, Munich; Embajada, San Juan, PR; ESSEX STREET, New York; Feuer Mesler Gallery, New York; Freedman Fitzpatrick, Los Angeles; Galería Agustina Ferreyra, San Juan; Galería Juana de Aízpura, Madrid; Galerie Balice Hertling, Paris; Galerie Barbara Thumm, Berlin; Galerie Barbara Wein, Berlin; Galerie Greta Meert, Brussels; Galerie Imane Farès, Paris; Galerie Lars Friedrich, Berlin; Gallery Buchholz, Cologne, Berlin, New York; Gallery Luisotti, Santa Monica; Gallery Meyer Kainer, Vienna; Gavin Brown's enterprise, New York; greengrassi, London; Hauser & Wirth; Kate Werble Gallery, New York; Kavi Gupta, Chicago; Kraupa-Tuskany Zeidler, Berlin; Maccarone Gallery, New York and Los Angeles; Marc Foxx Gallery, Los Angeles; Marlborough Chelsea, New York; Marvani & Mercier Gallery, Brussels; Mary Mary, Glasgow; Massimo De Carlo, Milan, London, Hong Kong; Mier Gallery, Los Angeles; Miguel Abreu Gallery, New York; Mitchell-Innes & Nash, New York; Moran Bondaroff, Los Angeles; Neue Alte Brücke, Frankfurt; Night Gallery, Los Angeles; Office Baroque, Brussels; On Stellar Rays, New York; PATRON Gallery, Chicago; Petzel Gallery, New York; Pilar Corrias, London; Project Native Informant, London; Queer Thoughts, New York; Rachel Uffner Gallery, New York; Rhona Hoffman Gallery, Chicago; Rodeo Gallery, Istanbul; Sadie

✠✠✠
ACKNOWLEDGMENTS

Gallery, Chicago; Rodeo Gallery, Istanbul; Sadie Coles HQ, London; Salon 94, New York; Sikkema Jenkins & Co., New York; Sprüth Magers, Berlin, London, and Los Angeles; Stuart Shave/Modern Art, London; T293 Gallery, Rome; The Box, Los Angeles; the Green Gallery, Milwaukee; What Pipeline, Detroit; and White Cube, London. Our thanks extend as well to the film production and distribution companies IDA.IDA, Paris; IDIOMS Films, Ramallah; Momento!, Paris; Picture Palace Pictures, New York; Poulet-Malassis Films, Paris; STX Entertainment, Los Angeles; Trilobite-Arts DAC, Charlottesville, Virginia; and Video Data Bank, Chicago.

Our sincere gratitude goes to the lenders to the exhibition, including Sophie Bielders, Chana and Cliff Chenfeld, Vinny Dotolo and Sarah Hendler, Asher Dupuy-Spencer and Ariella Thornhill, the Hort family, Marija Karan and Joel Lubin, David Kobosa and Frank Maurer, Kourosh Larizadeh and Luis Pardo, Wendy Lee, Nino Mier, Mia Romanik, Cindy and Arnold Schwartz, Cindy Schwartz and Robyn Siegal, Sam Sparro, Donovan and Matthias Vriens-McGrath, and Yugoexport, as well as those who wish to remain anonymous.

Lastly, and lovingly, we want to thank our respective partners, Cindy Lew and Jason Vassiliades, for being endlessly supportive of our commitment to this project.

—CHRISTOPHER Y. LEW AND MIA LOCKS

Scott Rothkopf: Let's start by talking about your process and the two of you. In 2015, as I began my job as chief curator at the Whitney, I thought a lot about what the first Biennial in our new building might represent. The show is often considered the Whitney's "flagship" exhibition. Yet the Biennial had actually become a bit disconnected from the rest of our program, because we weren't consistently showing emerging artists throughout the years in between. Downtown, we've recommitted ourselves to premiering younger talents and doing smaller group shows of new tendencies. So, I felt like this Biennial had to be even more engaged with emerging artists than recent installments had been—more in the trenches and far-reaching. Given Chris's key role in reenergizing our contemporary profile, it felt natural to task him with this brief. But apart from that, Chris, you were given carte blanche to fly solo or assemble a team.

Christopher Y. Lew: It's been an amazing opportunity to fold more emerging artists into our program. When approaching something as big as organizing the Biennial, I realized it calls for research conducted in conversation with others. I wanted a co-curator with whom I could be in real dialogue, and who would test my ideas about making the show. I don't think you can develop that level of trust and rapport overnight. Thinking about all this led me directly to Mia—for her rigor, and because we have an existing friendship. I knew it would be a fun process.

Rothkopf: Has it turned out that way?

Mia Locks: Yes. But it's been intense, too. We've spent more time together over the past year and a half than we have with anyone else.

Lew: It's written into the contract—joined at the hip. [*laughter*]

Locks: Though we'd never collaborated before, we were comfortable disagreeing with one another.

And when we differed, we challenged each other's tastes and ideas in a productive way. A Whitney Biennial should get beyond the personal tastes or affinities of a particular curator. It's different than a thematic group show or a show that might take years and years to research, so we were lucky that we could just kind of jump right into it without any of the—

Rothkopf: Dating before marriage?

Locks: We just hit the road.

Lew: We knew our respective strengths balanced each other's weaknesses. Having grown up in New York, and having worked in the city for over a decade, I have a sense of what's going on here. Mia had spent eight years in Los Angeles before moving east, and that also helped to jump-start our process. And, of course, we also aimed to cover as much ground as we could between those two art hubs.

Rothkopf: While it's pretty common for the Biennial to have co-curators, what differed this time is that you chose to convene a group of advisors with whom you collaborated closely. You credit them as contributors to the development of the exhibition.

Locks: Yes, they are also contributors to the catalogue. Their voices have been key. It's wonderful to get lost in your own thoughts, to fall into a hole and find all this other stuff—that's a great part of the process—but just like any writer needs a good editor, all processes like these need a kind of sounding board, peers with whom you can have a casual but committed conversation, where people don't just feel like, "Okay, we're having a drink, it's nice to see you." We wanted the advisors to be invested in this process and in an ongoing dialogue over the arc of the show.

Lew: To begin with, we had you, Scott, to advise us. You brought a broader institutional outlook,

SINCERELY YOURS:
A CONVERSATION WITH
CHRISTOPHER Y. LEW AND MIA LOCKS

Rothkopf, Scott

which—compounded by your regular reminders of trends that viciously return—gave the process real perspective when we were in the thick of it. And you've spurred everyone on by playing devil's advocate. [*laughter*]

Locks: Yes, I've appreciated your persistent willingness, Scott, to challenge our thinking by asking difficult questions.

Lew: We also invited Gean Moreno to be an advisor. He is curator of programs at the ICA [Institute of Contemporary Art] in Miami. He has his own artistic practice, and is kind of a human encyclopedia—particularly well versed in theory and things touching on the political sphere.

Locks: And we have Wendy Yao, who is in L.A. She is maybe best known as the founder of the store Ooga Booga and, more recently, an exhibition space called 356 Mission that she runs with the painter Laura Owens—it's one of the most exciting things that's happened in L.A. in recent years. Wendy moves beyond thinking institutionally about art. Actually, she came out of a punk scene. She was a musician herself.

Lew: Wendy has long-standing relationships with lots of musicians, chefs, and clothing designers.

Locks: And then there's Negar Azimi, a writer and a senior editor at *Bidoun*. She's on the board of directors at Artists Space here in New York, where she's based. On top of her broad knowledge of art, Negar has studied politics and anthropology, and thinks expansively about the cultures of the Middle East. That frame of thinking expanded into our conversations in a really meaningful way.

Lew: Aily Nash, who has organized programs at Basilica Hudson in upstate New York and for the New York Film Festival's Projections program, is an advisor and co-curator of the film program.

She represents a new generation of film-and-video curators who are thinking hard about what moving images mean in the twenty-first century. Scott, you felt it was important to have a strong film component.

Rothkopf: Well, in part because our new building has a proper theater as opposed to just a gallery dedicated to film and video like we had uptown. It seemed crucial to prioritize that aspect of the Biennial, which had become less present in some of the recent installments.

Locks: With the advisors, we held retreats, and in advance we'd send out a list of topics and artists currently on our minds—usually very stream of consciousness—as conversation starters.

Lew: The retreats were useful in that they prompted us to update our thinking. They helped us recognize when we were heading off course. If we had said something at one meeting, months later we'd convene and the group would remind us, "Well, where did this go?" They created a foundation, whereas if we were just having drinks with individuals each time afresh, we wouldn't have been able to build ideas in the same way.

Locks: It was also helpful for Chris and me to have conversations with individual advisors, to pose specific questions.

Lew: And it was cool that they would join us for studio visits whenever possible.

Rothkopf: Those ongoing exchanges gave a kind of narrative texture to the conversation. But in terms of tracking down new artists, how did you start, and where did you go? And how did you know to head toward what you didn't already know?

Lew: We reached out to curators, writers, and artists on the ground all over. Then we followed up with studio visits.

Locks: Let's see . . . We went to Boston and Providence really early on. Also to Atlanta and Los Angeles.

Lew: We went to Puerto Rico.

Locks: Yes, that was an early trip as well.

Lew: I remember San Juan vividly, being in a restaurant with artists and curators mostly involved with the artist-run nonprofit Beta-Local and a new space that has opened in the Hato Rey neighborhood, Embajada. They were speaking about the urgencies of Puerto Rico's bankruptcy issues. Some of them had snuck into this conference where investors could purchase pieces of the island's public assets—ports and things. There was a real urgency in San Juan that spoke to things going on across the country.

Locks: Yes, the debt crisis in Puerto Rico brought up a lot of national issues in terms of infrastructure and privatization. Going to so many cities as part of our research was about getting a sense of the cultural landscape. Most of our time was spent in studios, sure, but we also looked at exhibitions, project spaces, artist-run spaces—we were getting a sense of creative communities outside of what we already knew or had been privy to. Artists, like all cultural producers, are basically working from where they are, right? They're responding to the world around them, often in an immediate sense. I think particularly at this time in this country—not to get into politics right off the bat . . .

Rothkopf: Go for it. You *did* get into politics right off the bat, as I recall.

Locks: Okay, well, we're in a moment when things feel beyond us, or so hugely problematic that one response is to focus on locality, a sense of responsibility to the people around you, to your community. We saw this again and again, in cities big and small.

Rothkopf: I'm struck by how much the issue of the local comes up in the show, especially given that so many discussions in the art world lately have been about global or international currents. And in your catalogue essays, you're not talking about the refugee crisis or Brexit, or even something as far-reaching as climate change, but about the American presidential election, Black Lives Matter, mass shootings, and individual debt. It's not that these issues don't exist or have analogues in other cultures, but you seem to address them within the specific framework of the United States. It does feel to me like a very American show, and not just because these are artists who are typically living and working in the United States but because the topics and ways of working seem so specific.

Locks: When we first sat down with our advisors, we circulated Dana Miller's essay from the Whitney's recently published collection handbook, about the Museum's institutional history, as a kind of prompt to address that question of "Americanness." As much as the Biennial is oriented toward the art of the moment, and even as it has a kind of predictive framework, it's also a show with a deep history. It is a show that has taken place in some form since 1932, at the Whitney Museum of *American Art*. That is significant! In the past it has raised the question of who is an American artist—who qualifies and who doesn't. In this Biennial, something about American culture feels very much at stake. Traveling around the country in this election year has been a cultural experience in and of itself.

Rothkopf: Well, it's worth mentioning that this is the first Biennial organized during the run-up to a presidential election since the 1997 edition.

Locks: And this election will inevitably be remembered as a historically polarizing one. The issues being addressed, what's in the air right now . . . Every time we entered a studio,

SINCERELY YOURS:
A CONVERSATION WITH
CHRISTOPHER Y. LEW AND MIA LOCKS

Rothkopf, Scott

issues of inequality or racism or violence were being brought up in one way or another without our prompting.

Rothkopf: Mia, you use the word "unease" in your catalogue essay. Does the show have a rather bleak emotional tenor?

Locks: I think it's dark at times, but that's the moment we're in. The Biennial we've put together I don't think either Chris or I saw in advance. We surprised ourselves in a lot of ways. A process like this is so fast-moving, and the rise of Donald Trump literally coincided with our project. It became this kind of nightmare-slash-train-wreck that we were watching happen. What's most terrifying is what Trump has stirred up, what his rhetoric and behavior represent, which is a dark part of American culture and society that's always been there and now has a soapbox to stand on. And artists talked to us about what these current conditions do to one's ability to make work, how they weigh on us, and what we need to . . . not adjudicate . . . but what's the antidote to hate speech and narcissistic misogyny and blatant racism? Artists are asking very pointed questions about how to engage, how to model ways of thinking about ourselves as human beings.

Lew: The show may have very dark overtones, but there's another side to it that shows that artists can envision a future that *is* different. They are attempting to overcome the challenges we're facing today, and to return agency to the individual. I think of the painter Shara Hughes, who is making imagined landscapes that take on a very different affect in this moment than they might in another. The Biennial's promise is to provide a snapshot of this time—that is what we're trying to do.

Locks: That said, curating a show like this is a bit like fumbling around in the dark for matches. You pick up pieces and maybe they spark, or

they fizzle, and it takes a while before you can really get a flame going, before you start to see the shape. I think a sense of uncertainty or not knowing is embodied in some of the works. Park McArthur's project is an extension of a series she's been doing with infrastructural signage, where she omits the text so there's basically just solid color, just background. For the Biennial, she's creating signage for points of historical interest—think of those brown roadside signs you see. There's something interesting about this notion of way finding without text, without a directive, without content, and the idea of a historic moment that we can mark but it's blank. It lacks representation because it cannot be represented.

Rothkopf: Throughout the process I got the sense that most of the artists you considered weren't really working through pop culture or mainstream design and fashion. Chris, you write in your essay about *RuPaul's Drag Race*, but not so much about the idea of the Biennial's artists playing with camp or either espousing or deconstructing the tropes of mass culture or the media. This contrasts with a number of recent large shows like the 2015 New Museum Triennial or the 2016 Berlin Biennale, which was curated by the art collective DIS. Those shows felt very slick and pop, as well as attuned to the promise of fabrication and technology. In your Biennial, I've noticed that when the work gets closer to design or a functional aesthetic, it typically takes a hard left turn from high style or, on the other hand, from the look of IKEA. It feels much humbler, very DIY. I'm thinking here of Susan Cianciolo's emphasis on the handmade and her project for the Whitney's restaurant, or Jessi Reaves's oddly disheveled furniture.

Lew: Many of the artists are working in ways that are not ironic but deeply sincere. They are less engaged with corporate aesthetics, and there's an earnestness that cuts through any notions of camp or style, that gets closer to the functional, as you mention. These artists aren't just retooling

the pop that's out there, they're actually trying to get at an underlying sensibility that feels deeply urgent. Kamasi Washington, who is himself an emerging pop-culture figure, makes music that addresses social injustice and spirituality. And Puppies Puppies is thinking about pop through an emotionally laden lens and dealing with issues of freedom or the lack thereof. They are not just playing with pop culture in a tongue-in-cheek manner.

Rothkopf: I remember you guys coming back from meeting Puppies Puppies. You were so excited and confused that the hairs on the back of your necks were standing up. [laughter]

Locks: I guess our visit was the first time that Pups, as we like to call them, actually showed up in person for a studio visit—unmasked. They had done studio visits before, but only when their personhood was concealed behind a costume or behind their partner, who acted as a proxy, walking visitors through an arrangement of artworks. Anonymity is crucial to Pups. They are interested in the figure of the artist as a kind of work in and of itself. And we talked about the work in a pretty direct way. It was inspiring.

Lew: Unexpected.

Locks: Very unexpected. But aside from pop culture, it strikes me that there has been a renewed interest in a kind of lefty autonomous culture, in the face of mass homogenization. It's a reaction to a lack of creativity across the board. That's where somebody like Frances Stark comes in. She's one of the more established artists in the show, and she was a touchstone for us. Frances made a suite of large paintings based on enlarged page spreads from Censorship Now!! [2015], a book by the post-punk musician Ian Svenonius, who is an underground cult figure in his own right. Svenonius makes an argument that it's not freedom of speech that's needed to enable the arts to thrive. Rather, we need more censorship of

so-called creative expression—of bland bullshit, mass-produced pop as well as the "free press" and fascist ideology. Frances enlarges this provocation, underlining different sections of the text, as a way of embodying the extreme sentiment, the rage, the ambivalence. So there is a touch of sarcasm or irony in the show despite its prevailing sincerity, and I think it's compelling to think about this idea of pushing so hard that it goes all the way around—

Lew: To the extreme.

Locks: Right. So we wanted to ask, where does autonomous culture exist these days, if we can agree it does still exist, and how does it operate?

Lew: It's generally small in scale and rooted in a personal exchange. I'm reminded also of Asad Raza and The Home Show [2015] he presented in his modest one-bedroom in SoHo. Asad invited artist friends and family members to give him something for the intimate context of his home.

Locks: This idea of hosting extends to his project for the Biennial, which considers the social relationships that can emerge when we treat each other as hosts and guests versus other categories that are less hospitable, less generous. When you bring this to the space and scale of the museum, of course, a different dynamic is created.

Lew: And keep in mind there's the direct opposite of hosting in Jordan Wolfson's new virtual reality piece, which transports the viewer to the scene of a brutal beating. In some instances in the Biennial, the antithesis serves as a productive contrast.

Rothkopf: Well, throughout the show there's an almost idealistic emphasis on the notion of individual agency . . . I remember you started out with a thematic that had to do with an almost unreconstructed sense of self-expression or

⊠⊠⊠⊠○

SINCERELY YOURS: A CONVERSATION WITH CHRISTOPHER Y. LEW AND MIA LOCKS

Rothkopf, Scott

self-discovery—maybe even self-infatuation. I think at one point I joked that you should call the show "Self-Centered." [*laughter*] Chris, you're even quoting Emerson in your essay. Maybe because I'm just a few years older than the two of you, I struggled with the notion of sincerity at points in our process, and the prevailing lack of irony that you mentioned earlier.

Lew: Sincerity about the self goes all the way back to the founding ideals of the nation. It never went away.

Rothkopf: But I think that it did go away to a certain extent.

Locks: Yes, I mean, postmodernism . . .

Rothkopf: Exactly. Your conception of the self, as discussed in both your essays, is, to a certain extent, a little old-fashioned. It's not a purely autonomous conception of self, but it isn't a postmodern model of identity as a matrix of many different texts, or of someone who has constructed a life through social media so they can pretend to be someone they aren't. If there is a glimmer of hopefulness in your show, it's that both of you land, in different ways, on the idea of real relationships among real people. This is an idea of an essential self forged in relation to others, whether through intimate relationships or community structures such as schools or churches.

Locks: One thing that seems clear to me, and I hope to anyone who sees the show, is that subjectivity remains an open question—how it forms and operates, how we understand it, how it shapes our daily lives. All the energy and the urgency behind the "identity politics" of the '80s and '90s never really went away. The language just shifted to find viable terms or stakes in the age of social media.

Lew: Today museums can actually facilitate

nuanced and complicated conversations around things like identity.

Locks: Artists are, of course, very sensitive to the questions that should be asked.

Lew: And in our research process, we spoke to many artists about not just trying to make it alone, as an individual "brand," but instead thinking in terms of the communal and collaborative endeavor, about not being motivated by career as much as oriented towards the things a community needs.

Rothkopf: I wonder if this comes from a larger sense of political disillusionment among a younger generation of artists. Perhaps it's because we've had eight years of Barack Obama's presidency, yet the conversation around race is more contested than ever. And we had an opportunity in the wreckage of the financial crisis to reform our banking structures and tax codes, and that didn't really happen either. And then we elected Trump. Maybe all this has given artists a sense that the broader political conversation has failed, so they should focus on a local community, a group of friends. They're targeting their agency at a level of change that's more contained, looking beyond their studios but not at the globe.

Locks: It's not some huge claim of "I am going to save the world" or "Art can save the world." I think our generation, and those coming up behind us, feels a certain modesty or humility about what art can do. Artists are starting the conversation with, "Okay, what do I have around me? What are my immediate surroundings and what are their possibilities? How can we build out from here?"

Lew: In part this is in response to how art is being used as a financial asset—how it's shipped around the world and traded. This is not a dominant theme in the show, but KAYA, GCC, John Divola, and Oto Gillen all draw from the tangled web of aspiration, art, and finance.

Locks: As artists become increasingly aware of how their work does or might function in this process of financialization, they are thinking seriously about repositioning themselves in relation to it. At the very least, they want to slow it down.

Lew: To frustrate it.

Locks: Take Cameron Rowland, whose proposal for the Biennial is to ask the Whitney to facilitate a financial investment in what is known as a social impact bond. Or Irena Haiduk's project, which invites visitors to buy shares in a blockchain that will purchase land in the former Yugoslavia. So the economic conditions and possibilities are paramount from the outset in both Rowland's and Haiduk's works; they are central to the very idea of each project.

Lew: There's also Casey Gollan and Victoria Sobel's collaborative work stemming from their involvement with Free Cooper Union, a group of students who protested the school's instatement of tuition. Cooper had been free for over 150 years but recently started charging tuition due to poor financial management. Casey and Victoria's text pieces are infused with the emotions people experience under the weight of capitalist forces.

Locks: Maya Stovall has established her own home in a former financial institution—she actually lives in an old bank on the east side of Detroit. When we visited her studio, we literally gathered around a teller's desk as she showed us videos of her performances.

Rothkopf: Speaking of real financial exigencies, you two have proposed that, for the first time, all of the artists in the Biennial are compensated for their participation.

Locks: Yes, it's a symbolic acknowledgment. I can't speak for Chris, and I am in a slightly different position as a consultant to the Whitney, but I find there is a difficulty, a particular challenge that comes with a project like this. You have this fancy new building, everybody knows how expensive and amazing the space is, and you want to share the wealth. A lot of unpaid artistic labor goes into a process like this, so what can be done? And while this honorarium isn't going to change anyone's life, we wanted to allocate *something* for the artists. This is a conversation that is happening in the art world—groups like W.A.G.E. [Working Artists and the Greater Economy] are addressing this—it goes way beyond the Biennial. For artists, it's not just about getting more money. It's also about acknowledging the inequity in our field. Occupy Museums raises this issue in their *Debtfair* project, reminding us that the 99 percent versus the 1 percent is very much a reality in the art world.

Rothkopf: So you see this as a first step?

Locks: Absolutely. It's complicated, and there's no blanket solution that can be applied to every show or every organization. But the wealth gap has become such a prominent issue in the art world, and it felt very much part and parcel of the conversations we were having with artists for our show. This is really about putting your money where your mouth is, about taking action and doing what you can with what you have.

Lew: We want to acknowledge artists as people, as humans—to not just treat an artist as an abstraction, saying, "We want your work, but we're not going to deal with you as a person." We want to acknowledge the person across the table.

Rothkopf: We should also recognize the diversity of the artists in the show. It seems there is a greater proportion of artists of color than have ever been in the Biennial. Was this a specific goal, or did it happen organically?

Lew: We were actively thinking about diversity from the very beginning. If you look at the

SINCERELY YOURS:
A CONVERSATION WITH
CHRISTOPHER Y. LEW AND MIA LOCKS

Rothkopf, Scott

dominant systems of the art world, they're still strongly biased in favor of white men. That's who you are predominantly seeing in solo exhibitions here in New York, especially in Chelsea. And all institutions, big or small, participate in that. Mia and I, when we were doing our research, were mindful of this problem and actively sought to meet a range of artists.

Locks: Thankfully, we're seeing more and more public conversations about race and structural asymmetries. These issues have been taken up by Black Lives Matter in very significant ways. It's not always been the case in American history, or art history for that matter, that we've talked about these conditions in a direct way. This is happening right now, and it feels necessary to declare this as a moment—to think not just about race but about systemic racism, and how the various power structures that are in place are enmeshed. And I would add that a pet peeve of mine is when people assume that artists of color or women artists or those whose identities are more marked would be the only ones to address these issues. In our show, questions of inequity and asymmetry are driven by artists thinking across lines, developing ideas about allyship and coalition politics that go beyond the limited frameworks of the past.

Lew: That's something that is brought up in Aily Nash's roundtable in this catalogue—that these responsibilities fall on everyone's shoulders.

Locks: We all theoretically believe that there should be more equity or there should be more diversity in the field, but it all comes down to enacting change whenever you have an opportunity. There's no time like now.

Rothkopf: In addition to the political thrust we've been discussing, you've included artists who are playing with ambiguous narratives or working more abstractly. Some are creating phenomenological puzzles with glass and mirrors, or quiet

moments of contemplation, or even, dare I say, hits of chromatic exuberance. Are these inclusions meant to offer a pointed alternative to, or respite from, the show's charged topicality?

Lew: Definitely. Mia and I had a lot of conversations about how we didn't want the Biennial to be heavy-handed and didactic. We wanted to modulate the rhythm and pacing of the show. There are moments that, for me, provide remarkable pauses, such as Ulrike Müller's meditative engagement with the space of the Goergen Gallery, or Larry Bell's red glass cubes on the terrace. And Carrie Moyer's abstract paintings carry that punchy, energetic color you refer to.

Rothkopf: I'm glad you mentioned Larry's installation on the terrace, since having so much outdoor space is one of the many features of our building downtown. To what extent did the new architecture and neighborhood, or the sense of occasion, inform your thinking and the artists' approaches?

Lew: It's an exciting thing that we have this long tradition of the Biennial, but this new building offers something of a clean slate. We're more than a year into the programming here. Our invitation to artists to come and think about the building has resulted in Ajay Kurian's use of the grand staircase to comment on upward mobility, Zarouhie Abdalian's outdoor sound installation that speaks to visitors and the city, and Samara Golden's and Raúl de Nieves's works that incorporate the natural light and views afforded by the floor-to-ceiling windows.

Locks: This has been an opportunity to let the artists guide us in what the possibilities are for the new building.

Lew: But in terms of history, the curatorial staff at the Museum has been an incredible resource. It's such a long-standing team, with curators who have organized Biennials over the last three

decades. When the 2012 curators Elisabeth
Sussman and Jay Sanders recounted pitching
an empty floor dedicated to performance to
the Whitney's Director Adam Weinberg, we knew
anything was possible.

Rothkopf: I love this sense of possibility. It's part
of the Whitney's DNA and something we cherish.
We're starting over, but the history remains—not
just as a list of past exhibitions but in the artists
and curators who made them. We're adding a new
branch to our family tree.

BEING WITH OTHER PEOPLE

Locks, Mia

You can feel it in the air we breathe, social tension so thick it coats the throat. Emotions are running high, really high it seems, these past few years, thanks in part to the polarizing rhetoric of Donald Trump, the ongoing violence against people of color at the hands of police, and the hate-fueled mass shootings in Orlando and Charleston, to name only a few of many disturbing recent events. These are turbulent times. And the turbulence affects you, infects you, seeps in. Sometimes you sigh because it just feels *necessary*. "The sigh is the pathway to breath; it allows breathing."[1] Or you find the intensity of feeling manifested in some other way: a tightened jaw, a clenched fist, a lump in the throat, a shaking of the head.

In my conversations with artists and others during the past eighteen months, I've heard a lot of uncertainty about the recent litany of social crises and an overall concern about how human beings are treating each other right now.[2] Many works in the 2017 Whitney Biennial articulate that unease. More often than not, they do so by questioning in a willfully uncertain mode, testing supposed certainties, and asking us to reflect on the current conditions of social life in the United States. That the conversations linger and get stuck on social life seems symptomatic of our living, breathing present, a mood steeped in anxiety and alarm. Reflection, of course, is only one strategy by which art is social and political, and even so, art doesn't merely reflect social life; it contributes to it, through a range of means and methodologies, materials and forms. What, for instance, do Dana Schutz's paintings reveal about how it feels to be in the world right now at the level of the human body? How do moments of painterly abstraction function as tools for picturing corporeal violence? Or what questions, which explorations, does Maya Stovall's *Liquor Store Theatre* (2014–ongoing) make visible about the structural violence inflicted upon an impoverished Black neighborhood on Detroit's east side? Can a work like Postcommodity's *A Very Long*

Line (2016) do something different, do something *better*, than the toxic election-year discourses on the Mexico-U.S. border? How does Occupy Museums's *Debtfair* (2013–ongoing) provoke audiences to think more deeply about the economic inequalities underpinning the field—the industry—of contemporary art?

This year's Biennial juxtaposes and combines artworks that, fundamentally, have been made out of the stuff of our present moment, whether the general moods of anxiety, vulnerability, or rage, or the reverberations of specific social debates and struggles, such as state-sanctioned violence against Black bodies, new postcolonial critiques, or the burdens of financial debt. Against such a backdrop of uncertainty and strife, the exhibition seeks to frame a set of questions about the self and the social, how the two intersect, and, importantly, how rethinking our conception of the former might transform our relation to the latter. How might we imagine anew the category of human being, or better yet, what Sylvia Wynter calls "being human?"[3] Is there an ethical dimension, and if so, how and where does it get articulated? Can we conceive of ourselves not only as singular individuals but also as co-humans, our identities as much relational as private? Might that allow us to think about and inhabit social space differently? And could this, ultimately, help us to better negotiate our differences in a climate where people seem so polarized, angry, and afraid?

Several works in the exhibition conjure the physical and psychological experiences of stress and anxiety that pervade our daily lives at this contemporary moment. Directing our gaze toward scenes of societal violence, Dana Schutz's paintings draw inspiration from a mix of sensationalist news stories and imagined everyday encounters, conveying social angst in both theme

ⓧⓧ ◯ ◯ ◯

BEING WITH OTHER PEOPLE

Locks, Mia

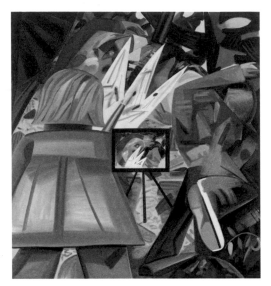

FIGURE 1. Dana Schutz, *Shooting on the Air*, 2016. Oil on canvas, 96 × 90 in. (243.8 × 228.6 cm)

FIGURE 2. Kaari Upson, *Left Brace Erase, Back Brace Face*, 2016. Polyurethane, aluminum, and acrylic spray paint, 80 × 84 × 82 in. (203.2 × 213.4 × 208.3 cm)

and style. The results are furious blows of color and hefty brushstrokes that form compositions packed with frantic figures—again and again, people are seen fighting for their lives. In *Fight in an Elevator 2* (2015), a group inside a cramped elevator is caught in rowdy conflict: one person strangles another; a shoe crushes someone's face. At least two weapons that look like blades— a knife? a chain saw?—appear to float in space, while severed limbs hover at top and bottom. What is the cause of this brutal clash? Is it a struggle for space, for breathing room, for room to live? In *Shooting on the Air* (2016), a figure is seen from behind firing a rifle at a terrified group scrambling to get away, their limbs akimbo and faces rendered in corresponding panic. The horrifying scene doubles inside the viewfinder of a television camera at center, recalling the fatal shooting of a news reporter and cameraman that was caught on live TV in 2015, an event that inspired the painting.[4] Set within some of the most intimate confines of our shared social space, whether riding in an elevator or watching the news in our living rooms, Schutz's scenes evoke the fear

of random acts of violence to remind us of the vulnerability of human bodies—of others and our own—in order to refine the stakes of the ever more porous distinction between what might be deemed private space and the one that we all inhabit together.

Bodily anxiety also finds form in Kaari Upson's mammoth gnarled sculptures, which cling to walls and spread across floors like clusters of metastasizing tumors. Made by casting run-of-the-mill pieces of furniture that typically signal relaxation at home (couches, cushions) and then splaying them open, flipping them on their sides, or twisting them inside out to expose their saggy guts, Upson's works flirt with abstraction yet retain just enough of their recognizable form to challenge the comforting notion that we might find respite from the world outside by cozying up on the living room sofa. Throbbing with feeling, their sumptuous shapes embody a material struggle, evincing the violent social forces that invade our private domestic retreats. An embodied struggle is also evident in Harold Mendez's *but I sound better since you cut my throat* (2016), a fifteen-foot-tall steel pole, irregularly bent and kinked as if wrested from some larger structure. Like scar tissue building up around a wound, a lump of

tree trunk is enmeshed with a snippet of chain-link fence, while the whole clot of metal and wood affixes so tenaciously to the pole that it appears to be clutching for dear life. According to Bessel van der Kolk, we absorb traumas into our histories and cultures as well as into our bodies and brains.[5] Upson's and Mendez's works call forth this double weight in forms that have been shaped by and through duress. They hold within them a sense of struggle that is viscerally affecting—it hits in the belly as much as the head—engaging our capacity to feel through them the impacts, both personal and collective, of our tumultuous present.

Zeroing in on particular social dynamics, some works emphasize the ways in which engagements with others shape our sense of self. A relational understanding of identity, for example, can be grasped in the collaboratively produced installations of KAYA, Asad Raza, Postcommodity, and Occupy Museums, in which the negotiations intrinsic to the social are foregrounded as part of the "work" of art. In different ways, these works embody aspects of sociality (reciprocal dialogues, the sharing of authorship, hybridized styles, negotiations of taste), which sometimes unfold in knotty fashion. Take KAYA's combinatory style of sculptural paintings (or are they painterly sculptures?)—amalgamated forms culled equally from the painting practice of Kerstin Brätsch and the sculptural one of Debo Eilers, with occasional marks added by Kaya, the daughter of a friend of Eilers's. Or Asad Raza's Biennial installation, with its bona fide grove of trees and performative "hosts," who guide visitors through the work, divulging personal stories and perhaps even offering food or drinks to share. A set of protocols based on social codes of hospitality loosely guide the hosts' interactions, but these are meant to be interpreted generously, such that each host may bring his or her own improvisational style into the mix.

Summoning an experience quite the opposite of welcoming hospitality, Postcommodity's

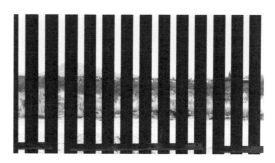

FIGURE 3. Postcommodity, still from *A Very Long Line*, 2016. Four-channel digital video, color, sound; looped

A Very Long Line drags the viewer into a frustrating video loop in which the Mexico-U.S. border appears projected in nonstop horizontal motion, at varying speeds and gyrating around all four walls of the room. The grating soundtrack (drone-like hums and metallic whirs) imparts a sense of hindrance and further disorientation, and underscores the discord that surrounds political debates regarding the border. As a collective of Indigenous artists from three different tribes, Postcommodity considers *A Very Long Line* within a history of struggle in the region, dating back to ancient Indigenous populations who have inhabited land on both sides of the border. Complicating the viewer's perspective, from a straightforward video clip (a long take of driving alongside the border) to a whirling visual and sonic squall across four channels, the work is immersive and overwhelming, suggesting a politics that extends beyond a mere geopolitical line separating two nation-states. The border instead becomes an experiential zone, a cluster of complex and disorienting feelings, a multidimensional manifestation of violent and ongoing disruption to lands, bodies, and communities alike.

In the wake of the Great Recession, personal indebtedness has continued to emerge as a dividing line of a different stripe, a largely invisible yet powerful demarcator of socioeconomic status that is made salient by *Debtfair*, an installation by Occupy Museums. The collective, which emerged

BEING WITH OTHER PEOPLE

Locks, Mia

FIGURE 4. Oto Gillen, still from *New York*, 2015–ongoing. High-definition video, color, sound (work in progress)

social networks that are connected through "a financial, rather than aesthetic or conceptual relationship."[6] This notion of debt as a mode of relating to others feels distinctly American: 80 percent of Americans are in debt of some kind, and U.S. household debt is now estimated at 130 percent of annual income on average.[7] A shared American experience indeed.

Conceived as a structural position—not a thing, not a place, but a relation—the undercommons, as formulated by Stefano Harney and Fred Moten, is "the common beyond and beneath" or "the general antagonism" that undergirds social life.[8] It is the stuff that is always and already happening between people, however informally, negotiating everyday lives and struggles. "Politics proposes to make us better," they write, "but we were good already in the mutual debt that can never be made good [. . .] We owe each other the indeterminate. We owe each other everything."[9] This notion of a shared, ongoing, and unpayable social debt to one another links us together in profound ways. The undercommons hinges on the belief that "[y]ou don't have to elaborate yourself as an individual to be with other people—and in fact it's a barrier to being with other people."[10] This means thinking far more imaginatively about collectivity, about being with other people *in difference*. It is about conflicting desires and interests as much as shared affinities. The works of Oto Gillen, Tommy Hartung, and Maya Stovall take up this challenge to the worn-out ways of thinking about collectivity. Contemplating feelings of aloneness and the struggle of the individual in a stratified society, these artists probe the tension between preserving private personhood and forming ties with others.

In Gillen's video slideshow installation *New York* (2015–ongoing), hundreds of individuals move through the urban landscape isolated from one another, caught up in their jobs and daily routines. Charting the cycle of a day and a night,

out of Occupy Wall Street, put out an open call to artists across the United States and Puerto Rico, asking them to disclose specific details about their relationship to financial debt (which types of debt they carry, how much they owe, to which instutions, etc.) and to submit artworks for display. Occupy Museums then organized a selection of the resulting artworks into "bundles," mimicking the way banks and other financial institutions create asset-backed securities from tranches of collateralized debt. These bundles, installed as if inset into the museum walls and hanging between exposed studs, index the concrete economic burdens facing artists and make visible what is usually kept hidden. In the process, they form a kind of refusal of the isolating experience that debt so often produces, creating instead

Gillen focuses his camera primarily on working people—food vendors, gardeners, police officers, delivery persons, and street musicians, to name a few. Against these bodies, he juxtaposes ominous nighttime images of high-rise luxury towers under construction, their lights so bright and blown out they create an aura. A meditation on the estranging gulf between the 99 percent and the 1 percent, *New York* also documents the relentlessness of the daily grind for much of the former. What could be more of a shared experience? However isolated we might feel from each other due to the demands of everyday life, Gillen's work suggests that we are also, in some way, together en masse.

Hartung's *The Lesser Key of Solomon* (2015) imparts another mode of struggle against bounded individualism. Centered on a two-part monologue appropriated and pieced together from YouTube clips, the eight-minute video is an appeal to and for humanity. "This life is kinda terrible," a man flatly states, speaking directly to his webcam. "It's a challenge [. . .] to suffer as a human." The emotional apex occurs when the audio breaks into the sound of an alarm (or is it a siren?), and we see a montage of Black faces morphing together, each one bruised and battered almost beyond recognition. "I am a human being!" the second voice shouts, at a notably higher pitch, against stirring background music. "But where is your humanity to my people, the Black people? When have you shown humanity to Black people? Yes, I'm a human being!" At a moment when Americans are, for the first time in decades and in a very public way, having honest discussions about the ongoing brutality against Black bodies, an appeal to humanity becomes a call to action. Hartung's work begs us to acknowledge each other as human beings. Period.

Pause to consider for a moment the idea that part of what it means to be human is "to feel others unmediated," as Harney and Moten propose, and that the space in which this occurs

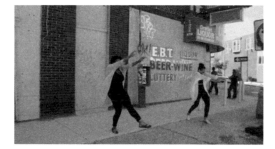

FIGURE 5. Maya Stovall, still from *Liquor Store Theatre, vol. 1, no. 1*, 2014. Digital video, color, sound; 4 min.

is "immediately social, amongst us, our thing."[11] Contemplate these as the needs, the stakes of social life, as what is meant by *humanity*. "The capacity to feel through others, for others to feel through you, for you to feel them feeling you."[12] Maya Stovall's video series *Liquor Store Theatre* employs "a dance ethnography of improvised urban spaces" toward the exploration of this human capacity.[13] Trained as an anthropologist as well as a choreographer, Stovall tests the vulnerability of bodies—her own and her performers'— by dancing on the sidewalks and in the parking lots of liquor stores in McDougall-Hunt, a low-income and primarily Black neighborhood in her native Detroit. The unannounced performances function as a tool for facilitating conversations about the vulnerability of other bodies, including the often impoverished and marginalized people who frequent these establishments. Offering a variety of everyday goods beyond liquor, these stores are of particular interest to Stovall because they are among the most successful businesses in the neighborhood, and because they effectively function as social spaces, too. In Stovall's video interviews, patrons and passersby offer their perspectives on the changing landscape of Detroit and reflect on their own lives. "I was born here, sweetheart, behind McDonald's," one woman explains. "My daddy bought the house in 1945." "I've been in this neighborhood for fifty-six years," a man declares, "and now there are a lot of abandoned houses." Yet another man

FIGURE 6. Pope.L aka William Pope.L, detail of *Claim*, 2014. Paint, pencil, sliced bologna, and 688 black-and-white photocopies, 16 × 36 ft. (4.9 × 11 m). Installation view: *Ruffneck Constructivists*, Institute of Contemporary Art, University of Pennsylvania, Philadelphia, February 12–August 17, 2014

dances alongside the performers for a bit, adding his own improvised moves. When he addresses the camera, his voice becomes a chant: "Power, power, power to the people! People to the power!"

Although Detroit once had one of the highest rates of Black homeownership in the United States, as Keeanga-Yamahtta Taylor has described, more than a third of Black families who took out mortgages between 2004 and 2008 have lost their homes to foreclosure.[14] Since filing for bankruptcy in 2013, the city has demolished more than 10,667 blighted buildings.[15] According to the U.S. Census Bureau, Detroit has the highest poverty level of any major city in the country.[16] We have heard these kinds of statistics about Detroit, but *Liquor Store Theatre* puts human faces to the numbers, making what Judith Butler might call "an ethical demand" on us as viewers.[17] Butler uses the phrase in her analysis of Emmanuel Levinas, the philosopher who believed that "to expose myself to the vulnerability of the face" lies at the very foundation of our ethical understanding as human beings.[18] Such exposure triggers our awareness of what Levinas calls "the extreme precariousness of the other."[19] Stovall's project puts pressure on the particular

precariousness of poverty and Blackness, specifically where these intersect in Detroit, asking us to consider how such categories of lived experience sit in relation to larger systems and forces of gentrification, racist housing policies, and predatory lending practices—all of which point to the irrefutable fact that the precariousness of humanity is unevenly distributed.

Pope.L aka William Pope.L takes the precariousness of the face to another level, if not another place entirely. His room-sized installation *Claim* (2017), composed of a floor-to-ceiling grid of approximately 2,750 bologna slices (a number purportedly intended to reflect 1 percent of the Jewish population of New York, according to a framed statement hanging among the cold cuts), shows us how and where identification *doesn't* work, where it breaks down.[20] Atop each slice of processed deli meat is a low-quality black-and-white photocopied image of a person's face, images taken from photographs snapped arbitrarily on New York streets. The faces are rendered further indecipherable by the casual application of acrylic paint dabs as fixative and the slimy secretions of the bologna leaking onto the image surfaces. Are these really supposed to be Jews? A conflicting mix of tidy data visualization (the grid) and sloppy data points (the faces), Pope.L's work puts us in an uncomfortable position: we tend to invest data with a desire for accuracy when, in fact, its value so often hinges on belief, on whether or not we believe in the framework, the methodological approach, the analysis. *Claim* doodles with "data" to create unstable ontologies. It makes us *not* believe; it makes us question. Moreover, it posits the face not as a reminder of our individual humanity but as a marker of race or other social category.

Putting forth an obviously risky proposition—that there is something distinctive about Jews as a race and that it can be known from their faces—and yet simultaneously unraveling that very

construct by completely disregarding any attempt to discern between Jews and non-Jews (recall the photos were taken at random, a point reiterated by the artist's accompanying text), *Claim* echoes Jelani Cobb's description of race as "a fictive garb [. . .] whose determinations are as arbitrary as they are damaging."[21] The work delivers a deliberately muddled message, forcing us to confront our own previously held assumptions about what constitutes Jewishness and how one gets identified as such—not to mention the underlying question of who gets to enforce/reinforce racial stereotypes and who does not, and which stereotypes are or are not okay to tamper with. What does it mean for the self-described "Friendliest Black Artist in America" to examine Jewishness?[22] And is that *really* what he's after? For an artist whose entire career has teased and tested the instabilities and contradictions inherent in social categories, the supposed "claim" here seems intended to trouble expectations. *Claim* acts like an open container— literally, the installation is a 225-square-foot box without a lid—to hold the uncertainties underlying identity itself, the wobbly foundation upon which all such claims are propped up. (Again, Pope.L's text probes: "WHAT is this? What IS this? What is THIS?") This live social process of destabilization, or disidentification, is activated by and through the installation—which reeks of bologna (or its homophone, baloney)—serving up stereotypes only to shatter them, "to reinvent what's beneath us, to remind us where we all come from."[23]

<p style="text-align:center">***</p>

As a snapshot of the past few years in American art practice and its critical discussions, the Biennial can be said to serve a kind of social purpose, despite whatever other associations might fasten themselves to an exhibition such as this (capturing the zeitgeist, presenting "the best of," discovering the next generation). I hold on to the double-pronged idea that an exhibition is a social space for aesthetic experience as well as an aesthetic space for social experience. Plotting courses from national borders to local neighborhoods, from city streets to inside elevators, the works in this exhibition at times make manifest the social strife that surrounds us, and at times generate alternate zones or worlds— each as a kind of coping, aiming to better understand, maybe even to heal, our collective wounds. In materializing different textures and types of social space, they isolate moments of conflict and confrontation, struggle and resistance, modeling ways of thinking about how we might engage differently. Putting us face to face with ourselves, our feelings and bodily sensations, our thinking and feeling through others, they remind us that we have the capacity to reimagine what connects us, and to consider more imaginative ways of being human together.

BEING WITH OTHER PEOPLE

Locks, Mia

[1] Claudia Rankine, *Citizen: An American Lyric* (Minneapolis: Greywolf Press, 2014), 60.

[2] In addition to all of the artists with whom I have spoken, I am grateful for the sustained and meaningful conversations I have shared, first and foremost, with my co-curator, Chris Lew, and with our Biennial advisors: Negar Azimi, Gean Moreno, Aily Nash, Scott Rothkopf, and Wendy Yao.

[3] Sylvia Wynter and Katherine McKittrick, "Unparalleled Catastrophe for Our Species?," in *Sylvia Wynter: Being Human as Praxis* (Durham, NC: Duke University Press, 2015), 9–89. On page 31, Wynter elaborates: "We need to speak instead of our *genres of being human*. Once you redefine being human in hybrid *mythoi* and *bios* terms, and therefore in terms that draw attention to the relativity and original multiplicity of our *genres* of being human, all of a sudden what you begin to recognize is the central role that our discursive *formations*, aesthetic fields, and systems of knowledge must play in the performative enactment of all such genres of being hybridly human." Wynter's emphasis.

[4] On August 26, 2015, Vester Lee Flanagan II shot and killed news reporter Alison Parker and photojournalist Adam Ward while they were conducting a live interview for television station WDBJ in Roanoke, Virginia.

[5] See Bessel van der Kolk, *The Body Keeps the Score: Brain, Mind, and Body in the Healing of Trauma* (New York: Penguin Books, 2014).

[6] Occupy Museums, proposal for *Debtfair: Whitney*, October 2016.

[7] Susan K. Urahn, Travis Plunkett, et al., "The Complex Story of American Debt" (Philadelphia: Pew Charitable Trusts, 2015), http://www.pewtrusts.org/~/media/assets/2015/07/reach-of-debt-report_artfinal.pdf. David Graeber, *Debt: The First 5,000 Years* (Brooklyn, NY: Melville House, 2011), 379.

[8] Stefano Harney and Fred Moten, *The Undercommons: Fugitive Planning and Black Study* (Brooklyn, NY: Minor Compositions, 2013), 20.

[9] Ibid.

[10] Ibid., 125.

[11] Ibid., 98.

[12] Ibid.

[13] Maya Stovall, "LST Notes," personal writing shared with the author, March 2016.

[14] Keeanga-Yamahtta Taylor, *From #BlackLivesMatter to Black Liberation* (Chicago: Haymarket Books, 2016), 12.

[15] City of Detroit, "Detroit Demolition Program," http://www.detroitmi.gov/demolition. Accessed October 30, 2016.

[16] Karen Bouffard, "Census Bureau: Detroit Is Poorest Big City in U.S.," *Detroit News*, September 17, 2015, http://www.detroitnews.com/story/news/local/michigan/2015/09/16/census-us-uninsured-drops-income-stagnates/32499231/.

[17] Judith Butler, *Precarious Life: The Powers of Mourning and Violence* (New York: Verso, 2004), 131.

[18] Emmanuel Levinas and Richard Kearney, "Dialogue with Emmanuel Levinas," in *Face to Face with Levinas* (Albany, NY: SUNY Press, 1986), 24; cited as well in Butler, *Precarious Life*, 132.

[19] Emmanuel Levinas, "Peace and Proximity," in *Basic Philosophical Writings*, ed. Adriaan T. Peperzak, Simon Critchley, and Robert Bernasconi (Bloomington: Indiana University Press, 1996), 167; cited as well in Butler, *Precarious Life*, 134.

[20] Pope.L's iteration of *Claim* for the Whitney Biennial follows his similar installation of the same title at the Institute of Contemporary Art in Philadelphia in 2014.

[21] Jelani Cobb, "Black Like Her," *The New Yorker* online, June 15, 2015, http://www.newyorker.com/news/daily-comment/rachel-dolezal-black-like-her.

[22] See Mark H. C. Bessire, "The Friendliest Black Artist in America©," in Bessire, ed., *William Pope.L: The Friendliest Black Artist in America* (Cambridge, MA: The MIT Press, 2002).

[23] Ibid., 23n10. Bessire credits this quote to Pope.L's *White Baby*, Cleveland Performance Art Festival, 1992.

YOU BETTER WORK
(ALL TOGETHER NOW)

Lew, Christopher Y.

Bob the Drag Queen. Louder and brasher than the rest, she walks into the room purse first: arm outstretched, clutch in hand, ready to spear the competition. The season eight winner of *RuPaul's Drag Race*, Bob the Drag Queen, as America's next drag superstar, is charged with carrying on the legacy of the drag mother to them all.[1] As RuPaul herself explicitly describes: "What we're looking for is someone who can really follow in my footsteps: someone who can be hired by a company to represent their product; someone who can put together a sentence on television and present themselves in the most incredible way."[2] In other words, the "werk" of drag remains work through and through, success predicated on discipline and effort; yet far from tedious drudgery, this is work that leads not simply to material gain but to personal fulfillment, too.

In preparing its girls for their dream careers, *Drag Race* may emphasize a professionalized form of drag culture rather than a more progressive, gender-fluid way of life, but at heart the show is an ecstatic celebration of the self, a search for queens who use the magic of artifice to embody a true sense of who they are, drawing from a traditional notion of American identity that connects to the writings of Ralph Waldo Emerson and the poetry of Walt Whitman. Emerson's regard for nonconformity and individualism, as well as Whitman's all-encompassing spirit, runs throughout the reality show, as does an almost Transcendental sense of belonging, despite the show's competitive format, with each season's contestants set within a lineage and tradition. RuPaul explains, "Yes, we're a competition reality show, but because we're doing it in drag, other levels of consciousness seep in."[3] It's that kind of greater consciousness—an awareness of the continued necessity to investigate and invest in the self, the true "you" that refuses to be defined by the powers that be— that is crucial to the 2017 Whitney Biennial, and as such, *Drag Race* serves as a foil for several of the ideas central to the exhibition—or, as she

likes to call herself in her fabulous Renzo Piano couture, Ms. Whitney *Biennale*.

This extends, in part, to the different ways artists have tried to forge bonds between individuals, foster communities, and create lasting networks using the creative energies that willfully ignore systemic biases or knowingly circumvent them, all in a manner that is in keeping with the ideals set down by our Transcendental forebears. Interested in face-to-face encounters and direct experience, many of the artists in the show seek a form of intimacy in both feeling and place. "The near explains the far," Emerson writes in "The American Scholar."[4] And, like Emerson's privileging of primary experience over secondhand learning, these artists prioritize practice over theory, a kind of "doing" set in the places they call home.

Henry Taylor and Aliza Nisenbaum primarily paint from life, creating portraits through hours-long sessions with their subjects. Both artists invite various aspects of their lives into their work, including the homeless who live near Taylor's Los Angeles studio and the immigrants who call upon the services of Immigrant Movement International in Queens, New York, where Nisenbaum has volunteered. In another way, Occupy Museums and Chemi Rosado-Seijo address, respectively, the systems and institutions that influence daily life. Through their project *Debtfair* (2013–ongoing), Occupy Museums bundles artworks to reflect the types and amounts of debt their makers have incurred, making visible the collective's argument that debt is one of the greatest commonalities among Americans, artists and non-artists alike. Rosado-Seijo highlights the promises and shortcomings of institutions by swapping a museum gallery with a school classroom: students attend class at the Whitney, and art is exhibited at the Lower Manhattan Arts Academy, a New York public school. In effect, the artist asks, whom does an institution serve? Likewise riffing on institutional

YOU BETTER WORK
(ALL TOGETHER NOW)

Lew, Christopher Y.

FIGURE 1. Bob the Drag Queen, center, and RuPaul in the season eight finale of *RuPaul's Drag Race*, May 16, 2016

FIGURE 2. Installation view of *John Riepenhoff*, Atlanta Contemporary Art Center, August 29–November 7, 2015

mandates, John Riepenhoff creates systems and structures to showcase the work of other artists. In his series *Handler* (2009–ongoing), Riepenhoff casts his legs in papier-mâché and adorns them with his own pants and sneakers, then uses these proxy legs as easel-like stands to display paintings by other artists. For a 2015 "solo" exhibition, they literally supported works by fellow artists from Milwaukee and beyond, such as Peter Barrickman, Michelle Grabner, Kojo Griffin, and Nolan Simon.

In these recent times of escalating strife and partisanship, artists have taken it upon themselves to bridge divides. There is a positive disavowal of the barriers and obstacles that appear insurmountable, allowing many Biennial

artists to find generative responses to the challenges at hand. The impulse is not to flee from the traumas of reality but to prevent that distress from becoming a determining force. Rather, that energy is harnessed—as just a few examples—in the interactive fiction of Porpentine Charity Heartscape, Cauleen Smith's banners of refusal, and the emancipatory rhetoric of Tommy Hartung's video *The Lesser Key of Solomon* (2015). Whitman articulates well these complex feelings in "Song of Myself":

Battles, the horrors of fratricidal war, the fever of doubtful news, the fitful events;

These come to me days and nights and go from me again,

But they are not the Me myself.[5]

RuPaul's Drag Race kicked off in 2009, during a cultural moment that felt open to greater inclusion and acceptance, as RuPaul herself noted in discussing her return to mainstream visibility: "[I]t seemed like the hostility towards people who dance to the beat of a different drummer had lifted a bit. The Bush administration was over, and there seemed to be this easiness in the air. The fear-mongering from 9/11 had died down, and so we took this show out."[6] While this shift in national mood allowed *Drag Race* to succeed on cable television, it also came at a time for many when the American Dream had come to be more fantasy than reality. Education, career, home-ownership, economic and social mobility, especially for the millennial generation—all increasingly seemed like promises deferred if not forever unfulfilled. Yet *Drag Race* doubles down on the American Dream and the notion that focus and work will lead to achievement, in combination with self-love—RuPaul and her guest judges repeatedly chastise the contestants for not

knowing who they are and not being true to that self. The show's unabashed gay sensibility is one that does not find agency solely through taste—the so-called queer eye for the straight guy—but, more profoundly, one that lays claim to what has so often been inaccessible to minority groups: upward mobility of one's own making. RuPaul insists that the American Dream be available to not just an elite class. Broadcast against the backdrop of economic turmoil, rising income inequality, and racial tension, *Drag Race* offers a grand narrative rooted in self-determination, here told by a middle-aged African American drag queen who helps continue the trajectory of a country that resolutely cast off the shackles of European titles and nobility for a pull-yourself-up-by-the-bootstraps ethos. As Emerson writes in "Self-Reliance": "A cultivated man . . . hates what he has if he see that it is accidental—came to him by inheritance, or gift, or crime; then he feels that it is not having; it does not belong to him, has no root in him and merely lies there because no revolution or no robber takes it away."[7] Our New World Polonius, Emerson advocates for an individual to be true to oneself and not live lazily off the labors of previous generations. "Do your work, and you shall reinforce yourself," he writes.[8] Rather than conform to preexisting ideas, one should put in the effort to develop one's own thoughts and personhood. We each can hold the idealistic excitement of being a clean slate, open to one's own promise and ingenuity. Or as RuPaul puts it, "We are all born naked, and the rest is drag."[9]

Liberty (Liberté) (2016) is what Puppies Puppies calls "a drag performance and sculpture" in which the artist or another performer dons a Statue of Liberty costume—complete with torch, crown, and mask—and stands in public.[10] The artist points to street performers and Liberty Tax sign spinners, who perform zany acrobatics on public thoroughfares to garner business for the tax prep company, as "quiet participants in the history of drag," noting it is common in these instances for

FIGURE 3. Puppies Puppies, *Liberty (Liberté)*, 2016. Performance, Galerie Balice Hertling, Paris, July 7, 2016

men to be dressed as Lady Liberty.[11] As someone who renounces gender in professional contexts, Puppies Puppies describes the performance as "a genderless artist imitating a performer already in drag."[12] *Liberty* flattens the social and sexual hierarchies of dominant society by letting anyone wear her robes. The work creates space for drag without the baggage of moving up or down the social ladder, avoiding any kind of minstrelsy. It is a claim for freedom starting from a kitsch level . . . for the huddled masses of the fiercest variety.

If RuPaul's male look—wigless and in boldly patterned two-piece suits—is what she refers to as masculine drag, then Celeste Dupuy-Spencer's drawing *It's a Sports Bar But It Used to Be a Gay Bar* (2016) points to an instance of gentrification as reverse drag, a heavy load of testosterone masking a queer space that reflects the jostling of hierarchies and cultural markers in the United States. Masses of bros in sports attire gaze up at flat screens installed over the bar, enthralled by a televised football game. Interacting with the screens more than each other, the fans are in striking contrast to the two ghostly gay couples in the foreground who appear to be deeply engaged in conversation. In her drawing, Dupuy-Spencer makes apparent the sports fans' performance of hetero norms—arms raised, jeering at

YOU BETTER WORK
(ALL TOGETHER NOW)

Lew, Christopher Y.

the game—and reaffirms another legacy, symbolized by a Sylvia Plath jersey, in their midst.

<center>***</center>

At the center of *Drag Race* is the "werk room," the workshop where the contestants—always men out of drag—apply their skills toward winning the challenge given to them during each episode. There they design, sew, and construct their outfits, write scripts and songs, choreograph dances, rehearse, contour their faces, and, of course, throw so much shade one can mistake day for night. The process of transformation is one of the main focuses, a fact critics say precludes trans* individuals from participating, but it also demonstrates the variety of skills necessary to compete.[13] One must be a veritable Jack—or Jane—of all trades to be a superstar, not unlike the flexible skill set demanded by our early twenty-first-century gig economy. Bob the Drag Queens's very name speaks to this. "It's my dad's name," she jokes, a jest that nevertheless points to drag as vocation, a trade that confers an identity, evoking a litany of historical surnames associated with one's trade, such as Smith, Miller, or Cooper.[14]

Work has been a classic avenue toward identity formation and self-determination, and the tools of one's trade and how one uses them are often part and parcel of the worker. A central component of Zarouhie Abdalian's site-specific installation *Chanson du ricochet* (2014) is a haunting sound work that evokes the labors of former slaves in New Orleans by listing the implements particular to their work. The paced enunciation of "funnel, divider, scoop, oven" and less common objects such as "scorp, marver, gear pump, die" serves not only as a list of things rendered seemingly ever more obsolete by the service economy but also as a metonymic link to the workers who toiled with these tools in hand. Abdalian's list in commemoration of workers and their materials echoes Whitman, who wrote of the tools on

his own celebratory list: "In them realities for you and me, in them poems for you and me [. . .] In them the development good—in them all themes, hints, possibilities."[15]

Various kinds of work offer up wide possibilities for Susan Cianciolo. One of the most exciting designers to emerge in the 1990s only to abandon the commercial fashion world, Cianciolo is also an artist, filmmaker, and, for a time, a kind of restaurateur. First presented at the former Alleged Gallery (which was across the street from the site of the new Whitney), her *Run Restaurant* (2001) emphasized local food, spirituality, and wellness long before their mainstream embrace. By "playing seriously with the idea of grandish things," Cianciolo built a fully interactive environment complete with an eatery, water garden, and children's play area, in addition to designing the restaurant uniforms and organizing a program of live music.[16] Restaged as a temporary takeover of the Whitney's Untitled restaurant, it returns as somewhere to commune, a clean, well-lighted place where service work is reimagined as something holistic, providing for the body, mind, and spirit.

Rafa Esparza's recent work begins with the making of adobe bricks, employing traditional methods of production the artist learned from his father. By using the bricks to construct structures and sites for his performances, Esparza echoes the legacy of 1970s process-based sculpture, but here it is imbued with notions of heritage, familial connections, and social practice. The artist emphasizes the material and cultural *terroir* of his native Los Angeles: the water and soil are drawn from the Los Angeles River, and his performances have referenced the indigenous Danza Azteca rituals that continue to be enacted in Mexican and Mexican American communities. That the labor-intensive adobe bricks serve as an almost literal foundation for the artist's work is key, exploring "what it means for Esparza

FIGURE 4. Jessi Reaves, *Foam Couch with Straps*, 2016. Polyurethane foam, fiberglass, wood, and jute, 29 × 77 × 35 in. (73.7 × 195.6 × 88.9 cm). Installation view: *Jessi Reaves*, Bridget Donahue Gallery, New York, April 10–June 5, 2016

to be born into and collaborate with a family of laborers, considering his roles as son and artisan, conceptual driver and manual worker."[17]

The humble materials and construction of Jessi Reaves's sculpture-furniture hybrids are self-evident, albeit seemingly ad hoc and tongue-in-cheek, the artistic corollary to Bob the Drag Queen's ratchet drag. Like Bob's drag style that spins ghetto into gold, Reaves's work is a hyperbolic take on the artisanal aesthetic that pervades Etsy.com while simultaneously riffing on iconic modernist pieces (Mies van der Rohe's Barcelona chair, Isamu Noguchi's coffee table). In a sense, they are Design Within Reach in drag, trickle-down midcentury looks that Susan Sontag would admiringly call "irresponsible in their fantasy."[18] The materials that are generally hidden or cleaned up—upholstery foam, batting, sawdust, plywood—remain untucked, without illusion.

Whitman's sweeping vision comes not from a superior perspective on high but from his observations on the ground: among the war injured, farm animals, or simply loafing in the grass. Deana Lawson's photographs similarly

draw from what is directly at hand, the sweat of experience that can bridge time and distance. Making pictures of the Black diaspora in the United States and the Caribbean in addition to photographing in Ethiopia and the Democratic Republic of the Congo, Lawson has sought to create images of love and dignity to counter the violence so often associated with Black bodies. Eschewing the documentary for the constructed image, she depicts couples embracing in modest domestic spaces; confident nude women who steadily return the camera's gaze; and a regal-looking couple in Ethiopia, in an image that cuts across decades, conjuring Haile Selassie. The subjects in Lawson's pictures project their self-respect from within the frame of the large-format camera. The sense of the performative they carry with them "suggests a dramatic and contingent construction of meaning," to use a phrase Judith Butler has deployed in the context of gender but one I would say functions also with race.[19] For the moment of the image, the artist and her subjects come together in self-possession.

The dance tracks that close out *Drag Race* make reference to the nightclub as a temporal, utopic community. Iconic places in club history like the Paradise Garage in New York, the Warehouse in Chicago, and the Music Institute in Detroit were birthplaces of house and techno as well as a place for communities of color and LGBTQ folks to call home. Leilah Weinraub's feature-length film *SHAKEDOWN* (2017) continues that arc of club history and ballroom culture by capturing nights at Jewel's Catch One and Shakedown, both in Los Angeles. Opened in 1973, Catch One was the longest-running Black-owned club in L.A. until it closed in 2015, serving as what the *Los Angeles Times* called one of the few "havens from the homophobia of broader society."[20] Featuring performances and competitions, the club show-cased a more inclusive range of gender and sexual expression than what is presented on *Drag Race*. Shakedown, a Black lesbian strip club,

YOU BETTER WORK
(ALL TOGETHER NOW)

Lew, Christopher Y.

FIGURE 5. Deana Lawson, *Kingdom Come, Addis Ababa, Ethiopia*, 2015. Inkjet print mounted on board, 50¾ × 43 in. (128.9 × 109.2 cm)

is what Weinraub describes as "the faster, bigger, younger, more underground version" of what Catch One helped to pioneer.[21] The film captures the club's intoxicating, sweaty mix of bass-laden hip-hop, fantasies propelled by hair, makeup, and nails, empowered sexual bodies, and the rain of dollar bills that keeps it all going.

The intersection of identity and community is at the heart of Lyle Ashton Harris's latest project, *The Ektachrome Archive* (2014–ongoing), which the artist describes as the crossing of the different worlds he inhabits, namely a gay world, a Black world, and an art world. By mining the Ektachrome slides, videos, and journals he first made in graduate school at CalArts in the early 1980s and continued to produce for more than a decade, Harris weaves together the personal and the public by juxtaposing candid self-portraits and travel photos with images of intellectuals like Stuart Hall and bell hooks; artists such as

Catherine Opie, Marlon Riggs, and Nan Goldin; and events like the 1992 truce between the Bloods and the Crips. Culled from material made decades before YouTube and Facebook, Harris's project serves as a model for how personal introspection can sidestep social-media narcissism, discovering as Emerson did that "the deeper he dives into his privatest, secretest presentiment, to his wonder he finds this is the most acceptable, most public, and universally true."[22]

"The American Scholar," "Self-Reliance," "Song of Myself"—these foundational texts have helped capture and articulate an ethos at the core of our national identity, the animating spirit behind the ideals upon which our country is founded. While their practice has been marred by prejudice and violent discrimination, these ideals still offer a greater promise to all who call themselves Americans, to make plane an uneven field where all can claim agency. "We will walk on our own feet; we will work with our hands; we will speak our own minds," Emerson declares.[23] Leave it to a reality-based TV drag competition to help make Emerson's "we" increasingly inclusive (and that much more glam). Likewise, the Whitney Biennial sees the ideals at the center of the American experiment not as a broken dream forever irreparable but as fertile ground that must still be worked. This time there's no one to "sashay away," but rather we must come together, on our own feet, hands at the ready, speaking our minds, *purse first*.

1 Special thanks go to the *Drag Race* fans in my life: Cindy Lew, Daniel Chew, and Scott Roben.

2 RuPaul, as quoted in Kyle Buchanan, "RuPaul on *Drag Race*, *Hannah Montana*, and 'Those Bitches' Who Stole Annette Bening's Oscar," Vulture.com, April 4, 2011, http://www.vulture.com/2011/04/rupaul_on_drag_race_hannah_mon.html.

3 RuPaul, as quoted in Rebecca Nicholson, "RuPaul: 'Drag is dangerous. We are making fun of everything," *The Guardian* (U.K.), June 3, 2015, https://www.theguardian.com/tv-and-radio/2015/jun/03/rupaul-drag-is-dangerous-we-are-making-fun-of-everything.

4 Ralph Waldo Emerson, "The American Scholar" [1837], in *The Essential Writings of Ralph Waldo Emerson* (New York: Random House, 2000), 58.

5 Walt Whitman, "Song of Myself," section 4, in *Leaves of Grass* [1892 ed.] (New York: Bantam Books, 1983), 25.

6 RuPaul, as quoted in Seth Abramovitch, "RuPaul, Inc.: Advice from a Business-Savvy Drag Queen," *The Hollywood Reporter*, April 3, 2013, http://www.hollywoodreporter.com/news/rupaul-advice-a-business-savvy-432486; cited in Mary Marcel, "Representing Gender, Race and Realness," in *The Makeup of RuPaul's Drag Race*, ed. Jim Daems (Jefferson, NC: McFarland & Company, 2014), 14.

7 Emerson, "Self-Reliance" [1841], in *The Essential Writings of Ralph Waldo Emerson*, 152–53.

8 Ibid., 136.

9 RuPaul, "Born Naked," in *Born Naked*, RuCo Inc., 2014.

10 Puppies Puppies, unpublished artist text, August 2016.

11 Ibid.

12 Ibid.

13 See Laurie Norris, "Of Fish and Feminists: Homonormative Misogyny and the Trans*Queen," in *The Makeup of RuPaul's Drag Race*, 31–48.

14 *RuPaul's Drag Race*, "Keeping It 100!," Logo TV, March 8, 2016.

15 Whitman, "Song of Occupations," in *Leaves of Grass* [1892 ed.], 176.

16 Holland Cotter, "Susan Cianciolo—'Run Restaurant,'" *New York Times*, March 9, 2001.

17 Raquel Guitiérrez, "Rafa Esparza: How Brown Matters in the Multiplicity of Presence," in *Made in L.A. 2016: a, the, though, only* (Los Angeles: Hammer Museum, 2016), 58.

18 Susan Sontag, "Notes on Camp," in *Against Interpretation and Other Essays* (New York: Farrar, Straus and Giroux, 1966), 285.

19 Judith Butler, *Gender Trouble*, 2nd ed. (New York: Routledge, 1990), 190.

20 Tre'vell Anderson, "Jewel's Catch One Disco's Demise Marks Era's End for LA's Gay Blacks," *Los Angeles Times*, March 16, 2015.

21 Leilah Weinraub, as quoted in Jenna Sauers, "The Best Documentary about Black Lesbian Strip Clubs You'll See Today," Jezebel.com, February 3, 2011, http://jezebel.com/5749449/the-best-documentary-about-black-lesbian-strip-clubs-youll-see-today.

22 Emerson, "The American Scholar" [1837], 53–54.

23 Ibid., 59.

THE OTHER SIDE OF THE SUN

Moreno, Gean

Our year of dreaming dangerously, which stretched four- or fivefold out of sheer defiance, has come to an end. The exaltation of occupying spaces and refusing to go on with the goings-on, the bad flow, the bad bets of daily life, broke on a dawn fogged by tear gas and nebulous explanations for extra-judicial murder. It broke on police acquittals. It broke on the gasping, the winded pleas—eleven of them. It broke on the grotesqueries of conceptual poetry. It broke on the imaginings of a new world on which the State—that compendium of effects—or impatience unleashed one of its surprise night raids (no one is quite sure when it happened . . . or if it's over yet) and kettled everyone in a ravine of despondency, a barren disposition that in other days we would have pried from ourselves and eaten like an enemy, embargoing its spirit, appropriating its magic. But this time it's in us ineradicably, in a bad new way, as an enervating hollow, as the evanescent thing that this hollow cups.

At 9 p.m. on July 6, 2016, this unthing is mobilized as a gutting of comprehension. A cell phone live-streams one more Black body, Philando Castile's, destroyed during a traffic stop; a ghastly second video goes around, uploaded a few hours earlier, viral already, of yet another Black body, Alton Sterling's, pinned down and blasted away. It had been transacting in the informal economy into which it had been forced, doing what needed to be done there—the goings-on, the bad bets— and that was enough, and enough to pin from the eaves common sense, to put into proper focus (for those supposedly not in the know) the fact that the line between being and not, between having a claim on life and not, doesn't cross at the same slant through all tones of flesh.

Here is what Afro-pessimism and Black optimism, married and divorced in the lesson and its entailments, teach: the foundational figure of the slave, a subject transmuted into fungible commodity and property, wrenched from

kin and place, available to limitless, gratuitous violence and claimed by social death, is the very edge that constitutes the world, that holds it together through that which it holds in exclusion of itself. Fungibility and vulnerability without boundaries are precisely what *cannot*, by the lights of the paradigm that organizes the world, apply to an entity if it is to be considered human.[1] The slave relation, subsequently "epidermalized" —that is, transferred onto ostensibly free Black bodies, laminated to skin—is the negative, a void where a relation to corporeal integrity and personhood should be, against which the subject who produces a world of positive relations and symbolic value is cast. There is no porous border or zone of indistinction here. Jared Sexton: "Black life is not lived in the world that the world lives in, but it is lived underground, in outer space."[2] Blackness is what the world is not. Figuratively, it is that which is consigned to an indeterminate and unprotected space past the lip of civil society, so called—a structural position rather than just an identity as such; literally, it is that which is stockpiled and warehoused in different physical configurations from the projects to the pen, and tossed into a sea of institutional practices and material privations that abstract it to no end. An ontological split inscribes itself as social geography and institutional protocol, duplicating in the pleats of daily living axiomatic conditions in which some *aren't*, and have to go under or take off, so that others can simply *be*.[3] The enigma of the ongoing violence pivots on this fact. It's an open secret. To remain riddled by it is to exercise a deliberate choice.

The current arrangement of the world withholds guarantees on the value of Black life. Grotesque videos, among so many other things, circulate as testimony of this fact. In their proliferation, and in a million other ways, the bad new days announce the depth of misery that they are willing to propagate, that they propagate already. Meanwhile, contemporary art—our thing—ensconces itself

THE OTHER SIDE OF THE SUN

Moreno, Gean

as a defanged amenity in enemy quarters, in deserts of luxury, uninterested in the contradiction—a contradiction at least for those of us that think of it as something other than a buttress or window dressing for structures of domination—when it should be harrowed to the molecules by it. Instead, unabashed, we film overly fenestrated desktops trained on the minutiae of our rudderless lives. We buy stock images or produce images that mimic them. We code clever animations, unwitting allegories of emaciated imaginations, blind to their own smallness. We film friends enacting some Brechtian awkwardness that has become the repertoire, stagnant and domesticated, and we redeploy the images in calculatedly careless montages (or produce their object equivalents), a little CGI folded in and liquidy graphics for the credits if we can afford them. And we think that these efforts speak the name of the moment. Even against it. We are children of smart tech, not of smarts. We form constituencies that, while savvy in the calculus of social-status distribution, are delinquent in their duty to establish paths of disorganizing retreat from a dead center, and deaf to the simpler task of galvanizing disgust so as to endow it with operational capacity, even if only as a battering ram in lieu of being a line of reorientation.

But sometimes, in the middle of all this, something spit-joined in a particular way glitches the streaming of what passes for experience. One knows it instantly. One feels the anomalous bump in the flow. The moment Nicolás Guillén Landrián's *En un barrio viejo* (1964) flicks on, for instance: the drums bounce around and thicken in a minute-long static shot of one of the old neighborhood's dwellers, who inhabits the houses and shops that the camera will eventually be trained on. Against the lack of movement on the screen, we plunge into the historical tangles out of which the music structures its forms. In a similar way, one feels a dissident moment occur halfway through Beatriz Santiago Muñoz's *Marché*

FIGURE 1. Nicolás Guillén Landrián, still from *En un barrio viejo*, 1964. 16mm film, black-and-white, sound; 8:38 min.

FIGURE 2. Beatriz Santiago Muñoz, still from *Marché Salomon*, 2015. High-definition video, color, sound; 15:57 min.

Salomon (2015), a short film shot in an open-air market in Port-au-Prince. Amid all the physical death in the stalls—once-living things quantified as pounds of flesh in an allegory of the social death that Haitian slaves and their descendants have lived in—a pair of adolescents hack and gut and sell bits of meat. They talk to pass the time and, along the way, marshaling the centrifugal force of a confabulatory imagination, spin their quotidian conditions into the beginnings of a cosmic tale. In spiraling patterns of teenage wisdom, they slowly begin to shed light on the energy flows of the universe—dark, divine, and otherwise—and to recast the thousands of flies darting around the dead flesh, the severed,

white-eyed goat heads, as negentropy's sacred instruments. The reoccurrence of the phrase *trou nwa*—"black hole"—in sinuous *kreyòl* establishes an independent time sequence beyond the functional demands of language and mutates into a groping for another order, naming the bankruptcy that ours conceals. A space of storytelling contrary to that of convention condenses; the adult teller that fairy tales call for to lead the circle of young listeners is no longer a figure with access to some enchanting beyond. From this moment on, narrative can only be built from the position inhabited by those who craft it and live it, in experimentation and improvisation, against the foreclosures that common sense stands to enact through its instruments of enunciation. The enchanted beyond is bricolaged then and there. In the end, the two teenagers in the film are nothing, the black hole itself, and as such, in the ambiguity that locates an absence, they are also the portals to the (dis)orders that may be possible in nothingness, the impossible sociability that, despite everything, can happen in what Édouard Glissant calls the nonworld, which begins in the hold of the slave ship and spreads through immanent *unfolding*—if unfolding is the right term to use, considering that every gesture on the way out also involves a pendular sweep back to the unrenounceable source; it involves the sort of boomeranging that plunges Ralph Ellison's Invisible Man through Louis Armstrong's "lyrical sound" to the lower frequencies that are nested in it and burps him back up again.

A sudden disalignment from the steady march of things, a squiggling of the pattern lines, also disturbs the beginning of Kevin Jerome Everson's *Lost Nothing* (2016). The first minute of the short film—much like that of Guillén Landrián's—is a tight frame on the face of Willie James Crittenden. The portrait puts no demand to us and demands everything at the same time; the two requirements live in absolute propinquity, sutured even, and yet never collapse into

FIGURE 3. Kevin Jerome Everson, still from *Lost Nothing*, 2016. Super 8 film transferred to digital video, black-and-white, sound; 3:30 min.

one another. On the one hand, staying close to Afro-pessimism's proposal—what could a nothing, flesh defined by the foundational condition of person-as-property, available to accumulation and fungibility, demand from a viewer who has structured her own fundamental being by the impossibility of having these traits ever apply to her, or even be visible on her horizon? On the other hand, it is precisely this unbridgeable disidentification, the very thing that cinematic grammar and the discourses that accrue around it perennially disavow or obfuscate, that impinges on looking. And I don't mean that there is a cheap recourse to liberal guilt-tripping, a call for moral attunement and atonement; rather, the film articulates an implicit demand for a more fundamental inquiry into the fact that Blackness, right there on the screen supposedly, lacks temporal and spatial location, defies incorporation into the current orderings of the world, and is forced to go underground or flee to outer space.

The air quivers again, and the moment vibrates into separate layers, at the film's culmination with Crittenden's last line, a statement of survival compacted into a memorable structure like that of a refrain, able to be retrieved whenever needed: "I ain't lost nothing up there." *There* refers to the

THE OTHER SIDE OF THE SUN

Moreno, Gean

clink. But language delaminates from itself in the very word. It articulates in subterranean fashion a structural condition: the nothing of Blackness can never be lost in this world, certainly not up *there* on the screen. On another plane, however, in what Fred Moten might call fugitive articulation, one senses that Everson, deploying the vignette as major form, is at once snapping Crittenden's emotional heat signature in all its singularity and pushing for its place in the common project, against what is possible perhaps. He demands a disaligning of our looking from the schemas that usually guide it; or, more precisely, underpins the film with a chiasmus that sends us looking down two paths simultaneously, each a part of and apart from the other.

Cameron Rowland approaches that *there* where Crittenden ain't lost nothing, the carceral complex and the ontological field, by swelling the impermeable meridian—that end that is not the end, as Guillén Landrián used to say to close his films—between the world and what it excludes. In doing this, he stays in the "belly of the boat" that, Glissant reminds us, "dissolves you, precipitates you into a nonworld."[4] It is the only place where a denizen of a nonworld can think at all, plot the trajectories of madness and devastation that stretch behind her and mark her to this day, and stretch ahead indefinitely. And it is also there, looking at things from a different angle, where she can value the detours from these trajectories, the collective building and dwelling in exclusion, the new forms of sociality and expression, and measure the ways in which they materialize the vestibules of another world, or of whatever is after the world. They continue to multiply *against* the condition of social death, against the logic that the *not* doesn't need to be accounted for except in the logbooks of the chain gang and the Excel spreadsheets of the convict-leasing program, except, as always, in ledgers endowed with a sorcery that turns subjects into nothing.[5]

FIGURE 4. Installation view of Cameron Rowland, *91020000*, Artists Space, New York, January 17–March 13, 2016

Rowland engages the means that keep things on course and perpetuate social violence, which are always to be found in one form or another—the Black Codes, for instance, which criminalized Black life as a response to the Thirteenth Amendment in the wake of its passage, "align[ing] the status of the ex-slave and the pre-criminal" in order to build a prison population whose labor could be put back where it had just been.[6] A cartography of this continuance spreads across Rowland's recent text and exhibition, both titled *91020000*. It was mapped in the displayed objects—a desk made in Attica, manhole extenders from Elmira, court benches from Green Haven—produced by inmates paid scandalously insubstantial wages, $0.10 to $1.14 per hour. Each object doubles as necessary grounding and reminder that, beyond conceptual or paradigmatic orderings, all this is inscribed in concrete institutional practices and the social existence reproduced by such practices.

A fundamental observation on the hypertrophied prison system Rowland maps is that its growing dark population finds no correlate in increased crime rates. This fact reflects what Loïc Wacquant calls the "extra-penological" function of the contemporary carceral apparatus: management of the stress to which the social plane is

vulnerable in light of the disappearance of steady wage labor, the disintegration of the ghetto, and the retraction of social benefits—all of which push symbolically denigrated and materially deprived social sectors, in particular the lowest economic rung of the Black population, into ever more precarious lives and deeper poverty. In this situation, prisons become "instruments of naked exclusion," forming one side (with the collapsed ghetto, beset by failing public and autochthonous institutions, as the other) of "a single *carcelar continuum* which entraps redundant populations of younger Black men (and increasingly women) who circulate in closed circuit between its two poles in a self-perpetuating cycle of social and legal marginality with devastating personal and social consequences."[7]

The vicious feedback loop that results rearticulates a perennial social dynamic: a darkened prison population sustains justifications for aggressive policing and sentencing that target in particular always-already-offending Black bodies, which in turn produces the obvious consequence of increasing the number of Black bodies circulating through the system. This cycle endlessly inscribes fresh stigmas on racialized bodies and unfurls new modes of marginalization, recasting the Black body itself as barely indistinguishable, if at all, from the criminal subject, dishonored prior to any act, coded as a sinkhole in the logic of free and equal citizens that supposedly underpins our democracies, even when imperfect and aspirational, and it ties the current inflated prison complex to historical institutions established to perpetuate the production of race and develop accompanying mechanisms of domination, each bound to particular economic regimes and exclusionary social initiatives. These institutions include slavery itself and its place in the plantation economy; Jim Crow in the agrarian South and its production of a caste system based on skin color and lineage; the establishment of the urban form of the ghetto with the migrations

north, balancing the entrance of the Black population into the industrial economy with continued segregation; and the swelling prison system in post-Fordist times of deregulation and insecurity.[8] This network of material structures and practices—which appear to incautious looking as fully differentiable rather than overlapping and threaded together—finds its current modulation as a gargantuan penal system that has settled into its role as the contemporary apparatus that determines the symbolic and existential conditions of Black bodies, conditions that perpetuate their devaluation and renew their availability to wanton violence, to abolition, with the bonus of preemptively mitigating the pressure that they represent to a socioeconomic sphere that is no longer conditioned to meet their basic needs.

FIGURE 5. Cameron Rowland, *Insurance*, 2016. Container lashing bars, Lloyd's Register certificates; 102 × 96 × 11½ in. (259.1 × 243.8 × 29.2 cm) or 149 × 18 × 4½ in. (378.5 × 45.7 × 11.4 cm)

Lloyd's of London monopolized the marine insurance of the slave trade by the early 18th Century. Lloyd's Register was established in 1760 as the first classification society in order to provide insurance underwriters information on the quality of vessels. The classification of the ship allows for a more accurate assessment of its risk. Lloyd's Register and other classification societies continue to survey and certify shipping vessels and their equipment. Lashing equipment physically secures goods to the deck of the ship, while its certification is established to insure the value of the goods regardless of their potential loss.

⊠ ⊠ ⊠ ⊠

THE OTHER SIDE OF THE SUN

Moreno, Gean

Against the nefarious magnitude of this complex and its deep historical roots, there is the broken year of dreaming dangerously, stripped of its vatic drift. Refusing to make idolatry of its ending or participate in counterfeit prolongation, one goes looking, instead, for ways to suture the shards into new configurations, searching for new vectors through which turbulence on the surface can reach down and shake the seabed, stir the sands of the social relation—to say nothing of the sediments of ontology itself, that hard-walled contrivance that gutters people beyond its edge, where neglect and violence are authorized. In these bad new days, then, what is contemporary art good for? The question is worth asking, since it seems to be willfully articulating itself anyway as ambient disquiet, the reverberations of a reprimand. Should it augment the *auxiliary* role it can play for rigorous analysis and activist intervention while, more importantly, rerouting resources away from production of the status quo to more urgent expression—at the risk of finding itself maimed by tendentiousness and piety? Can one imagine a repurposing of the supplementary space of art production, that matrix of institutions and funding bodies and entrenched habits that envelop but do not constitute the discrete objects displayed and the practices that produce them, into relevant new pedagogical platforms, disfiguring the schema to which they are adjusted with the pressure of partisan knowledge-building, targeted study, target practice? Can contemporary art, plugging for a moment the seepage of disenchantment, foster moments of exception from existing conditions, in which vestibules of another world, or what is after the world, coastlines on the other side of the sun, can be imagined in flight from all that the times are possessed by? Of course, all and any of these possibilities are haunted by the indelible suspicion that contemporary art itself is simply one of the enclosures that we should be looking for ways to breach. Contemporary art, a commitment to it, is the armature of our unsureness. But contemporary art, despite everything, is also a harbor for those of us who have decided to make use of it as a jerry-rigged coastal-defense structure against a sea of social abstractions bent on reproducing the existing and intolerable order of things at any cost.

[1] See Frank B. Wilderson III, *Red, White, and Black: Cinema and the Structure of U.S. Antagonisms* (Durham, NC: Duke University Press, 2010), particularly section 4, for a comprehensive development of Afro-pessimism.

[2] Jared Sexton, "The Social Life of Social Death," *InTensions* 5 (Fall/Winter 2011): 28. By "world," Sexton means "the universe formed by the codes of state and civil society, of citizen and subject, of nation and culture, of people and place, of history and heritage, of all the things that colonial society has in common with the colonized, of all that capital has in common with labor—the modern world system." Ibid.

[3] Also finding its foundation in the historical abomination of the Atlantic slave trade, Black optimism proposes a different possibility—a different tenor—of what it means to live beyond the world. In Fred Moten's take: "[It] is not (just) that blackness is ontologically prior to the logistic and regulative power that is supposed to have brought it into existence but that blackness is prior to ontology [. . .] Blackness is the anoriginal displacement of ontology, that it is ontology's anti- and ante-foundation, ontology's underground, the irreparable disturbance of ontology's time and space. This is to say that what I do assert, not against, I think, but certainly in apposition to Afro-pessimism, as it is, at least at one point, distilled in Sexton's work, is not what he calls one of that project's most polemical dimensions, 'namely, that black life is not social, or rather that black life is lived in social death.' What I assert is this: that black life [. . .] is irreducibly social; that, moreover, black life is lived in political death or that it is lived, if you will, in the burial ground of the subject, as Abdul JanMohamed would say." Moten, "Blackness and Nothingness (Mysticism in the Flesh)," *South Atlantic Quarterly* 112, no. 4 (Fall 2013): 739.

[4] Édouard Glissant, *Poetics of Relation*, trans. Betsy Wing (Ann Arbor: University of Michigan Press, 1997), 6.

[5] One can *pace* Wilderson on this, and one can *pace* Moten, and in their divergences one will find an argument—between staying in the hold of the ship and the fantasies of flight, between the ontological paradigm that organizes the world and the possibility that there are things beyond its domain—that holds Afro-pessimism and Black optimism in fertile tension.

[6] Cameron Rowland, *91020000*, exhibition booklet, Artists Space, New York, 2016. In order to purchase the convict-made objects in the exhibition, Artists Space was required to register with Corcraft, the commercial arm of the New York State Department of Corrections; 91020000 is the gallery's registration number under that system. See http://artistsspace.org/exhibitions/cameron-rowland.

[7] Loïc Wacquant, "From Slavery to Mass Incarceration: Rethinking the 'Race Question' in the U.S.," *New Left Review* 13 (January–February 2002): 52–53.

[8] Ibid.

HAIR; OR, NOTES ON A FINE METAPHOR FOR THESE TIMES

Azimi, Negar

I like my baby heir with baby hair and afros
I like my Negro nose with Jackson Five nostrils
Earned all this money but they never take the
 country out me
I got hot sauce in my bag, swag
—Beyoncé, "Formation," 2016

As everybody knows, but the haters & losers
refuse to acknowledge, I do not wear a "wig."
My hair may not be perfect but it's mine.
—Donald J. Trump, Twitter, April 24, 2013

How can he not love your hair? . . .
It's his hair too. He got to love it.
—Toni Morrison, *Song of Solomon*, 1977

In the Yoruba cultures of Nigeria and Benin, humankind is defined as "the species that grows hair mainly on the head." The hair on our heads, in other words, is what sets us apart from other animals—like language or our ability to grasp iPhones.

Incidentally, hairdressers in Yoruba lands, treated with a respect bordering on reverence, are referred to as "masters." Imagine that.

By the time this essay circulates, the presidential election of 2016 will be a thing of the past. (How many ways to say, "Phew"?) We will have grown accustomed to the sight of a new commander in chief. Most of us, dare I presume, will pine for Barack and Michelle. Barring disaster—and disaster, it should be said, is the order of the day— our new president will have a blond-streaked bob of high volume and medium bounce. The election culminating this *annus horribilis*, now a distant nightmare, was marked by many things, not least the surreal and superfluous discussion of the candidates' hair.

But first, an admission. When I began to write this piece, I thrilled at the adjectival possibilities

afforded by that squirrelly mane—by which I mean Donald Trump's conspicuous coif. I even, it could be said, felt a psychic bond with it: for years, my hair has been marked by a Trumpish swoop, executed through a mostly arbitrary cock-tail of hair spray and hair dryer. In other words, I felt uncommonly up to the task. And yet, by hour two of researching "Donald Trump's hair"— if deep Googling qualifies as research—my eyes glazed over. Why on earth were his tea-stained follicles taking up so much of my time?

You see, writing about D. T. upsets me. So I will leave him for now. But it's only possible for so long.

For some time, I've been working on a book about the 1960s and '70s. Along the way, I've thought a great deal about the semiotics of hair. Hair, perhaps especially in the era of Woodstock and Third World revolution, communicated what side of history one was on. Conjure, if you will, images of Che's shoulder-length Sierra Maestra do or Joan Baez's long, luscious locks. In trying to write about hair and communism, I stumbled on an essay from 1973 by Pier Paolo Pasolini called "The Hippies' Speech." Encountering two hippies in Prague, the director of *Teorema* and *Arabian Nights* couldn't help but linger over "the language of their hair." He writes: "It was a single sign— the length of their hair—in which all the possible signs of an articulate language were concen-trated." Pasolini continued:

What was the meaning of their silent and exclu-sively physical message?

It was this: "We are two hippies, we belong to a new human category that is appearing on the face of the earth these days, and that has its center in America [. . .] The bourgeois are right to look at us with hatred and fear, because the essence

HAIR; OR, NOTES ON A FINE METAPHOR FOR THESE TIMES

Azimi, Negar

FIGURE 1. #TrumpYourCat

FIGURE 2. Pier Paolo Pasolini on the set of *Arabian Nights*, 1973

itself of the length of our hair challenges them. But they should not think about us as impolite and wild people; we are aware of our responsibility. We don't look at you, we remain among ourselves. You should do the same and wait for the Events.

Apropos responsibility. Apropos "the Events."

For the past year and then some, Black Lives Matter has become a vivid, inescapable feature of our political times. Along with Bernie Sanders's best attempts at fomenting a "revolution" (his word), Black Lives Matter is probably the most animated progressive national movement since Occupy Wall Street called out the primacy of greedy corporate interests in America. With its dogged insistence on reminding us about the precarious state of Black bodies in America, Black Lives Matter has left its marks on our shared visual culture: Trayvon Martin's hoodie; die-ins en masse; the sight of Ieshia Evans, impossibly elegant, resplendent in a summer dress, staring down storm troopers on a Baton Rouge street.

In this Black Lives Matter lexicon, Black hair, too, has assumed a totemic quality. Like the Black liberation movements that preceded it, Black Lives Matter insists that Black (hair) is beautiful.

"I'm Black as the moon, heritage of a small village," Kendrick Lamar sings in "The Blacker the Berry." He goes on: "Pardon my residence / Came from the bottom of mankind? / My hair is nappy, my dick is big, my nose is round and wide / You hate me don't you?" In her hit song "Formation," the video for which offers up an ecstatic mish-mash of images drawn from an imagined African Americana, Beyoncé also celebrates Black hair. In it, versatile Queen Bey dons, among other things, serpentine butt-length box braids, freeform curls, a blonde afro, and low-hung bouffant ponytails.

Black Lives Matter, it should be said, stakes out a psychic territory. Here is hair, again: "It can do literally everything," Black Lives Matter cofounder Patrisse Cullors recently said in an interview for an online video series entitled *Hair Tales*. "Our hair is like shape-shifters—we have the most resilient hair, ever."

Ev-er. Of course, the taming—policing?—of African American hair harks back to grimmer periods in American history. In nineteenth-century Louisiana, for example, the "tignon laws" mandated that colored and mixed-race women cover their hair with the head scarves known as tignons, which approximate the turbanlike West African *gélé*. Ostentatious hairstyles, it was said, drew the attention of white men—and the ire of

white women. Inevitably, the put-upon pushed back, defiantly decorating their head scarves with exuberant ribbons, feathers, and jewels.

In the city of Toronto, in 2015, an eighth-grader was sent home for hair that was said to be "too poofy and unprofessional." After her aunt posted a screed about the incident on Facebook, a flyer circulated through Black Lives Matter networks: "We are especially looking for: peeps with AFRO, big, poofy, fly weaves, boxbraids, bantu braids, locks, twists/twist-out, Marley twists." In December, hundreds assembled on the steps of the Toronto District School Board's headquarters to protest the incident. "Say it loud, I'm Black and I'm proud," they chanted.

The afros, dreads, and cornrows of Black Lives Matter, in other words, are an affront to the square, accommodationist, golf-playing manes of the Condi Rices of the world. It is, you could say, the era of Lupita. The Kenyan star of *12 Years a Slave* needs no last name. She need not fuss with her hair, either, which she usually wears boy short. When *Vogue* compared the extravagant beehive hairdo she sported at last year's Met Gala to Audrey Hepburn's, she demurred, offering up a Zulu reference instead.

Literature and the visual arts, too, have deigned to take the temperature of this political moment. In his magisterial *Between the World and Me*, Ta-Nehisi Coates reminded us, once again, of the violence exercised on Black bodies. "Racism is a visceral experience [. . .] It dislodges brains, blocks airways, rips muscle, extracts organs, cracks bones, breaks teeth," he writes, in a book that proves him a true son of James Baldwin. Oh and it felt good and it felt right that there was a flurry of David Hammons shows—in London, New York, elsewhere—this past year. His oddly fangled sculptures, many of which were fashioned using Black hair swept from salon floors, seemed to breathe with new life.

FIGURE 3. Protesters assemble at the Toronto District School Building, December 4, 2015

FIGURE 4. Lupita Nyong'o at the Costume Institute Gala, Metropolitan Museum of Art, New York, May 2, 2016

HAIR; OR, NOTES ON A FINE METAPHOR FOR THESE TIMES

Azimi, Negar

FIGURE 5. Zulu women, Durban, South Africa, c. 1908

Hair is community, too. When we hear people speak of bad hair days and good hair days we immediately know what the other means. We've been there. We *feel* each other. "I want to know if my hair is just like yours," five-year-old Jacob Philadelphia of Columbia, Maryland (yes, a mouthful, repeat it), said to President Obama in May 2009. POTUS leaned over, as if genuflecting to a pint-sized monarch, and let Philadelphia of Columbia pat his head. When Michelle Obama evoked the incident at the 2016 Democratic National Convention, she knew she was tapping into a deep well of feeling. After all, it was a surreal path that brought the Obamas into that particular white house. Don't forget, she reminded us, "I wake up every morning in a house that was built by slaves."

The hair salon is a world unto itself. Within its bounds, women congregate to share, bitch, scheme, and love. Literally anywhere. You see it in Le Petit Sénégal in Harlem. You see it among the Navajo of the American Southwest, and in the salons of Accra, Beirut, and Mumbai. Here's bell hooks on hair, the kitchen salon, and ritual, from her 1989 essay "Black Is a Woman's Color": "There is a deeper intimacy in the kitchen on Saturdays when hair is pressed, when fish is fried, when sodas are passed around, when soul music drifts over the talk. It is a time without men. It is a time when we work as women to meet each other's needs, to make each other feel good inside, a time of laughter and outrageous talk."

My own secret sorority takes the form not of doing my hair but, shamefully, removing it. As a woman with hirsute Middle Eastern genes, I've spent a fair amount of time in the corridors of waxers, artful eyebrow shapers, and, more recently, laser hair-removal centers. Do not laugh, for hair is existential. At Romeo and Juliet Laser Hair Removal in midtown Manhattan, I marvel at the web of men and women in the waiting room, exchanging stories, connected by a common will to shed. Such communities exist online, too, where there are literally thousands of message boards and forums devoted to the vast and vexed subject of hair.

This is good. We're feeling good about hair. It binds us, after all. But I didn't tell you how Pasolini's essay ended. I should, because he was onto something.

Revisiting a trip to Isfahan, Iran, in 1972, the director remembers surveying the young men before him in the ancient city's central square. Pasolini the Orientalist is shocked. Hurt, even. Lo and behold, two "monstrous beings" are sporting Western hair, "long on their shoulders, short

FIGURE 6. Jacob Philadelphia touches President Barack Obama's hair at the White House, 2009

in front, sticky because of the artificial stuff they put on." Why, he wonders, were they following "the degrading order of the horde?" Here he is again: "Nowadays no one could ever distinguish, from the physical presence, a revolutionary from a provocateur." He continues, "The horrible masks that the young people put on their faces to make themselves dirty like the old whores of an unjust iconography, objectively re-create on their features that which they only verbally had condemned forever."

Finally, in exasperation he declares this: "Left and Right have physically merged."

In other words, there's a flip side to hair's revolutionary bona fides. The Persia of Pasolini's fantasies is soiled. It is, he writes, "an undeveloped country, as they horribly say, but ready to fly, as they also horribly say." This hippie of lore has been commodified, rendered an export for the "ready to fly." Alas, the renegade posture of the Left has been adopted by the petty bourgeoisie.

Like the "artificial stuff" the Iranian youth were putting in their hair, free-market capitalism has gifted us with a bounty of products like Bed Head and Surf Spray for the strenuously tousled, I-don't-care, *je ne sais quoi* look. The logic of "any hair you want" extends to social media,

where some men who shall remain nameless post pictures from ten or fifteen years ago as their online avatars. In these snaps, the currently hairless are often suddenly rendered their younger, hairier selves. (Acquaintances, of course, are too polite to point out the sudden fountain of youth.)

Joan Didion once wrote of a tribe who lives in mortal fear of "wearing the wrong sneaker." Her immediate target was Woody Allen's filmic *Manhattan*, where narrow self-actualization was the order of the day. But her real target was the real Manhattan, the American El Dorado. Fast forward three and a half decades and a veritable oligarch of Manhattan real estate has attempted to make the almost unbelievable transition from reality television star to leader of the free world. "Almost unbelievable" because we are in America, after all.

In his unlikely and "meteoric" rise—is that my boilerplate or his?—there are many lessons. He, his rent-a-wife, his creepy Ken and Barbie children, seem to communicate an essential truth about the American Dream: you are only as good as the number of Twitter followers you have. "I like thinking big," intones Donald in *The Art of the Deal*. "If you're going to be thinking anything, you might as well think big." Don't be a loser, America. Communicating hard-boiled overconfidence, virility, and contempt for fact, he represents the apotheosis of a certain kind of "self-made man." Donald Trump is pure potential. Somewhere, between *The Art of the Deal* and *The Apprentice*, lies a distinctly Trumpian ethics.

There is also, inescapably, his hair—equally "self-made" in its refusal to bend to time, logic, or gravity. The subject of endless analyses, at least one overlong investigative report care of Gawker, and an astounding array of descriptors (from "burnt Cheerios auburn" to "cigarstained-teeth blonde"). Over the years, his hair has assumed multiple and motley forms. Perhaps the only constant is its unflagging

HAIR; OR, NOTES ON A FINE METAPHOR FOR THESE TIMES

Azimi, Negar

FIGURE 7. Still from *The Simpsons* short "3 a.m.," posted on YouTube, July 30, 2016

braggadocio. (Like the late anthropologist Edmund Leach, who authored the pivotal 1958 study "Magical Hair," Trump seems to equate the loss of his hair to a symbolic castration.) And so critics have obsessed over it, as if understanding Donald's hair would shine a light onto his soul. The preoccupation with whether it is dyed, implanted, combed over, surgically flapped, or toupeed has revealed more about us than it does about him. Like his paternal grandfather, who strategically Anglicized his name from Friedrich to Frederick, Trump's successive hairdos were another way of donning the emperor's clothes.

Google "American Dream," I dare you, and you will eventually land on an address in London—for hair extensions. Which is to say, hair, finally, heartbreakingly, has become a metaphor for our culture, and for these strange times.

Hair and demagoguery, of course, did not begin with Donald Trump. On the head or above the lips, the two have been twinned for years. Cue Hitler, Hirohito, or Stalin. More recently, one need only look to equally xenophobic Dutch politician Geert Wilders's wavy helmet head or Boris Johnson's post-Brexit Trump Lite. But it's not so much the eccentricity of his hair that distinguishes Trump but rather its particular metaphysics. Or better, the philosophy it embodies.

At the Grand Guignol known as the 2016 Republican National Convention, his daughter Ivanka told the world that her father raised her to believe she could do anything she set her mind to. Like sprouting hair from barren follicles or having any hair you set your mind to ("Think big!"), this sort of magic is distinctly American.

It is also, we are led to believe, the opposite of what happens in the dim, distant lands of the unfree. Why, Donald asked, was Khizr Khan's wife, Ghazala Khan, silent at the Democratic National Convention as her husband delivered one of the most poignant rebukes to Trump's Islamophobic tirades? Did Trump pick on her because she wore a head scarf? The East, implied Donald, is where men make women cover their heads, shut their mouths, where bodies are subject to control. (Never mind the control exerted by the values of a Miss Universe pageant, for which he was, until recently, a chief patron.) The people of the boat, those on the other side of the wall, or indeed under that veil, do not have the freedom we hold dear—and they certainly aren't going to get it here. What "Make America Great Again" really means is this: Make America *White* Again.

In this America, a yellow-haired zealot can reinvent himself as many times as he chooses. Like the Hypercolor T-shirts of the '90s—wait, did that trend really happen?—he transitions seamlessly from yellow to red to salmon to gold and back again. But it's always "authentic," insists the Hologram Man. Touch it, he urges celebrity interlocutors. This hair obliterates fact, celebrates reinvention, embraces unforgivable hyperbole, manipulates reality. How else can we explain the fact that the scion of a prominent real-estate dynasty has positioned himself as the hero of the common man?

Here's everyday Donald again, from his 2004 tome *Trump: How to Get Rich*:

The reason my hair looks so neat all the time is because I don't have to deal with the elements very often. I live in the building where I work. I take an elevator from my bedroom to my office. The rest of the time, I'm either in my stretch limousine, my private jet, my helicopter, or my private club in Palm Beach, Florida.

Hair, you see, can take up all the air. It can also cloud your vision. Perhaps especially in a society of the self and the selfie. It's not what's underneath that counts in this playground of appearances. Perhaps it never was. America: where anyone can be a chameleon, where the spectacle is real, where the "degrading order of the horde" that once haunted Pasolini looms large.

At the time of this writing, scrunchie-wearing Hillary Clinton is just a hair ahead of Donald Trump, the man she once called "an id with hair." That which makes us human is also what makes us monsters.

A CONVERSATION WITH BASMA ALSHARIF, KEVIN JEROME EVERSON, AND JAMES N. KIENITZ WILKINS

Nash, Aily

On a July afternoon in 2016, three artists selected for the Whitney Biennial film program—Basma Alsharif, Kevin Jerome Everson, and James N. Kienitz Wilkins—joined me at the Museum for a discussion about their work. Watching their films in advance of our conversation, I was reminded of Judith Butler's observation: "For representation to convey the human . . . representation must not only fail, but it must *show* its failure. There is something unrepresentable that we nevertheless seek to represent, and that paradox must be retained in the representation we give."[1] This impossible paradox of showing what cannot be shown is at the crux of these artists' practices. Through strategies of rupture and ambiguity, as well as the subversion of cinematic and documentary conventions, all three convey the inherent failures of representation, and bring to the surface the complexities of making images of people.

Aily Nash: The three of you share an inclination to subvert expectations—whether those of the audience or relating to medium, genre, or identity. And this impetus seems foundational for your formal approaches. Basma, you've discussed your relationship to your identity as having evolved over the last several years, navigating the ways in which your work is categorized. You've said that you feel identity-specific commissions—say, an invitation to be in a show about the Arab world—provide an opportunity to subvert such categories, to directly reject notions of authenticity through creating your own images.

Basma Alsharif: With everything that's going on in the world right now, the notion of identity feels really crucial. I like what you say about it driving the way all three of us are making work. I see it as this idea of things not being what they seem, of introducing someone to an idea they're familiar with, then rendering the whole thing unfamiliar. For me, this is a way of reconciling an identity

that doesn't make sense or isn't fixed, and of trying to find ways to connect that to someone else's experience. There's often this assumption that identity belongs only to minorities.

Nash: Right, as if there's ever a neutral identity.

Kevin Jerome Everson: Yeah, that drives me nuts.

Alsharif: Identity is a global thing. It's what you see as a mass and not as an individual. And yet, for any minority, it feels like the mass becomes the individual. That's why it feels like you're representing a group that doesn't necessarily represent you—that you may even feel the need to defend. And on top of that, it flattens a more nuanced reading of your work.

So, yes, it's something that has driven the way I work. It's not about my personal story, even though it's very connected to my biography, nor is it representative of a people. Rather than refusing shows or programs that categorize work based on nationality, race, or gender, I've been trying to make work that doesn't comfortably sit in any one category.

I'm more and more aware of how much the context for making work today has become globalized. Even if you're in a country that's under occupation and you've never traveled, you probably have the internet, people probably come to visit from other places—your access to visual culture is not necessarily local. So questions of unfixed identities aren't specific to minorities. It's a little patronizing to be told that you're dealing with "identity politics"—as if other artists are excluded from having to.

Everson: When I show films to my students, I always say, "This is by a white guy" or "This is by a white woman." Students are at first like, "What's going on?" But then they realize it makes a difference, and we all have different histories—that's

A CONVERSATION WITH BASMA ALSHARIF, KEVIN JEROME EVERSON, AND JAMES N. KIENITZ WILKINS

Nash, Aily

FIGURE 1. Basma Alsharif, still from *Farther than the Eye Can See*, 2012. Digital video, color, sound; 13 min.

the implied backstory. But it's true in Black American culture, too. Black Americans from Oklahoma have a different history than Black Americans from Ohio. It's not so cut-and-dried, like the ruling class would like to think. It's more complex.

Alsharif: Do you feel like you answer to that in your work?

Everson: I used to fight it all the time. I'm the senior dude here. I got out of grad school right when multiculturalism was happening in the early 1990s, and I turned down more shows than I was in.

Nash: Curators were asking you to be in shows as a Black artist?

Everson: Yeah, because they wanted to go to heaven. And a lot of public funding was based on diversity. I didn't like their language. There were a couple of physical altercations I had with curators where they would just—

James N. Kienitz Wilkins: I hope you won?

Everson: Yeah, all of them. [*laughter*] Well, I think I'm 9 and 0. But I remember people who hadn't even seen my work would invite me to be in shows. I was like, "You've got to be kidding.

You've got to come see the work." I just turned down a show recently—I think people wanted me to put representational work up on the wall, and I was like, "No, I'll put something else up." For me, it was always problematic how the ruling class wouldn't like what I was doing because I wasn't centering them.

Kienitz Wilkins: Centering their preconception?

Everson: Yeah. Or actually informing them of what it was, or who I was. I ain't got time for that. It's expensive to teach you. With representational or nonrepresentational work, it was always the kind of formal qualities of how you presented the subject matter. The ruling class couldn't adjust to anything. Even if their observations trumped their perceptions, they couldn't handle it.

And that was true with a lot of curators. They didn't give the observations a chance to sink in, so their perceptions weren't going to change. And that's when the fights came in—because they wouldn't do their job as curators, or educators, of informing the public. They wanted me to do it, and I was like, "No, that's your job."

I think the ruling class just wants to put you in their perceived niche of what you should be doing. Of course, they still want to be the center of attention. So in my work, I never think about the way I frame because I don't make the work for the audience. In fact, I'm super hostile to my audience on all levels. Hell, I have two films that are eight hours long. [*laughter*] I make work for the subject matter and for the landscape, but not for the viewer. There's never that kind of centering.

Kienitz Wilkins: Actually, that resonated when I recently read an online interview with you, Kevin.[2] You were saying something about how people are still unnerved by just seeing an image of a Black person on-screen in certain environments.

Everson: Yeah, totally. Still! [laughs]

Kienitz Wilkins: I think one thing all three of us clearly have in common is that form is of utmost importance. With my work, I have to do everything—shepherding how it's going to exist, selecting a still and what it means, the text that surrounds it. I know that just a simple, low-resolution talking-head still of a young Black guy can be novel. There's nothing to pin to him; it's just his face. You don't see that very often. And it's such a simple thing.

FIGURE 2. James N. Kienitz Wilkins, still from *Special Features*, 2014. MiniDV transferred to high-definition video, color, sound; 12 min.

Everson: When I make trailers of films, the footage is never from the films. I just make new objects.

Kienitz Wilkins: I think what you're getting at is another similarity—ambiguity. And it's not a confused ambiguity, like, "Oh, we don't know what we're doing" or "Just throw some stuff together." It's almost like an ethical ambiguity. Kevin, you're going out and doing your thing but not revealing that you've made the objects in your films—not really caring if the audience knows that or not. I see that with Basma's work, too, especially with your use of text, the layering and equalizing of languages, the deployment of subtitles—normally considered a compromise—as images as much as syntactical tool. I think this creates an ethical ambiguity.

FIGURE 3. Kevin Jerome Everson, still from *Sound That*, 2014. 16mm film transferred to high-definition video, color, sound; 11:40 min.

Nash: I've been thinking about the agency of subjects in all your work. Kevin, in yours this idea of construction is really central. Your subjects are very active and aren't just being observed by the viewer. Your films are often reenactments or reperformances of gestures, actions, or events. They're negotiated in this way and fabricated, just like your sculptures, but they're often perceived to be "documentary."

Everson: Everything's fake in a weird way.

Nash: Right. And that gives way to this agency—

Everson: Or the potential for being fake does, yeah. In *Sound That* [2014], with the guys working in the streets, we were only supposed to shoot for two days, but the City of Cleveland's water department wanted them to look good, so we kept going to these nice neighborhoods. [laughs] The workers wanted us to film them digging a real hole, and we ended up shooting a third day because they were so proud of what they did. Their nobility of labor was important to me—and more important to them. But I framed it up as if they made it up. It was almost like a set, with the flat lighting.

Nash: And Basma, thinking back to *Home Movies Gaza* [2013] and something you mentioned about

A CONVERSATION WITH BASMA ALSHARIF, KEVIN JEROME EVERSON, AND JAMES N. KIENITZ WILKINS

Nash, Aily

FIGURE 4. Basma Alsharif, still from *Home Movies Gaza*, 2013. High-definition video, color, sound; 24 min.

FIGURE 5. James N. Kienitz Wilkins, still from *Indefinite Pitch*, 2016. High-definition video, black-and-white, sound; 23 min.

not looking straight on at something but looking beside it, I'm reminded of the image of the TV and the elephant being eaten, in a National Geographic documentary. This image is disrupted by visual interference, caused by nearby drones. It's an oblique view on what's happening in the domestic spaces of Gaza. We're not looking at a victim or at ruins; instead, you're directing our gaze to the activities of life in proximity to devastation. You're asking us to consider the conditions of what created the image.

Alsharif: I didn't want to revictimize the subjects. *Home Movies Gaza* is the first piece I made in Palestine after being away for ten years, and I was initially pretty devastated at what had become of that territory. I had zero distance emotionally or psychologically from it. Then a war started in the middle of my visit. Returning to Gaza allowed the territory to stop existing as the public space I saw in the media and returned it to the emotional, private space of my memory and childhood. I felt I was playing with fire in trying to make a work there because I had an underlying awareness that as soon as I started recording, I would be exploiting that territory.

Everson: You've got to check the nature of your visit. When I used to do street photography, I'd think, I'm here to make art. You stay in that mode.

Alsharif: I think that gives you the perspective of the viewer. When you shoot, you're already looking at a place as an outsider, trying to understand how a subject will read. All of the footage was shot before the war started, but the war led me to understand what it represented. Here were all these things that I didn't know about the landscape until the war began—like the TV-satellite scramble as a result of drone interference.

Nash: For all of you, your focus on the aesthetic of the everyday reflects your interest in the sociopolitical and economic conditions of your subjects. James, I noticed a recurring fascination with a basic, *normy* suburban aesthetic—the Panera in *B-ROLL with Andre* [2015], the backdrops for *Mediums* [2017] that you have up in your studio of the Dunkin' Donuts in the strip mall. All three of you negotiate aesthetics in relation to your subject matter, which can get complicated when it comes to war or poverty or race.

Kienitz Wilkins: *Special Features* [2014] was shot on MiniDV. I knew that if it ever showed in a really big theater—blown up to HD—it'd be a beautiful image. I have faith that even the shittiest thing has its value. Bringing it back to Panera and Dunkin' Donuts, sure, there's a comedic aspect for me. But it's also just true. I'd rather find beauty in the real lives we lead than in the beautiful ones we wish we led.

A CONVERSATION WITH BASMA ALSHARIF, KEVIN JEROME EVERSON, AND JAMES N. KIENITZ WILKINS

Nash, Aily

bare—perhaps it's related to exposing the "conditions of production" that you're after.

Kienitz Wilkins: For sure, that's a good way of putting it. Also, the content in *Indefinite Pitch* could go on forever because it's this armchair pontificator—which is me, or all of us to the degree that we gain all of our information from Wikipedia. You can have this seemingly comprehensive understanding of your local history, but there's no grounding, so the little personal bits become the things that you glom onto. The only centering that can possibly be found is the personal—it's the only thing I'm somewhat sure of. With *Indefinite Pitch* and *TESTER* [2015], I'm voicing the character. But I also wrote it. If someone were to say, "Well, these are your thoughts," I'd say they are, but they also actively aren't—they're a character. To bring it back to the ambiguity or to multiplicity, *Indefinite Pitch* is autobiographical, and it's all true, but it's too much truth, too many facts. I have been experimenting with what it means to implicate myself.

Nash: Kevin, how do you feel about your work being read as personal?

Everson: Well, with *Ears, Nose and Throat* [2016] people aren't going to know that it's about my son until I tell them. Even if the woman on-screen had been an eyewitness to somebody else's murder, I liked her as the subject. She has a great presence. In my humble opinion, she's a star.

Nash: How about for you, Basma?

Alsharif: I always feel a little sad when a piece is referred to as "very autobiographical."

Everson: Oh, me too.

Alsharif: With *The Story of Milk and Honey* [2011], everybody assumes it's my story, while the whole premise of the piece is about fabricating a

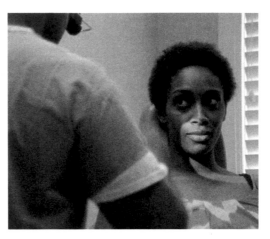

FIGURE 7. Kevin Jerome Everson, still from *Ears, Nose and Throat*, 2016. 16mm film transferred to high-definition video, black-and-white, sound; 10:30 min.

story—that the way a story is told is its own story. I think that because I'm in the diaspora, people read a lot of personal narrative into my work. I don't think a personal connection necessarily legitimizes making work about a political subject, but in all of our works there's an inherent legitimization, a clear connection to subject and subject matter. And actually, the work is about that accountability.

Nash: Do you think this has to do with a political urgency that drives your practice, a need to work out the complexity of identity?

Kienitz Wilkins: Today it's as if we need to work out our own identities before someone else does it for us. And the three of us probably more so than our friendly local white male filmmaker—I wouldn't want to be like *that guy*. [*laughter*]

Everson: Under any circumstances.

Kienitz Wilkins: But I'm half that guy. For sure.

Alsharif: And the way that we're talking about things is shifting so much, but it feels like the institutions haven't caught up.

Everson: No, they're totally behind.

Alsharif: Institutions still use these catchall phrases that are supposed to present shifting ideologies and identities and histories. We're "American" artists, and yet we operate from all these different positions.

Everson: Back in the late '90s, everybody was trying to make work about theory to accommodate the writers. But now the writers, or even institutions, just can't keep up with what folks are doing. What James was saying, too, about how Americans think we have to do things in a certain way—people *think* they have to revert back to what they *think* film or visual art should be, instead of being into what they're invested in. And me, making work within Black American culture, the ruling class would tell me something like, "Oh, you're limiting yourself." What does that mean? There's forty-nine million Black Americans—there's more Black Americans than Canadians, for Chrissakes!

Alsharif: You were limiting yourself in terms of—

Everson: Like, if you just make work about Black folk, that's limited. And that's because the ruling class is limited, because they're not very smart. They just assume that there aren't any more stories or fictions or anything else you could make work about.

But also, you said something earlier about work being autobiographical. Was Ellsworth Kelly less of a human being because he was into abstraction? The ruling class have an origin and narrative for you. If you don't fit it, they can't see you going out and making what doesn't fit with their narrative. I'm an old man, and it still happens. People are like, "Oh, so where are you from?" I'm like, "South of the Canadian border." But only in New York and Los Angeles do those questions come up, because these are the most segregated, racist cities in the United States. They're coming to Lincoln Center, and these institutions, and they don't see anybody who doesn't look like them. Because the art world is not a shared space. But in the other places, like Chicago, Mississippi, Ohio, Philadelphia, there's shared space. You go to Milwaukee, folks come out like, "Hey!" [*laughs*] When I started showing *Erie* [2010] around, people were hostile, saying, "I feel alienated." I was like, man, eighty minutes of people who don't look like you and you freak out? [*laughs*]

Kienitz Wilkins: I had an experience this morning that is apropos to this conversation. My biological father, who is Black, called me. We hadn't talked in a long time, and I had sent him a package of DVDs and articles. He lives in Boston, in basically a halfway house.

Everson: Oh no, poor guy. But he's doing alright?

Kienitz Wilkins: He's fine. He's just poor. It's not drugs or anything. But he watches DVDs and reads all day. One DVD was Richard Linklater's *Boyhood*, from a few years back. And so he called me and was like, "I watched that movie *Boyhood*. I thought it was an interesting slice of life, an American boyhood, like an American childhood." And sort of as an aside, he was like, "There weren't very many colored people in it." And I was just thinking, wow, this is funny. This movie that claims to be comprehensive. Like, if you were watching it and you were white, you'd say, "Oh yeah, this is the American boyhood." My father watches it, and he's not like, "Why are there so many white people?" He's just like, "It seems a little strange, but, you know, I'll accept it as boyhood."

Everson: Or *a* boyhood, not *the* boyhood. I made my class watch season two of *Girls*, on HBO, because I had an ex-student who did the editing on it. And we hate the title. It should be called "White Girls." But it becomes this kind of

A CONVERSATION WITH BASMA ALSHARIF, KEVIN JEROME EVERSON, AND JAMES N. KIENITZ WILKINS

Nash, Aily

generalization, as if it's just neutral. It's abusive in a lot of ways.

Nash: Definitely.

Everson: They're going to Christopher Columbus everything, right? They want to label it. So I just never pay attention. I just keep grinding. I don't think it ever affected me or stopped me. I know people get pissed off.

Alsharif: Why do you say that?

Everson: Don't ask me a question if you don't want my answer. They always want me to answer it the way *they* want it to be answered. The questions keep coming because I'm not appeasing them. People think what I do is easy because I'm around Black people. It's just more exoticizing, I think. I don't set up that formal element for them to see it as exotic. And their questions keep coming, so we never talk about the films. We talk about racism. And then I'm saying, that's not *my* problem, that's *your* problem. I'm just trying to get a sandwich!

Alsharif: That's a really important question. If all of us are making work about issues that are somehow socially engaging or political or come from a background that is considered minority, and when you make that work you are engaged on those levels and not in the aesthetics of the piece, how do you respond to that? Because it's something I'm a little reticent to get into—I'm like, hey, I really don't want to educate you!

Everson: Yeah, I want to talk about lenses!

Alsharif: But I sometimes think, well, if I'm present, isn't that exactly the opportunity to engage in discussions about these things? Isn't that exactly why I'm making this kind of work—not to educate but to have discussions, to humor people's weird or ignorant or honest and sincere

FIGURE 8. James N. Kienitz Wilkins, still from *B-ROLL with Andre*, 2015. High-definition video, color, sound; 19 min.

questions that might not be very informed? Does it make sense to always shut people out, or does it make sense to always answer people's questions?

Kienitz Wilkins: It's an opportunity to talk about that stuff when in person. I just won't promise that what I'll say is going to hit the mark.

Everson: Yeah, I'm not an expert.

Alsharif: But do you think of strategies of talking that make that clear? I also feel like I have this reaction of not wanting to talk about politics when it's a Q&A at a film festival. If there's an interest in engaging with the politics, I'm going to use a different medium—I'm going to write a paper, give a lecture. I'll find a discursive way. I struggle with this because my work is operating in a whole different world that isn't activism, that isn't "on the ground," while also having a strong desire to be politically active, to cause some kind of change.

Everson: There's always these meetings about diversity at my university, and I won't go to these things, there or anywhere else. I'm like, let them figure that out. I am not going to walk up and make y'all feel happy about diversity. Because if you ask for it, you don't want it. Everybody is like, "How do we get more Black people here?" Don't ask me. Ask white people, because I am not going to be the agent for that kind of stuff.

Nash: Right, the ambassador.

Everson: I just can't—there's too many of us. But it's interesting, because seeing Black people on-screen sparks questions in people; they have these preconceived notions of what people should be.

Kienitz Wilkins: In *B-ROLL with Andre*, there's a stock image of this guy in a hoodie, but he's silhouetted, so you can't know what race this person is.

Nash: It's not even a person. It's a shape.

Kienitz Wilkins: It's a cutout that's been embodied. It's stock footage that was forty seconds, just looped. But depending on the voice that's accompanying it or the material—

Everson: But even the voice is almost spoken through some kind of—

Kienitz Wilkins: Through the clichéd anonymous-witness-protection-pitch-shift filter. But actually, three voices shift—there's three actors. One is Hispanic, one is Black American, and another is a white guy from upstate New York. Even though there's the voice encoding, there's still inflections to associate. I guess I was interested in inviting people to apply their assumptions.

Nash: You provide a blank figure, and the cadences and vernaculars in the speech are read by the audience, highlighting their own preconceptions or prejudice.

Kienitz Wilkins: Right, *Special Features* is a good example. My mom, who's white, watched it, and so there's one guy telling a story, then it cuts to another guy continuing, and it starts to shuffle the deck. She sent me an email after she saw it on Vimeo that was like, "I thought it was an interesting movie. I just have a question, why did you have two guys talking?" Well, there's actually three . . . but, like [*laughter*], that's kind

FIGURE 9. Basma Alsharif, still from *The Story of Milk and Honey*, 2011. Digital video, color, sound; 9:58 min.

of the point of the movie. And she responded, "Oh my God, I'm so embarrassed. This is horrible." But I thought, that's fine. There's manipulative editing, and also there's playing with this racial thing. I think a lot about the construction of a formal language. Basma, it's interesting because you actually deal with language visually—

Everson: You use text a lot—

Alsharif: Yeah, it's one of my strategies. It also has to do with not knowing how to position myself. I was asked in school to identify whether I wanted to be a Palestinian artist or an American artist making work about Palestine. My identity isn't that clear. Neither is anybody's, so it was weird to be asked that. But I was really conscious of wanting to make work that was somewhere in between, where a viewer could access different kinds of information based on what information or knowledge they brought to the piece. Working with multiple languages and subtitling is a way of saying that if you understand Arabic, you will understand something about the film, and if you read the English text, you'll get something else. Not that one has more significance than the other, but they are really different experiences.

There's also a distancing strategy, of making my own material foreign to me. I often separate the image from its sound.

A CONVERSATION WITH BASMA ALSHARIF, KEVIN JEROME EVERSON, AND JAMES N. KIENITZ WILKINS

Nash, Aily

Everson: Oh, wow. Well, I like your sound. Because they come together at the same time.

Alsharif: Yeah, they're meant to. The film that did it for me was [Jean-Luc] Godard and [Anne-Marie] Miéville's *Here and Elsewhere* [*Ici et ailleurs*, 1976]. It uses words as icons and sounds as emotional triggers, and the image is always a representation of an idea that we have preconceived, that the filmmakers try to disrupt our understanding of. There's also something about wanting there to be inherent pleasure in the experience of a work, not based on aesthetic beauty, necessarily, but in the visceral aspect of the work.

Everson: Totally.

Kienitz Wilkins: And then there's the pleasure of seeing the filmmaker get pleasure out of something, which is actually more pleasurable than a beautiful image. I think that's really effective pleasure.

Everson: Yeah, you can tell the artist is enjoying making it.

Kienitz Wilkins: And then you feel like you're part of it. If somehow I can be engaged in its production, that, to me, is really productive.

Alsharif: Yeah, that's what I'm talking about.

Kienitz Wilkins: I sense that from all our work. You can feel how we want to be doing what's happening—sort of self-serving, but in a positive way.

[1] Judith Butler, *Precarious Life: The Powers of Mourning and Violence* (London and New York: Verso, 2004), 144. Butler's emphasis.

[2] Terri Francis, "Interview: Kevin Jerome Everson—Contemporary American Artist and 'Black Filmmaker,'" *IndieWire.com*, January 21, 2014: http://www.indiewire.com/2014/01/interview-kevin-jerome-everson-contemporary-american-artist-and-black-filmmaker-2-162472/.

ARTIST ENTRIES

ABDALIAN, ZAROUHIE

Born 1982 in New Orleans, LA;
lives in New Orleans, LA

Although the site-specific projects of Zarouhie Abdalian may borrow from various strategies of Minimalism, Conceptual art, and institutional critique, it is the artist's nuanced engagement with space that typically determines her projects' trajectories. Each installation responds to its public or institutional site as an immersive landscape, which Abdalian often activates as an environment for visual, aural, and physical engagement.

Abdalian's installations typically begin with research, as she is sensitive to ways in which cultural context influences individuals' interactions with a given place. Before her arrival, she may study how imagery and text have publicly historicized the site, and she often visits the site to observe how people navigate its various spaces. She then begins to discern how structural compositions and conditions might converge with behavioral conventions to guide visitors' movements. A single component of the site, whether a particular object, material, or visual detail, often initiates her compositional process. Her projects then unfold through a series of physical and/or sonic interventions that reflect the site's historical conditions while shifting—and, in turn, defamiliarizing—its current ones.

Abdalian's project for the Whitney Biennial is an extension of two recent installations in which she staged alterations in multiple liminal spaces at each site, subtly emphasizing features that otherwise might have remained invisible or forgotten. For *Chanson du ricochet* (2014), part of *Prospect.3* in New Orleans, Abdalian placed handmade mirrors on fences and the facades of antebellum buildings that now form the campus of the New Orleans African American Museum of Art, Culture, and History (closed for renovation at the time). The sound of a male voice reciting the names of tools used at the site both historically and today could be heard, its softness sometimes encouraging viewers to move closer to the structures. In 2016 at the Massachusetts Museum of Contemporary Art, Abdalian created an installation in which a voice similarly recounting the names of tools ushered visitors along a service road joining a garage and outbuilding near what was a construction project at the time. The sound, therefore, literally and conceptually linked these past and present building efforts to one another. In each case, Abdalian's subtle modifications to these in-between places became catalysts for reconfiguring viewers' engagement, offering newly perceptible connections between the sites' embedded histories of labor, their existing material structures, and their future potentialities.

—JD

Chanson du ricochet, 2014. Sound and
mirrored surfaces. Installation views:
Prospect.3: Notes for Now, site: New Orleans
African American Museum of Art, Culture,
and History, October 25, 2014–January 25, 2015

ALSHARIF, BASMA

Born 1983 in Kuwait City, Kuwait;
lives in Los Angeles, CA

Superimposition, strobing color, hallucinatory effects, text laid brazenly onto image—in the work of Basma Alsharif, such disruptions of documentary sobriety constitute a powerful filmic language for probing the affective dimensions of displacement. Alsharif was born in Kuwait to Palestinian parents and raised in France and the United States, a personal history that informs her films even as her work evades autobiography. Refusing the familiar iconography of mass-mediated conflict in the Middle East, Alsharif calls on images of catastrophes only as a structuring absence. In lieu of totalizing narratives or myths of objectivity, she offers a fractured and poetic negotiation of inheritance and loss, of being at once here and elsewhere.

In *Home Movies Gaza* (2013), made when Alsharif returned to the Gaza Strip after a ten-year absence, everyday spaces refer to the crisis obliquely, if at all. A girl practices the cello; the artist roams through the garden at night with the sound of drones overhead; cats lounge on a ground pulsating chroma-key blue. Life goes on in all its banality yet marked by the strangeness of permanent emergency. Alsharif's haunting and textured film *O, Persecuted* (2014) shows us no contemporary images of the occupied territories. The 1974 Palestinian agitprop film *Our Small Houses* is projected onto a painted surface and rephotographed in grainy, sometimes unrecognizable detail; then, Alsharif superimposes footage of a belly dancer over Israeli spring-breakers captured in the sharp edges and saturated colors of high-definition video. *O, Persecuted* repurposes two very different images of militant

certainty—one commemorated and the other condemned—but holds both at a distance through subjective intervention.

While grounded in locational specificity, Alsharif's practice equally extends beyond it. "I wanted Palestine to become everywhere, every place. To shed its identity as a kind of singular conflict and to explore it as a phenomenon of the human condition," she has said. This aim is especially clear in *Ouroboros* (2017), a feature-length work in which the protagonist, Diego, takes a looping journey across a ruined world, beginning and ending in Gaza. His goal is not unlike Alsharif's own: to search for a way to survive among the wreckage, for hope after hopelessness.

—EB

Stills from *Ouroboros*, 2017. High-definition
video, color, sound (work in progress)

BAER, JO

Born 1929 in Seattle, WA;
lives in Amsterdam, the Netherlands

"I don't know how to describe myself except as ... a real painter," Jo Baer declared in 2015. Even as her engagement with visual styles and movements has shifted during the course of her more than sixty-year career, Baer's radical individuality has remained a hallmark. In the 1960s and early '70s, the artist's linear compositions that extended to and around the edge of the canvas helped secure her a place as one of the only women among the key figures of Minimalism in New York, and she continued to advocate for painting's sustained relevance even as her peers embraced sculpture. In 1983, she published a manifesto that explained her turn to "radical figuration," a technique that eschewed Minimal painting's self-referential formalism for illustrative works that connect their subjects to social realities. She now designates her painting "New Age figuration."

Baer's series *In the Land of the Giants*, begun in 2009, stakes out new territory for her investigations of painterly representation. At the series' foundation is the Hurlstone, a prehistoric megalith with a hole bored through the center that Baer became familiar with while living in County Louth, Ireland. Through local lore as well as her own research and physical exploration of the land, she concluded that the stone likely functioned as a spatial marker within a network of ancient sites that delineated early trade routes, marked important burial sites, and mapped constellations of heavenly bodies.

Ways in which the lifestyle of Neolithic Irish peoples, both farmers and seafarers, offered them special insights into spatial relationships between the earth and cosmos fascinated Baer and provide the narrative roots for her latest series. The artist sourced imagery for a range of her subjects on the internet and developed compositions with computer software, building a rhythmic layering of temporalities and compositional strategies into each work. In some paintings, Baer materializes the celestial sight lines between the Hurlstone and neighboring monuments by rendering them in thick bands. These diagrammatic gestures divide the canvases' neutral grounds and create a structure of provocative juxtapositions among her subjects. The same timeless celestial paths orient giants and humans alike. Neolithic structures share space with more contemporary cartographic symbols. Ancient ruins and classical sculpture appear with representations of Baer herself, suggesting they are less material objects than fruits of the artist's psychological and aesthetic archaeology. By combining remnants of ancient cultures with fragments of our visual culture today, Baer unites each work within her own sense of "deep time" in which past and present intermingle.

—JD

Dawn (Lines and Destinations), 2009/2011.
Oil on canvas, 64¼ × 86¼ in. (163 × 219 cm)

BAUDELAIRE, ERIC

Born 1973 in Salt Lake City, UT;
lives in Paris, France

Central to Eric Baudelaire's work is the allegorical form of the *anabasis*, a term derived from Xenophon's epic account of the Greek army's journey home from Persia in the fourth century BCE—the anti-Odyssey, inherently unheroic and incomplete. In Baudelaire's work, the ambivalent homecoming unfolds as a wayward path across a number of mediums: film, video, photography, and installation. In the tradition of filmmakers Chris Marker and Chantal Akerman, Baudelaire inscribes a nomadic sensibility into his subject matter through discursive modes such as the essay film, the epistolary form, and the travelogue. His work takes on a sprawling range of subjects—historically and geographically—from the indefinite temporality of the War on Terror (*Sugar Water*, 2007), to a never-realized Japanese period in the career of Italian film director Michelangelo Antonioni (*The Makes*, 2010), to the uncertain existence of Abkhazia, a partially recognized state in the Caucasus (*Letters to Max*, 2014).

Baudelaire's most frequent subject and collaborator is Japanese filmmaker and former militant Masao Adachi. In *The Anabasis of May and Fusako Shigenobu, Masao Adachi, and 27 Years Without Images* (2011), Baudelaire recounts—through a mix of landscape cinematography, archival imagery, and personal reflections from his subjects—the time Adachi spent living underground in Lebanon; the childhood of May, the daughter of Japanese Red Army member Fusako Shigenobu whom Adachi helped to raise; and their eventual return to Japan. Baudelaire continued to work with Adachi for *The Ugly One* (2013),

scripted and narrated by the Japanese director and filmed by Baudelaire on location in Lebanon—where Adachi himself is now forbidden to travel. Baudelaire returns again to Adachi in *Also Known as Jihadi* (2017), specifically to Adachi's idea of *fukeiron*, which looks to the landscape for signs of power structures that may relate to social alienation and inexplicable trajectories of violence. Drawing upon Adachi's *AKA Serial Killer* (1969), Baudelaire's film retraces the steps of a young Islamic State enlistee from public housing in the *banlieue* on the outskirts of Paris where he grew up, to his grandmother's neighborhood in Algiers where he spent his summers, to the site of his arrest at a ferry terminal in Spain, and to the prison where he is currently incarcerated. By looking closely at these locations, as well as interrogation reports and other judicial documents, Baudelaire's film is less definitive than tentative, a reconstruction of its subject that retains a sense of the fundamental ambiguity of experience.

—LG

Stills from *Also Known as Jihadi*, 2017.
High-definition video, color, sound; 99 min.

BEAVERS, ROBERT

Born 1949 in Brookline, MA;
lives in Berlin, Germany, and Falmouth, MA

As he enters his sixth decade of practice, Robert Beavers stands firmly established as one of the central figures of avant-garde filmmaking. Resolutely devoted to the craft of 16mm film, Beavers pursues his medium as a mode of thought and feeling, manifesting an unflagging devotion to what he has termed the "philosophical majesty of the image." His oeuvre consists of intimate, artisanal works of unparalleled formal precision, informed by his long-standing interest in classical civilization and deep immersion in poetry and art history. In the past decade, Beavers has shot films such as *Pitcher of Colored Light* (2007) and *The Suppliant* (2010) in the homes of individuals close to him—his mother and a deceased friend, respectively. These rigorously edited, luminous films are marked by an earnest attentiveness to the details and textures of domestic space, and infused with a melancholic acknowledgment of mortality.

This emphasis continues in *Listening to the Space in My Room* (2013), filmed across the seasons in Zumikon, Switzerland, in the home of a couple in their nineties with whom Beavers was living at the time. It is a film of love and renewal, concerned with the mystery and mutual transformation that inhere in a life lived together in the pursuit of creativity. He is a cellist; she is a gardener. Beavers films them in intimate proximity as they undertake their labors, his tilts and pans combining with exquisite close-ups in an expressivity at once rhythmic and lyrical.

Listening to the Space in My Room gazes outward, at the quotidian world of Beavers's landlords,

but also inward, at a moment of personal transition for the filmmaker as he prepares to leave their home and embark upon a new phase of life. Beavers reads from a book on Plato and Aristotle in voice-over: "Harmony, not unison. Each responds to the other immediately and intuitively as if there were no obstacles of egoism or ignorance. Their lives become not the same but are at one." *Listening to the Space in My Room* evokes the beauty of this formulation in its depiction of the elderly couple but also invokes it as a maxim for all the springtimes and autumns to come.

—EB

Stills from *The Suppliant*, 2010. 16mm film, color, sound; 5 min.

BELL, LARRY

Born 1939 in Chicago, IL;
lives in Taos, NM, and Los Angeles, CA

During the 1960s, a number of artists felt limited by the qualities then commonly seen to define an object as a work of art. A frame determined an object a painting, a pedestal determined it a sculpture. A new generation of American artists, the Minimalists, tossed aside such embellishments and stripped art to its barest essentials: color and form. Larry Bell is often associated with this pioneering group, as well as the Light and Space movement in California, although he is ambivalent about such labels.

His signature material is glass, which he gained experience with as a young artist working in a frame shop. The material spoke to him, Bell remembers, "because it did something that nothing else I knew of did. It had some very special qualities: it reflected light; it transmitted light; it absorbed light—all at the same time—and had a shelf life of about three million years."

Bell has exploited the transparency and reflectiveness of glass to great effect since the very start of his career. In 1962, he inserted a square piece into his painting of a cube and titled it *Ghost Box*. Bell made his first three-dimensional cubes that same year, out of wood and mirror; by 1964, they were all glass, and coated by the vacuum deposition process he uses to this day. Through Bell's plating process, evaporative metals and quartz can be applied to glass, pliable plastic, and paper in a vacuum environment. The combination of crystalline metals and light on coated surfaces creates the perception of refraction—or the breaking up of the light spectrum—and reflection.

Bell began experimenting with freestanding glass walls in 1968, leading to site-specific installations that are improvised to be interactive for the viewer. His 2015 exhibition at the Chinati Foundation in Marfa, Texas, was a tour de force of coated-glass "Standing Wall" sculptures: thirty-two human-scaled panels assembled at right angles to create sixteen units, both discrete and interrelating. Often Bell's panels appear visually ambiguous—real or unreal—due to their characteristic layers of mirrored and reflective coating. At the Whitney, Bell has installed his work on the terrace, where its surfaces become integrated into the climate and urban frenzy of their surroundings.

—CB

Pacific Red, 2016. Laminated glass, twelve 72 × 96 in. (182.9 × 243.8 cm) panels and twelve 72 × 48 in. (182.9 × 121.9 cm) panels. Installation view: *Pacific Red*, Pacific Place, Hong Kong, March 19–April 17, 2016

BROWNING, MATT

Born 1984 in Redmond, WA;
lives in Seattle, WA

Matt Browning's work is composed of craft materials and material contingencies. For Browning, who studied fiber arts at the University of Washington, weaving, stitching, and whittling represent a non-optimized kind of labor, the value of which is not necessarily in the finished objects themselves but in the labor that produced them. As such, his works become congealed time, while simultaneously engaging in a dialogue between traditional modernist and craft forms.

For *Tradition as Adaptive Strategy* (2010), Browning carved thirty-four blocks of fir wood into the same abstract form, a conical funnel suspended from a delicate three-legged pedestal. The repetition refers to mechanized production, yet replication is precluded by the variable nature of each piece of wood and the imprecision of hand-carving, pointing back to the intricate "whimsies" historically produced by migrant workers during the early twentieth century. Natural processes add variability as well: Browning coated and filled each funnel with viscous tree sap, lending each wooden structure a sludgy veneer. Insofar as the origins of Browning's works contribute to their meaning, even when those origins are not fully evident in the finished work, the artist is part of a lineage of process-based sculptors such as Jackie Winsor for whom sculpture is the result of a material transformation.

Browning's recent untitled works in wood, however, challenge the expectation that the labor of craft be evident in the final object even as they retain the value accrued though their production: a series of wall objects so precisely hand-carved as to seem nearly identical. In these works from 2016, the artist expands the dimensions of a single block of wood by carving it into interlocking sections, a Minimalist take on whittled whimsies in the form of a gridded chain. Prior rectangular works woven of wool and linen have the appearance of abstract paintings, even as their tactility grounds them in craft. Invoking the tension between material and abstract, incidental and laborious, Browning's practice recuperates both disregarded forms and the kinds of activity that bring them into existence.

—JPF

Untitled, 2016. Wood, collapsed: 3½ × 3½ × 18¼ in. (8.9 × 8.9 × 47.6 cm); expanded: 17¾ × 17¾ × 4 in. (45.1 × 45.1 × 10.2 cm)

CIANCIOLO, SUSAN

Born 1969 in Providence, RI;
lives in Brooklyn, NY

Since the 1990s, Susan Cianciolo has worked at the intersection of fashion, art, and performance, deliberately ignoring the distinctions between these categories. Following the founding of her fashion label, Run, in 1995, Cianciolo's deconstructed garments made largely from recycled or found textiles quickly gained a cult following, with her collections carried by Barneys New York and featured in *Vogue*, yet she eschewed virtually every convention of the industry. In lieu of a factory, a "sewing circle" consisting of the artist's family members and friends constructed each piece entirely by hand. (One collection featured a "DIY Denim Skirt Kit," inviting the wearer to customize the skirt with the scissors and pins that were included.) Likewise, Cianciolo's fashion shows were often held at galleries, accompanied by films and zines, and took on the character of participatory installations or happenings: for one, she distributed fake "Run Money," inviting viewers to pretend to purchase the looks on display.

In 2001, Cianciolo closed Run and turned her attention to making one-of-a-kind sculptural garments—described by the artist as "costumes" rather than "clothes"—and other artistic projects. That same year, she created the installation *Run Restaurant*, transforming Alleged Galleries in New York's Meatpacking District into an eclectic Japanese-inspired tearoom, with handmade linens, an ad hoc water garden, and a gift shop, which featured a selection of her garments for sale. Over the course of a month, Cianciolo and a team of friends and collaborators prepared and served lunch to the installation's visitors. As with the Run label, the pop-up restaurant suggested

the possibilities of imbuing commercial or transactional structures with a ludic, even utopian spirit. For the 2017 Whitney Biennial, Cianciolo is reprising the restaurant as an intervention in the Museum's own eatery, Untitled, working in collaboration with chef Michael Anthony.

The artist has recently turned her attention as well to her series of what she calls "kits": Fluxus-inspired boxes, decorated by hand and filled with fragments drawn from her life and work, including garments and ephemera from Run collections, sketches, pages from her diaries, and her daughter's notes and drawings. When the kits are exhibited, viewers are guided through the contents of the boxes by an interpreter who explains the significance of each artifact, transforming the act of viewing into a form of ritual performance.

—RW

Untitled, 2000. Watercolor on paper,
24 × 18 in. (61 × 45.7 cm)

CLARK, MARY HELENA

Born 1983 in Santee, SC;
lives in Hamilton, NY

Manipulating light and darkness, contour and motion, Mary Helena Clark troubles notions of what an image is and how a moving image is apprehended. Importing the notion of trompe l'oeil from painting into cinema, her films start with cinema's basic illusory quality—the medium's capacity to conjure rich and disorienting experiences from fragments of image and sound. Actions, objects, and spaces serve as clues to unspoken mysteries. Clark's characteristically oneiric work *Palms* (2015) sets uncanny images—of gesturing hands or tiny headlights emerging from inky blackness—against distinctive sounds—a tennis match, a metronome, crickets. It's a puzzle film that emerges out of precise optical and aural counterpoint.

Clark's work brings together an array of cinematic styles and experimental practices, from appropriation to psychogeography to observation to abstraction, and recalls the molecular found-footage deconstructions of Malcolm Le Grice as well as the impressionistic flânerie of Nathaniel Dorsky or Chick Strand. But she is unique for her discursive, free-floating style of editing and careful attention to the rhythms of everyday hallucination. Working with both 16mm film stock and digital imagery, Clark's distinctive palette subtly, subversively nods to the history of classical narrative cinema through both sumptuous color and high-contrast black-and-white. In *The Dragon Is the Frame* (2014), a half-remembered reconstruction of Alfred Hitchcock's *Vertigo* (1958), Clark explores real and imaginary spaces through montage—elusive glimpses of the original film's locations, its plays of shadow, illumination, fog,

and reflection. For *Orpheus (outtakes)* (2012), Clark used an optical printer to manipulate material from Jean Cocteau's 1950 film *Orphée*, indulging in spectral alternations of black and white and the minute imperfections of processed film.

Shot on crisp high-definition video, *Delphi Falls* (2016) drifts with two young characters through landscapes both natural and artificial: a hyper-real forest, an abandoned house, and a rec room lined with faux-wood paneling. Hinting at an oblique narrative just beyond the frame of these vivid images, the work unsettles our expectations about the ways editing connects visual ideas in order to tell stories. In *Delphi Falls*, Clark continues to play with the tension between the unique properties of the visual and sonic fields and the logical processes of their assemblage.

—LG

Stills from *Delphi Falls*, 2016. High-definition
video, color, sound; 20 min.

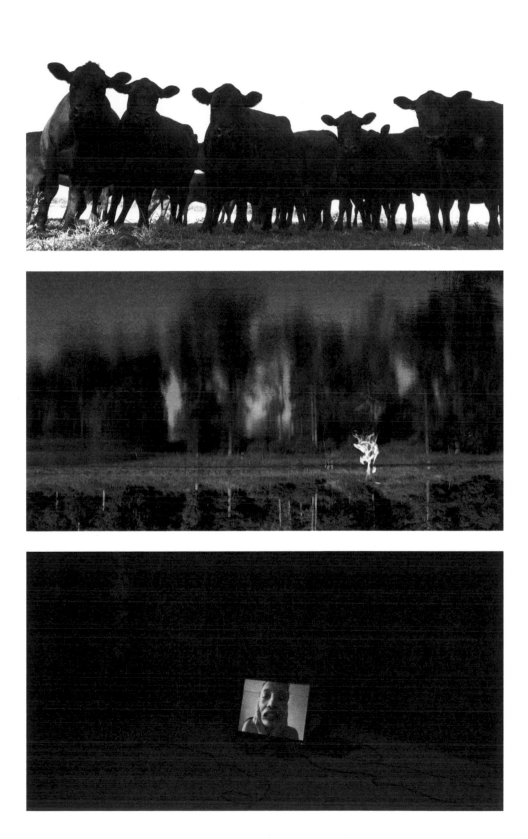

DIVOLA, JOHN

Born 1949 in Santa Monica, CA;
lives in Riverside, CA

In the mid-1970s, John Divola began photographing the interiors of abandoned houses in his native Southern California, treating the recession-hit area's many empty structures as makeshift studios. For his series *Vandalism* (1973–75), Divola added his own spray-painted marks to the existing graffiti he encountered in the buildings and staged the surrounding debris, photographing the results in closely cropped black-and-white images. As the artist has described, his only access to the major artistic movements of the era—performance art, Postminimalism, earthworks—was through photographic documentation, leading him to the conclusion that "all painting and sculpture and performance was, from a practical point of view, made to be photographed, to be recontextualized and talked, or written, about."

In the series *Zuma* (1977–78), Divola turned to color, documenting a single structure over the course of two years: a deserted lifeguard's quarters on Zuma Beach near Malibu that was periodically used by the local fire department as a training site. In his photographs, Divola captures the changing states of the house, as natural entropy intersected with the man-made destruction wrought by the firefighters and by ordinary vandals, alongside the artist's own graffitied contributions. In each of the photographs, however, the shack's deteriorating thresholds frame views of the beach outside, resulting in surreal juxtapositions of picturesque Pacific vistas and the house's staged ruins. *Abandoned Paintings* (2007–08) is one of several of Divola's recent bodies of work that revisit the themes explored in these early series, ranging from tropes of neglect and disuse to multiple authorship.

After stumbling upon a trove of abandoned student paintings in a dumpster near the University of California, Riverside, where Divola has taught since 1988, the artist began to incorporate them into his work, hanging the amateurish canvases on the walls of various abandoned buildings. In the photographs, the paintings appear to uncannily echo the characteristics of their environments: in *Abandoned Painting B*, the sideways glance of a portrait appears to be peering out of an adjacent window, while the pale yellow background of the painting in *Abandoned Painting C* seems to match the decaying wallpaper visible in the next room. In staging each scene as a *mise en abyme*, Divola calls attention to the deliberate framing of the image, pointing to the tension between indexicality and artifice inherent in the medium of photography.

—RW

Abandoned Painting E, 2008. Inkjet print,
44 × 54 in. (111.8 × 137.2 cm)

DUPUY-SPENCER, CELESTE

Born 1979 in New York, NY;
lives in Los Angeles, CA

Celeste Dupuy-Spencer's paintings and drawings offer wry, sensitive commentary on the times in which we live. Her style is raw and cartoonish, covering every inch of the canvas or paper, and her subject matter boldly topical. One drawing from 2016, titled *Trump Rally (And some of them I assume are good people)*, portrays figures at a political rally under a banner that reads: "Trump: Cause We Don't Know What The Hell Is Going On!!!!" A watercolor from 2015, *The New Left Wing*, offers a trenchant take on the self-centered oblivion of the political left: a group of plump, tattooed figures are pictured with speech bubbles that include phrases such as "I strive to find my center through nutrition and Eastern healing arts." The political fringe, well-heeled partygoers mingling at a swanky home, or teenagers scuffling in a backstreet in St. Tammany Parish, Louisiana—these characters are made real through expressive gestures and carefully observed accoutrements.

Dupuy-Spencer's titles typically volunteer information to reinforce the socially charged context of the scene at hand. A 2016 watercolor of a crowded sports bar features patrons cheering a football game in full color, while in the foreground appear rosy-hued couples chatting at café tables—apparition-like. The combination would be perplexing were it not for the title *It's a Sports Bar But It Used to Be a Gay Bar*, through which the artist subtly but poignantly points to the diminishment of safe, distinct spaces for the LGBTQ community to gather and mingle.

In rendering an unsparing portrayal of the human condition with tenderness and authenticity, Dupuy-Spencer's work is in dialogue with that of many painters throughout the course of art history. The artist's closest spiritual peer is surely the politically active and relentlessly productive nineteenth-century painter Gustave Courbet, whose subjects included laborers and the bourgeoisie, and who wrote of his commitment to "realism" and the portrayal of modern life: "It is society at its best, its worst, its average. In short, it's my way of seeing society with all its interests and passions. It's the whole world coming to me to be painted."

—CB

Fall with Me for a Million Days (My sweet waterfall), 2016. Oil on canvas, 60 × 48 in. (152.4 × 121.9 cm). Private collection

ESPARZA, RAFA

Born 1981 in Los Angeles, CA;
lives in Los Angeles, CA

Since 2014, multimedia and performance artist Rafa Esparza has built structures out of hand-made adobe bricks that unite different artists and communities in his native Los Angeles and speak to multiple aspects of the artist's own identity, the politics of space, and the contested nature of land. Despite the bricks' durable material-ity, Esparza's emphasis on the process of their creation links them to his rich performance prac-tice: his adobe structures often serve as physical platforms for him and the other artists he invites to animate his work and their own.

Con/Safos (2014) is a two-walled structure, like a fragment of an abandoned, partially collapsed building, built on a postindustrial lot along the Los Angeles River. Its adobe bricks were made by Esparza and his father, along with family and friends, using dirt, hay, and horse dung mixed with water from the river itself. In Los Angeles, graffiti is sometimes signed with "C/S"—*con safos* ("with safety")—granting the work immu-nity from being repainted by other street artists. Likewise, the walls of *Con/Safos* are a safe space for artists invited by Esparza to contribute a work of public art, at a time when the city of Los Angeles has been working to remove the histori-cal graffiti that once lined the river's banks.

In another project along the L.A. River titled *building: a simulacrum of power* (2014), Esparza activated Michael Parker's site-specific instal-lation *The Unfinished* (2014). As in *Con/Safos*, Esparza and his family made adobe bricks, which they then used to cover the entirety of Parker's installation. Once the bricks were laid, the

structure became a stage for Esparza and a collab-orator, dancer/choreographer Rebeca Hernandez. The performance, which involved elements of a Danza Azteca water dance, paid tribute to the sun and earth that had made the material of the bricks, and also to the collective labor that produced them. "It was important for me to honor this labor and to share it with my family by having my father teach us how to build," Esparza has said. The artist's request of his father, who built his own home in Durango, Mexico, using the same ancient technique, coincided with a tense juncture in their relationship, just after Esparza had come out as gay.

For the artist, whose work often thematizes queer Chicano experience, adobe not only reconnected father and son but also brought his personal artis-tic practice into dialogue with the traditions of his Mexican immigrant family. Recontextualizing their labor in his own work, Esparza uses adobe to transform his environment both artistically and politically. In this sense, Esparza's practice materializes words attributed to the revolutionary Emiliano Zapata: *la tierra es de quien la trabaja con sus manos*—"the land belongs to those who work it with their hands."

—JPF

building: a simulacrum of power, 2014.
Performance on the site of Michael Parker's
The Unfinished (2014), The Bowtie Project,
Los Angeles, August 24, 2014

EVERSON, KEVIN JEROME

Born 1965 in Mansfield, OH;
lives in Charlottesville, VA

A film by Kevin Jerome Everson might last two minutes or eight hours; it might be a patient, real-time observation of a particular action, a reenactment laden with high artifice, or something in-between. It could be in black-and-white or color, and shot on any number of formats. Everson's practice is flexible, but it is far from inconsistent. Over the last twenty-five years, the artist has produced a body of work that captures the mundane details, political challenges, and labor conditions of Black lives in America with tremendous generosity and precision. Though his practice includes sculpture and photography, Everson is best known for moving-image works that marry a documentary impulse with questions of materiality and form more associated with the experimental tradition.

In *Sound That* (2014), shot with members of the City of Cleveland's water department as they search for leaks, the task-based actions of blue-collar workers are the subject of sustained attention, underlining the persistence of manual labor in an economy now largely automated and post-industrial. Even when the workplace is out of frame, the relationship between life and labor remains key, as Everson consistently returns, whether implicitly or explicitly, to the geography and aftermath of the Great Migration. *Eason* (2016) crosses the North and the South to offer a portrait of transport workers and college basketball players that is haunted by the death of James Walker Hood Eason, a leader of the Universal Negro Improvement Association who was shot in the back in 1923.

Everson's relationship to his subjects is not one of distance but of an intimacy compounded by the many and varied ways that the artist's own life intersects with his subject matter, even as he avoids autobiography. In *Ears, Nose and Throat* (2016), a woman recounts witnessing a young man killed on the street in 2010; the dedication is to Everson's own deceased son. Here, and throughout his work, Everson starts from the local and the particular, finding within it a means of reflecting on race and class that avoids the pitfalls of generalization.

—EB

Still from *Ears, Nose and Throat*, 2016.
16mm film transferred to high-definition video, black-and-white, sound; 10:30 min.

GCC

Founded 2013

The structures, performance, and strategies of power are the subject matter for the eight-member collective GCC, which includes artists Khalid al Gharaballi, Nanu Al-Hamad, Abdullah Al-Mutairi, Fatima Al Qadiri, Monira Al Qadiri, Aziz Alqatami, Barrak Alzaid, and Amal Khalaf. The group borrows its name from the abbreviation for the Gulf Cooperation Council, known officially today as the Cooperation Council for the Arab States of the Gulf, a political and economic alliance among Bahrain, Kuwait, Oman, Qatar, Saudi Arabia, and the United Arab Emirates. With members living in New York, Kuwait City, Amsterdam, Berlin, and London, the GCC traces its founding, the group says, to the "VIP lounge of Art Dubai" in 2013. Its favored mediums—high-definition promotional video, banal yet expensive-looking objects, and large-scale installations—echo the state-sanctioned propaganda used to burnish the branding of the council's member nations.

For *Chartered Cruise* (2013), GCC offered visitors rides in a gleaming Rolls-Royce during the group's exhibition *Achievements in Swiss Summit* at Project Native Informant in London. Enveloped in a microclimate of leather upholstery and inlaid-wood paneling, visitors listened to a recording of the collective's "official communiqué," an altered version of the Cooperation Council's charter in which the names of GCC's artists replace the names of member states, and the words "art" and "Federation of Gulf Artists" are substituted for "Islam" and "League of Arab States," an intervention that underlines the empty bombast of the charter's bureaucratic language. The reign of form over substance is crystallized in a series of sculptural works called *Congratulants*, glittering trophies in glass and metal. Yet close inspection reveals that these trophies are blank, empty gestures for unrealized achievements, mirroring a regional practice of nurturing allegiance to the state.

For its contribution to the 2016 Berlin Biennale, GCC addressed another form of institutional co-option: the usurping by government propagandists of New Age movements, whose marketable mantras are disseminated like other products of global capitalism. In the group's installation, the figure of a woman practicing a healing gesture called "quantum touch" reaches out to a young boy while an audio track preaches the importance of positivity. The pair is surrounded by the lanes of a running track, a symbol of quantifiable success, looping through piles of sand—as if to parody the notion that positive thinking, rather than wealth and power, is alone responsible for the transformation of desert dunes into thriving metropolises.

—JPF

GCC Portrait, 2016. Digital photograph, dimensions variable

GILLEN, OTO

Born 1984 in New York, NY;
lives in New York, NY

Oto Gillen's photographs of New York present the city in which the artist lives and works as if glimpsed, he says, "through a door slightly ajar." Through the artist's use of digital projection to present the pictures one after the other at large scale, these images together evoke the kaleidoscopic experience of traversing the urban landscape—both throughout the course of a day and over the two years during which Gillen has been making the series. Portraits of passersby and close-ups of found objects capture the intimate, fleeting encounters that punctuate daily life at street level, while views of looming skyscrapers, many under construction, convey the city's vast scale and continually evolving skyline. At night, the streets empty to reveal atmospheric, sometimes eerie scenes of the remnants of the day, or of trees silhouetted against the dark sky. Gillen's compositions record moments of exchange and contact—a wisp of bright pink fabric screening a crowded tank of fish, a woman carrying an oversized bag of recyclables—that speak to the complexity of the urban ecosystem and to the larger economic, political, and social forces in which its denizens are entangled.

In addition to his own experiences and childhood memories of the city, Gillen takes inspiration from a long line of photographers who have documented New York, from Alfred Stieglitz to Garry Winogrand and Diane Arbus. Yet while Gillen continues to explore the gelatin-silver print process that characterized straight photography throughout much of the twentieth century, he embraces digital photography as well, using a telephoto lens to record the rich hues, textures, and intricate details of his subjects while also manipulating aspects of exposure in ways that alter the perception of everyday things. The resulting images reflect the influence of a range of cultural forms beyond photography, from nineteenth-century Impressionist paintings and Japanese woodblock prints to the production design and cinematography of the 1982 dystopian film *Blade Runner*, as Gillen deftly exploits photography's capacity to crop, focus, and reassemble in order to render the ordinary unfamiliar and new.

—FJP

Still from *New York*, 2015–ongoing. High-definition video, color, sound (work in progress)

GOLDEN, SAMARA

Born 1973 in Ann Arbor, MI;
lives in Los Angeles, CA

A strange domesticity defines Samara Golden's site-specific installations. She takes apart architecture we often take for granted, reassembling it to reveal the psychological effects of commonplace interiors. In *Mass Murder* (2014), an immersive installation at Night Gallery in Los Angeles evoking "typical" American homes from the late 1970s or early '80s, viewers moved through conflicting emotional landscapes. There was a huge living room complete with carpet, couches, and a grand piano, and around the corner, a suffocating kitchen lit orange by heat lamps. These spaces became more unsettling through the musical accompaniment of multiple radios broadcasting simultaneously. *The Flat Side of the Knife* (2014), an elaborate tableau at MoMA PS1 in New York, featured wheelchairs perched precariously on stairways leading to nowhere and a floor of mirrors reflecting living-room furniture attached to the ceiling. The *real* sculptural elements and these reflections combined to create three distinct visual levels, which the artist describes as three levels of consciousness.

Golden locates her practice in the act of materializing and relating psychological states, or ways of *being*. Her work is informed, in part, by her experiences assisting her father, a commercial photographer, in taking pictures of nursing homes in West Virginia. Golden was tasked with rearranging furniture, equipment, and plants to make these facilities appear more perfect. She has recounted feeling "terrified" by the way we treat people in these care centers. Her critique of the domestic sphere to reveal underlying conformist agendas and the erosion of independent thinking recalls the work of other Los Angeles–based artists such as Mike Kelley, Paul McCarthy, and Charles Ray.

In creating dreamlike alternatives to the rooms in which we dwell, Golden often situates her installations to transform existing architecture. For *A Fall of Corners* (2015), she took over CANADA gallery in New York, building an elevated walkway from which viewers could locate themselves at the center of four rooms—or vignettes—each on a different wall. A dizzying array of banquet tables, chairs, and sofas were attached to the walls and reflected in a mirrored floor, allowing viewers access to what looked like an aerial view of each room. The artist relates this vantage point to astral projection or to the idea of holding multiple thoughts in one's mind at once. The overall impact of Golden's constructions is disorienting but inspiring, suggesting that gravity may be defied and other constraints, both physical and cognitive, overcome.

—CB

A Fall of Corners, 2015. Foam insulation board, resin, fabric, paint, lighting gels, found objects, mirror, video projection, and sound, 35 × 35 × 15 ft. (10.7 × 10.7 × 4.6 m). Installation view: *Samara Golden: A Fall of Corners*, CANADA, New York, September 12–October 25, 2015

GOLLAN, CASEY
Born 1991 in Los Angeles, CA;
lives in New York, NY

SOBEL, VICTORIA
Born 1990 in Washington, DC;
lives in New York, NY

Although Casey Gollan and Victoria Sobel met in art school, their collaboration was formed not through the making of artworks but instead in the service of protest. In 2011, New York's Cooper Union for the Advancement of Science and Art announced that it would begin charging tuition for the first time in more than a century, a move in direct conflict with the wishes of its founder, Peter Cooper, that education be "as free as air and water." The decision sparked outrage, along with accusations of financial mismanagement on the part of the administration, and fed into the nationwide debate surrounding the increased corporatization of higher education. Gollan and Sobel, both undergraduates at the time, joined other students to form Free Cooper Union, under whose banner they organized protests, sit-ins, meetings, and a community residency and think tank called Nonstop Cooper. While they relied on civil disobedience and organizing techniques employed by Occupy Wall Street, their investment in institutional critique and political action also stemmed directly from their arts education. As Sobel has said, "We tried to translate the values instilled in the classroom to the work that needed to be done on the institution." By 2015, Cooper Union's president and several trustees had resigned, and after the release of a damning report from the New York State Attorney General's office, the school agreed to a settlement that increases financial monitoring, reforms its governance, and moves toward reinstating free tuition.

Today, Gollan and Sobel continue to be invested in the issues of transparency, accountability, and accessibility that galvanized Free Cooper Union, but their work now looks beyond the scope of a single institution. An effusive, playful spirit combined with a belief in the potential of open-ended, collective action continues to characterize their work together, where they call for a space of "para-institutionality," a term suggesting a sphere of collective social action that exists alongside, in dialogue with, and in resistance to formal institutions. In an untitled 2016 artist book, they poetically declare: "I would love to put together something unregulatable, incomparable, non-standardized across infinite variables."

—FJP

Calla Henkel and Max Pitegoff, *Window I, Nonstop Cooper, Cooper Union, 31 3rd Avenue, New York, October 2015*, 2015. Inkjet print, 9¾ × 8¼ in. (24.7 × 21 cm)

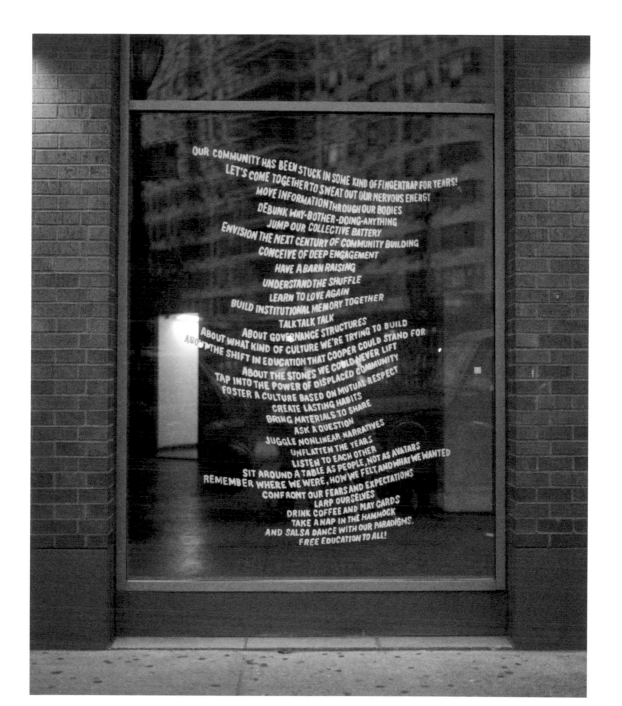

HAIDUK, IRENA

Biographical information not given

In her 2013 text *Bon Ton Mais Non*, Irena Haiduk mounts a takedown of what she calls "polite art": art that is typically nourished by contemporary cultural institutions. Such spaces provide a comfortable zone for the consumption of "critical" but ultimately toothless art: "It looks corrupt, but it does not corrupt. Polite art takes bribes. It is an amateur at corruption." Haiduk's mode of aesthetic address resides in the figure of the siren, whose allure ultimately serves annihilation: "Only sirens cannibalize. They know things about you, things you will never know."

Haiduk's work assumes a nonaligned political posture and employs orality and blindness as countermeasures to Western image-based traditions and the worlds that such traditions forge. In *Seductive Exacting Realism* (2015), at Chicago's Renaissance Society, she populated the eaves of a darkened gallery with sirenlike figures while filling the space with the sound of two actresses who gave voice to an android and Apple's Siri. The text: an interview Haiduk conducted with Srdja Popović, a Serbian activist and leader of CANVAS, an organization that advocates global nonviolent regime change while allegedly maintaining ties with Western corporations. For Haiduk, Popović is a model of the compromised position of the artist. Instead of instantaneously consuming the work, gallery visitors are suspended in anticipation, a slowness that seduces and engulfs.

For the 2017 Biennial, Haiduk mobilizes the Whitney's network resources to create *SERVERS FOR .YU*. This collaboration with jesus.d and Daniel Sauter superimposes the former Yugoslavia's national top-level domain, .yu, onto the searchable internet on the Whitney's free Wi-Fi network. While users still reach their intended searches, this subtle transformation of the URL signals another dimension—a space left unoccupied by a country that no longer exists. "Yu" also orients the atmosphere toward the South: *jug* names this cardinal direction in the Slavic languages spoken in the Balkan region.

SERVERS FOR .YU advances the mission of Yugoexport, an entity Haiduk created in 2015 as an "oral corporation" (OC) using the name of a defunct Yugoslav state manufacturer. The servers also host *Frauenbank* (2017), a work from Yugoexport's art collection. Titled after a pioneering women's cooperative from 1913 Berlin, *Frauenbank* manifests as a bank and a domain. Female visitors to the Whitney may purchase shares in the bank executed by the *Frauenbank* blockchain. The bank uses the capital to buy Serbian land, owing to a 2017 law that allows foreign acquisition of public and private lands. The *Frauenbank* generates a cooperative space and a new kind property, grounded in former Yugoslavia's digital and physical domain.

—IH

Siren Bay, Renaissance Society, 2015.
Digital photograph, dimensions variable

HARRIS, LYLE ASHTON

Born 1965 in Bronx, NY;
lives in New York, NY

Photography, video, performance, and installation commingle in the practice of Lyle Ashton Harris as the artist explores themes of race, sexuality, and identity—and in the process exposes the camera's dual status as a tool of empowered self-representation and oppression. Harris's early works often take the form of performative self-portraits: in his series *Americas* (1987–88) and *Constructs* (1989), he poses nude in signifiers of minstrelsy and drag, challenging conventional representations of Black masculinity and the body. For the extended series *Chocolate Portraits* (1998–2008), Harris invited a range of figures—from Al Sharpton and Chuck Close to a nightclub performer with the stage name Mystery—to sit for studio portraits taken with a large-format Polaroid camera. Capturing closely cropped images of the backs of his sitters' heads alongside their faces, and employing a cross-processing technique that gave the prints a deep brown tone, Harris alludes to mug shots and ethnographic typologies, emphasizing the ways in which such photographic catalogues have been used to police social "others" since the medium's inception.

In 2013, Harris began to revisit a trove of more than 3,500 35mm Ektachrome slides that he had been storing in his mother's basement. Taken between 1986 and 2001, the slides are largely made from snapshots that document the artist's life, ranging from intimate portraits of friends and lovers to events such as the Black Popular Culture Conference in 1991, the truce between the Crips and the Bloods in 1992, and the Black Nations/Queer Nations Conference in 1995. Harris's current body of work, *The Ektachrome Archive* (2014–ongoing), makes use of these photographs, which he combines with journals, video, notes, and ephemera from the same period to display in the form of archival installations, photocollages, and performative slide lectures. From the vantage of the present, once-personal images take on new significance as historical documents: in one photograph, the late filmmaker Marlon Riggs is seen taking the anti-HIV medication AZT on the set of his final film, *Black Is . . . Black Ain't* in 1994; in others, Harris's work hangs on the walls of the Whitney Museum during the opening of the now-iconic exhibition *Black Male*. By documenting intimate moments alongside landmark events, *The Ektachrome Archive* constructs collective and private narratives to discuss identity, desire, sexuality, and loss. The resulting assemblage serves not only to memorialize but also to evoke lived moments at the intersection of the personal and the political, presenting a dynamic experience that reengages time past to affectively impact the present.

—RW

Mark, Isaac, and John, 2 Brydges Place, Covent Garden, London, 1992, 2015. Chromogenic print, 15 × 20½ in. (38.1 × 52 cm)

Uma vez, uma vez/Once, once, 2016. Two-channel digital video, Hi-8 film transferred to digital video, MiniDV transferred to digital video, and three-channel high-definition video, color, sound, with inkjet prints. Installation view: *Incerteza viva: 32ª Bienal de São Paulo*, September 7–December 11, 2016

HARTUNG, TOMMY

Born 1979 in Akron, OH;
lives in Queens, NY

Combining video, sculpture, and animation, Tommy Hartung constructs hallucinatory montages that consider the cultural and ideological role of the moving image. In his work, Hartung draws on an expansive range of references, sources, and narrative conventions, from the realist novel of the nineteenth century to YouTube videos: Hartung's *The Ascent of Man* (2009) was inspired by Jacob Bronowski's 1973 BBC documentary series charting the evolution of the human species, while *Anna* (2011) is a rereading of Tolstoy's *Anna Karenina*, juxtaposed against scenes from Soviet filmmaker Alexander Dovzhenko's 1930 epic, *Earth*. Originally trained as a sculptor, Hartung creates the sets and props for his videos by hand from everyday materials, integrating found and appropriated footage into the intricate stop-motion animations he produces in his studio.

Hartung's recent films have turned to the subject of religion, obliquely referencing the artist's own Evangelical upbringing as he probes both the rhetorical tropes and social implications of religious fervor. *THE BIBLE* (2014) is loosely structured around the Old Testament, stitching together representations of catastrophic violence and destruction culled from contemporary news footage, eyewitness videos, and Hartung's own animated reenactments. *The Lesser Key of Solomon* (2015) is titled after a *grimoire* compiled anonymously in the seventeenth century that details the seventy-two demons believed by occult practitioners to have been evoked by King Solomon, as well as the rituals required to summon them. Eschewing a coherent narrative arc, Hartung employs a soundtrack juxtaposing two impassioned orations on the nature of humanity, layered over a kaleidoscopic animation that combines flickering projections, occult imagery, and otherworldly landscapes. The video opens with a YouTube clip of a man addressing his webcam as he implores his viewers to stay away from the dark magic contained within *The Lesser Key of Solomon*, too powerful to be handled by humans, before he meditates on what it might be like to become a god. In the second half of Hartung's film, the audio is drawn from a Nation of Islam sermon, in which the speaker, Leo Muhammad, assails the hypocrisy of a racist society in which equality exists in name only as he repeats the refrain, "When did I become a human being?"

—RW

Stills from *The Lesser Key of Solomon*, 2015.
Ultra-high-definition video, color, sound;
8:05 min.

HEARTSCAPE, PORPENTINE CHARITY

Born 1987, location not given;
lives in Oakland, CA

Porpentine Charity Heartscape is an artist, game designer, and writer whose work explores trauma, love, and physical transformation. Heartscape makes language-based, interactive games that take the player through a series of nonlinear choices using hypertext. In contrast to the products of mainstream gaming—made by legions of designers with Hollywood-size budgets—Heartscape's are developed using the open-source program Twine, a relatively simple tool requiring little computing power. Her games are graphically minimal and typically played in a few minutes; they are also deeply personal, emotional, and strange. Regularly using the second-person-singular "you" form, they are designed to implicate the player, who enters into a fictional, intimate space to confront questions about identity, loneliness, and pain.

In *howling dogs* (2012), the player begins alone in a fluorescent-lit metal cell. There are basic amenities for sanitation and nutrients; a picture of "her," the player's lover, hangs on the wall. As time passes, the waste in the cell builds up, and the picture of "her" gradually disappears. But once a day the player escapes to a virtual reality both macabre and euphoric. By making the player bargain her way through isolation, abandon, and the indulgence of fantasy, *howling dogs* is a meditation on depression and social detachment.

Companionship is important in Heartscape's work, and she regularly collaborates with other artists. In *With Those We Love Alive* (2014), created with Neotenomie, the player is a talented artificer, recovering from trauma while performing tasks for a corrupt empress. At times, the player is prompted to "connect" with reality—told to draw sigils on her skin representing her feelings during play, or to breathe for mindfulness. Escape is possible only by choosing to be banished, but a friend can join. In the multimedia bildungsroman *Psycho Nymph Exile* (2016), collectively authored by Heartscape, Neotenomie, and Sloane, two trans* lesbians help each other survive complex post-traumatic stress disorder in a toxic society by creating bubbles of possibility with other alienated people—bubbles that can become fetid or beautiful or both.

In the artist's words, "Other people are already built into the world . . . and parts of themselves have already been understood and prepared for. But everything that I value does not exist in the world yet." Couched in pop—anime, sci-fi, fantasy—Heartscape's work raises issues of power and indignity to directly challenge, and at times frustrate, the player.

—ME

Vesp: A History of Sapphic Scaphism, 2016. Hypertext

With Those We Love Alive, 2014. Hypertext

Wasps smolder and burst on the grills of the market row, corrugated awnings dripping with congealed grease like caves of sick honey.

Not hungry for food

Which month were you born in?

One, the Broken Coffin
Two, the Flower Eater
Three, the Ocean Cloud
Four, the Fruit Heart
Five, the Angel's Egg
Six, the Dire Maiden
Seven, the Orphan
Eight, the Snake's Milk
Nine, the Locust Kill
Ten, the Moth Vendetta
Eleven, the Eye in the Ground
Twelve, the Salt Key

HOPINKA, SKY

Born 1984 in Bellingham, WA;
lives in Milwaukee, WI

In the films of Sky Hopinka, the principal technique is that of layering: sounds, images, words, and perspectives interweave with one another to form a complex tapestry in which the personal, communal, natural, and historical are intertwined. By combining these multiple aspects of his subject matter, Hopinka aims to bring the known into dialogue with the unknowable.

In *Jáaji Approx.* (2015), Hopinka, a member of the Ho-Chunk Nation who traces his lineage as well to the Pechanga Band of Luiseño Mission Indians, layers his own experiences and history over those of his father, whom the artist rarely saw growing up. In the Hočak language spoken by Hopinka's paternal family, *Jáaji* is the direct address of one's father, and the artist journeys by car through the same landscapes once traveled by his own father, whose stories, songs, and conversation overlay what the viewer sees through Hopinka's windshield. These are pulled from informal recordings the artist made over the course of ten years, amounting to a kind of personal ethnography. "It's like the relationship I have with my father is through these recordings and these landscapes," Hopinka has explained. "The sounds and the sights make an approximation of the relationship between us and ways of trying to engage with one another." The artist, who is learning to speak Hočak, also enlists the tools of formal scholarship: in *Jáaji Approx.*, his father's words appear on the screen in the International Phonetic Alphabet, used by ethnologists to document languages that lack their own orthographies. The technique suggests both Hopinka's distance from his father and his drive to understand him. For the artist, film represents a new possibility for making personal meaning out of tradition. In *I'll Remember You as You Were, Not as What You'll Become* (2016), Hopinka pays tribute to poet Diane Burns, another artist caught between past and present, tradition and the avant-garde. Her words become the basis of "a place for new mythologies."

Throughout Hopinka's films, language represents both a means to knowledge and a frustrating hindrance to understanding. In *Visions of an Island* (2016), Hopinka presents a portrait of St. Paul Island in the Bering Sea, home to the largest Aleut population in the United States and great colonies of seals and seabirds. In one scene, silhouetted figures speak haltingly in the language of their ancestors, struggling to communicate in words that both connect them to and estrange them from their cultural history. Their painstaking attempts remind us that heritage is defined neither by land nor by parentage—rather, it is a practice, one that must be enacted to come alive.

—JPF

Still from *Visions of an Island*, 2016.
Digital video, color, sound; 15 min.

HUGHES, SHARA

Born 1981 in Atlanta, GA;
lives in Brooklyn, NY

The lush visual mélanges of color, pattern, and texture within the paintings of Shara Hughes originate in the artist's own experiences. Rooted in memory and affect, they manifest as psychic collages, wild transmutations of the physical world. Hughes's process tends to unfold extemporaneously, sometimes stemming from a drawing but other times beginning directly on the canvas itself. Through organic permutations of the artist's own idiosyncratic visual language, shapes beget, entwine, and challenge other shapes to eventually build a composition. These more current explorations extend Hughes's prior investigations of subjective relationships to space and time, in which she has navigated fluid distinctions between interior and exterior as well as past and present, whether in her totemic sculptures composed of found objects or her figurative paintings, which often feature subjects caught in the ecstatic throes of conflicting emotion. Critics have noted stylistic affinities in Hughes's work with Matisse's Fauvist color palettes, the decorative patterning of the early Impressionists, Surrealists' intuitive articulations of the unconscious, and the pursuit of nature's sublimity by painters of the Hudson River School. Other comparisons have been drawn to the angular landscapes of Richard Diebenkorn and the evocative figuration of Dana Schutz and Philip Guston.

In Hughes's most recent paintings, she experiments with amalgamations of oilstick and acrylic, oil, and vinyl-based paints, combining manual and airbrush techniques with gusto. What results are psychedelic landscapes that challenge any distinction between vistas that do actually exist somewhere in the world and those that only exist somewhere in the mind. Natural elements such as tree trunks, clouds, and grassy knolls both contribute to these scenes and surround them, straddling dual roles as image and border, frame and pane. The pictures' fissured constructions recall an absurdity at the very heart of the creative traditions from which they deviate: any attempt to fix a landscape in a single, cohesive image belies the multidimensional, multiperspectival, ever-changing dynamism of the natural world and our relationship to it. Hughes's imagery eagerly embraces this perennial tension. Shedding prescriptive categories like so many semantic shackles, her vistas leap into the groovy blue yonder of ontological uncertainty.

—JD

We Windy, 2016. Oil, acrylic, and enamel on canvas, 56 × 48 in. (142.2 × 121.9 cm). Collection of Chana and Cliff Chenfeld

XXXXXXXXXXXXOOOOOOOOOOOOOOOOOOOOOOOO

JAMISON, AARON FLINT

Born 1979 in Billings, MT;
lives in Portland, OR, and Seattle, WA

For his solo exhibitions at Artists Space (2013) and Miguel Abreu Gallery (2015), Aaron Flint Jamison relocated the institutions' offices off-site and left the galleries almost bare. The artist then tailored these spaces to function as self-enclosed systems that exposed the base materiality of technology while testifying to its simultaneous capacity for abstract flows of information. On the ground floor of Miguel Abreu, Jamison affixed to the ceiling both a heat-sensitive camera and a sculpture composed of purpleheart and cedar woods with hydraulic arms. In the basement—normally closed to the public—a PC embedded in a desk also made from purpleheart maintained a live web stream of the gallery above. The visitor's progression from ground floor to basement prompts consideration of where the artwork lies: Is it in the discovery that one has been implicated in the system and surveilled? Or is it detached appreciation for how these artisanal objects perform a regulated technical service regardless of the viewer's presence? Whereas artists' statements and press releases often serve as guides to answering such questions, Jamison declines to provide these in his exhibitions.

The voluminous machine situated near the desk in the basement of Jamison's Miguel Abreu exhibition was activated at closing time each evening during the show. A gallery attendant would insert a large sheet of black paper into this machine, which was composed of exhaust tubes, digital temperature controls, and ultraviolet grow lights. The paper subsequently baked overnight under the lamps. Titled *Breathers*, these faded papers were then distributed free at the end of the

exhibition, ambiguous tokens of either a masterful or malfunctioned program.

In addition to his installations, Jamison's approach to exploring the movement of information includes publications, performances, and art centers that he has cofounded. As editor-in-chief of *Veneer Magazine*—first published in 2007—Jamison embraces unique production material for each issue; the spray-foamed edges of every copy of issue five, for example, forced readers to peel away flaky layers to discover the content inside, such as artist Adrian Piper's article on practicing Jñāna yoga. This literal and conceptual unfolding focuses attention toward the activity involved, connecting on a macro level to the type of work supported by Jamison's former artist-run center Department of Safety (2002–10) in Anacortes, Washington, and Yale Union, which he cofounded in 2008 in Portland, Oregon.

—EC

List of Works, 2015
18 sheets carbonless paper, clamshell magnet box
11¾ × 10¼ × ⅞ inches (29.8 × 26 × 2.2 cm)
Edition of 18 + 2 APs
[AJ1007.15]

MACHINE-MARBLED MAGNET PRESENTERS

Here, an edition of 18 noumenon prints from the Chandler & Price in three various forms. There will, in turn, be the checklist and publication for the exhibition. These noumenon prints are such on carbonless paper in a multiple of two. I wrote this language in lead throughout the production process. Each foil will interface directly with individual pieces, but also who knows. Unfurled, one of the prints will be approximately 18" long. Do you think that this is terminal marbled paper inside the magnetic box? It is not. It is made by a machine. And what about this PU coated black shelf? Also made by a machine. Who assembled their materials into the system that could house the noumenon prints? It is a concert of technology and craft. This box is a set of brackets.

...ISK

...mation Adaptor, 2015
...icro SD card, plastic, copper heatsink,
...ous cables, circuitry, fan

...¼ x 3½ inches (30.5 x 8.9 x 8.9 cm)
...4 x 4 inches (28.6 x 10.2 x 10.2 cm)

List of Works, 2015
18 sheets carbonless paper, clamshell magnet box
11⅝ x 10¼ x ⅞ inches (29.8 x 26 x 2.2 cm)
Edition of 18 + 2 APs
[AJ1007.15]

KAYA

Founded 2010

The works that emerge from the collaboration between painter Kerstin Brätsch and sculptor Debo Eilers bear the hallmarks of both artists' individual practices, but each new body of work brings them deeper into a new mode of creation. Brätsch and Eilers seek not merely a combination of their different styles but rather the development of a third consciousness from which new work might emerge. The avatar and namesake of this project is the daughter of a friend of Eilers's, who was thirteen when the two artists first hit upon the idea of asking her to take part in an exhibition they were then preparing at the now-defunct New York art space 179 Canal in 2010. Sometimes a third collaborator, sometimes a surrogate for the "third body" Brätsch and Eilers seek to manifest in working together, Kaya's involvement shifts with each new KAYA exhibition, and her own physical and personal growth parallels that of the project.

At that first exhibition, all three of them used finished artworks as experimental performance sites. Kaya added her own marks to the works' surfaces as well as to that of Eilers's body, coated in plaster to serve as a canvas. In Brätsch and Eilers's recent "body bag" works, twisted, puckered sheets of transparent plastic serve as support and site for Brätsch's luminous, bright-edged facial abstractions and Eilers's totemic epoxy forms strung together with wire and black straps that suggest fetish gear. "We wanted to have each of our individual practices collapse onto each other," Brätsch explains. The "body bags" in particular suggest the work of art as a surrogate for the human body. Casts of Kaya's own body

formed the kernel of some pieces in *KAYA V* at Vienna's Galerie Meyer Kainer in 2015.

The live reworking of their pieces signals the artists' interests in giving up control: of the autonomy of their artistic vision, of the claim to absolute authorship, and of the fate of the works themselves. In 2013, for the opening of *KAYA III* at 47 Canal in New York, visitors were invited to pay $20 to participate in a gambling game involving counterfeit coins. The event's proceeds were donated to Kaya's college fund, and at the end of the night, the winner chose an artwork to take home as a prize. Such gestures destabilize both the value and the aesthetic autonomy of the work of art, returning emphasis to the processes—reworking, performing, playing, gambling—that Brätsch and Eilers use to activate it.

—JPF

Unholdenberg, 2015. Performance, Bregenz, Austria, August 30, 2015, as part of the exhibition *KAMP KAYA*, KUB Arena, August 27–30, 2015

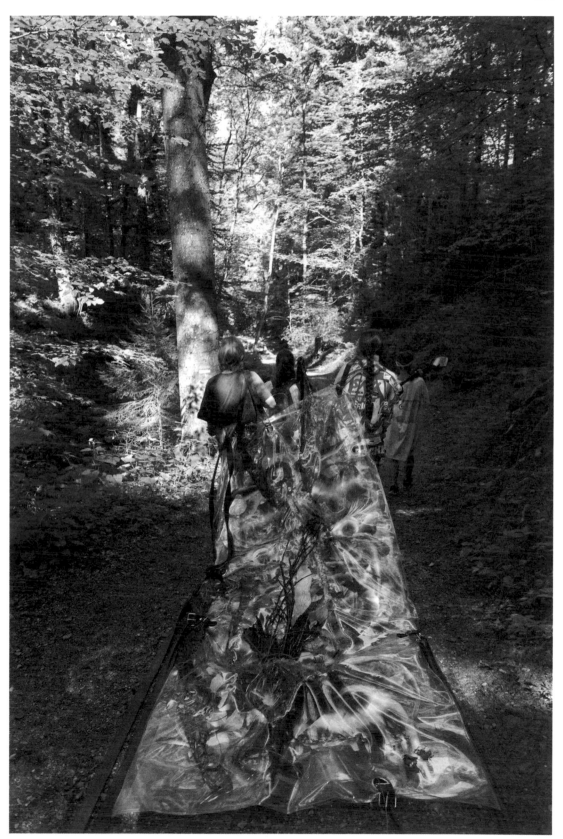

KESSLER, JON

Born 1957 in Yonkers, NY;
lives in New York, NY

In 1985, Jon Kessler participated in his first Whitney Biennial with two works, including *Isolated Masses (for Peace)*, a heated sculpture that warmed approaching viewers. *Isolated Masses (for Peace)* represents many attributes of Kessler's kinetic work of the 1980s and '90s, when he was modifying used objects, bringing detritus to life with motors and lights. Enchanting and estranging, Kessler's early sculptures evoke shadow plays and other forms of pre-cinematic entertainment without occluding the mechanics behind the movement.

After 9/11, he began experimenting with video, combining his interests in moving sculptures and moving images, particularly the optics of endless war. In *One Hour Photo* (2004), a chain drive resembling a commercial film-developing apparatus carries postcards of the Twin Towers past a surveillance camera. Two years later, this piece was included in Kessler's sprawling installation *The Palace at 4 A.M.*, at MoMA PS1 in New York. Surrounded by screens, automatons, and images of George W. Bush and Osama bin Laden, viewers confronted media representations—both distancing and distorting—of violence at home and abroad. Referencing Alberto Giacometti's 1932 sculpture of the same name, *The Palace at 4 A.M.* conjured, in Kessler's words, "the insanity that happens at the hour when no one is watching." And yet, surveillance cameras are always watching. In 2013, for his immersive installation *The Web* at the Swiss Institute in New York, Kessler took up another ubiquitous image technology, the sleek screen of Apple products, and devised an app allowing viewers to live stream images onto surrounding monitors—bringing Bruce Nauman's and Dan Graham's closed-circuit video installations into Apple's digital universe.

Recently, the artist has shown work that returns to his early mechanical objects. His 2015 exhibition at Salon 94 gallery in New York of small sculptures he had gifted to friends and family had whimsy and wit, without an overt political edge. Kessler's contribution to this Whitney Biennial, which is part of his work-in-progress *The Floating World*, maintains the ingenuity of his kinetic experiments but is also steeped in the social and environmental effects of climate change. The installation features sculptures addressing the effects of global warming on our planet—from mass migration to rising ocean levels and the loss of animal habitats—arranged within a massive inflatable iceberg that is seemingly pumped up through the labors of an animatronic polar bear on a bicycle. Kessler describes *The Floating World* as using "fear and folly to provoke a dialogue about our collective course as a planet."

—CI

Exodus, 2016. Mixed media with motor, surveillance camera, and LCD screen, 81 × 47 × 66 in. (205.7 × 119.4 × 167.6 cm)

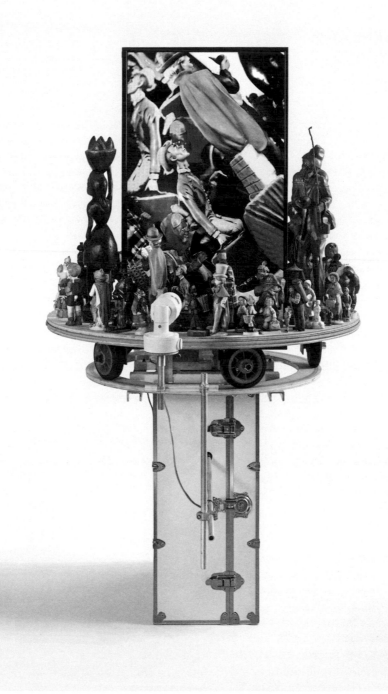

KIENITZ WILKINS, JAMES N.

Born 1983 in Boston, MA;
lives in Brooklyn, NY

In his Andre trilogy, a series of videos made from 2014 to 2015, James N. Kienitz Wilkins creates a narrative universe with a missing center. The figure of Andre serves as the thread uniting the three works, but he remains insistently out of frame. We hear of his exploits only as they are recounted by others: his work as a hulking bodyguard, his love of video technologies, his murder of a rich girl, his flight from prison. Kienitz Wilkins has said that the inspiration for this elusive figure came to him in a dream, making it fitting that Andre escapes embodiment, forever remaining an amorphous projection amenable to whatever shaggy-dog turn the story will take.

For Kienitz Wilkins, what is told is inseparable from the telling. It is a concern that extends beyond the trilogy to more recent films, such as his jury duty–inspired *Mediums* and layered digital feature *Common Carrier* (both 2017). Text is spoken in a manner that invokes the antecedent presence of the words on the page—these are voices reading prose written to sound like speech. The trilogy's titles—*Special Features* (2014), *TESTER* (2015), and *B-ROLL with Andre* (2015)—explicitly invoke the vocabulary of film production. Narrators often discuss shifting video technologies and the variability of image definition, issues that the works confront formally in their use of multiple formats. This reflexivity exists alongside intersecting considerations of race and class within a strip-mall imaginary of Panera Bread, the 2014 Hollywood movie *Gone Girl*, and protein shakes. In *TESTER*, Kienitz Wilkins delivers a detective's monologue over a found Beta SP tape in the best hard-boiled

tradition, while *Special Features* and *B-ROLL* are each structured around several first-person testimonies. *Special Features* plays with the dynamics of authenticity and performance in three interviews conducted by an offscreen Kienitz Wilkins. *B-ROLL* opts for obfuscation, disembodying and disguising voices on the soundtrack, while its image track is dominated by a black hoodie, that depersonalizing icon of the murder of young Black men. Echoing David Hammons's 1993 work *In the Hood*, the hoodie seems to cloak no body, no face, just darkness. Here, Andre's invisibility begins to resonate differently and multiply— as an index of pervasive racism, an escape from stereotype, a reclaiming of opacity. Triangulating such concerns with experiments in narration and the world of consumer electronics, Kienitz Wilkins offers a trilogy fit for an era of capture and control.

—EB

Stills from *B-ROLL with Andre*, 2015.
High-definition video, color, sound; 19 min.

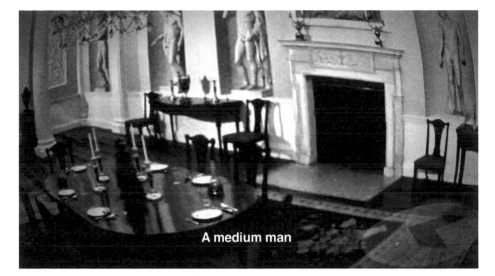

KURIAN, AJAY

Born 1984 in Baltimore, MD;
lives in Brooklyn, NY

In his installations and sculptures, Ajay Kurian employs a range of unusual materials—candy, bodily fluids, e-cigarettes, expanding foam, fluorescent lights—to construct surreal landscapes that examine contemporary civilization through an archaeological lens. For his 2015 exhibition *Work Harder Under Water* at Rowhouse Project in Baltimore, Kurian transformed the entire space—a former home—into a series of abject tableaux that seemed to tap into a dark vein of the American subconscious to expose the insidious effects of racism on everyday life. At the entrance, a kitschy Bombay Company frog butler, remade as a "blackamoor," greeted visitors with its pants around its ankles and a tray of bubbling pink cornstarch surrounded by foliage. On a nearby wall, a smeared screenprint in ghee bore a caricature of the artist made by a high-school classmate in which Kurian is depicted as an ape. In one room, a monitor displayed a video of a Black puppet dressed as a police officer eating its own arm; in another, a rough-hewn metal figure of a male teenager—equipped with a water pump—seemed to urinate into the mouth of another below while a third adolescent watched.

No less unsettling, Kurian's 2016 installation at JOAN in Los Angeles, *Unilateral Educational Disarmament*, took the socialization of children as its central theme, reflecting upon childhood as a time in which the imagination confronts—and is shaped by—dominant cultural norms and the institutions that transmit them. Modeled on an elementary-school gym class, the installation considered the educational system's function as a behavioral "training ground" in which children act out small-scale versions of broader societal dramas. A series of distorted metal figures, each outfitted in the guise of contemporary American kids' clothing—custom T-shirts, baggy shorts, colorful sneakers—hung from climbing ropes above a rubberized floor strewn with glowing casts of deflated, misshapen dodge balls. Titled after a line from *A Nation at Risk*, a seminal 1983 report commissioned during the Reagan administration that described the challenges of public education in the language of military conflict, Kurian's installation positioned the gymnasium as a kind of war zone in which children perform a disturbing array of violent fantasies: one figure raises his foot, about to kick a peer off the rope; another, its face frozen in a menacing smile, points a gun through a hole in its own head, aiming directly at the viewer.

—RW

Installation view of *Unilateral Educational Disarmament*, JOAN, Los Angeles, February 13–March 27, 2016

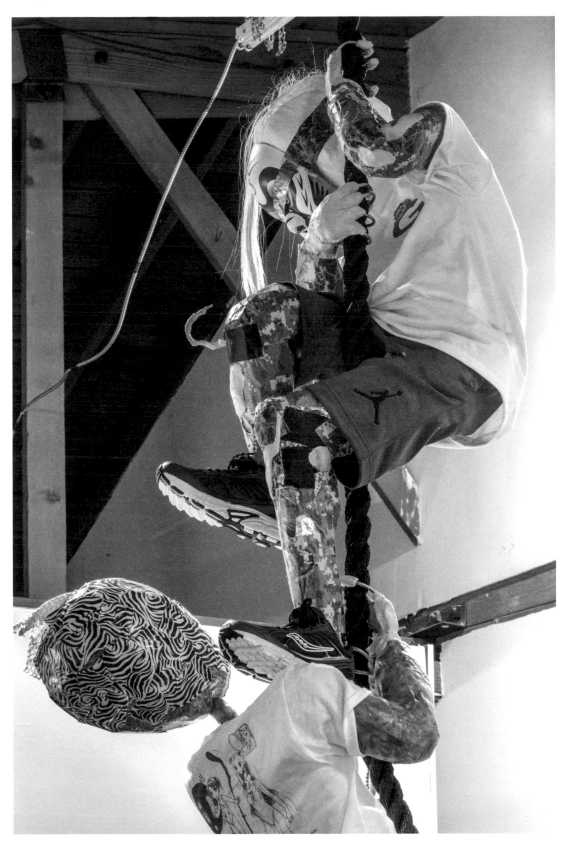

LAWSON, DEANA

Born 1979 in Rochester, NY;
lives in Brooklyn, NY

While sight is the sense usually linked with photography, in Deana Lawson's work, touch, as a means by which intimacy is expressed, plays an equally important role. Lawson's subjects often present themselves in poses of embrace and interconnection—familial, erotic, performative. Her own "touch" is evident throughout her photographs, which are carefully staged, often based on compositional drawings. Lawson frequently works with people she has encountered in her daily life. These images evolve out of a relationship—a reciprocal, even collaborative process of working with her subjects. In this way, the surfaces of her large, lusciously colored prints, which she has imagined as "sweating, like skin," become an intimate interface of connectivity between the viewer and the subject.

Guided by the model of the family album—that careful construction of memory and self-presentation—Lawson has grounded her work and her choice of subjects in her experiences of African American family and community. Lawson envisages her photographs as "visual testimonies" of her subjects' lives. While a sharp eye for the communicative power of pose and gesture generates her photographs' expressive punch, she is also closely attuned to material culture and domestic space as a means of representing Black aesthetics. This attention to the visual and material textures of cultural identity extends through Lawson's use of found photographs, which she sometimes enlarges and shows alongside her own. While Lawson follows in the visual tradition of documentary practice, she simultaneously offers resistant counterimages to the ethnographic and colonial violence that photographers have enacted on Black bodies. For an ongoing series begun in 2013, Lawson travels to sites along transatlantic slave-trade routes, including New Orleans, Haiti, and the Democratic Republic of the Congo, to produce linked images of diasporic Black cultures. Her subjects may be separated geographically, but, through her work, they come together, almost close enough to touch, building what she calls a "mythological sense of family."

—NR

The Key, 2016. Digital photograph, dimensions variable

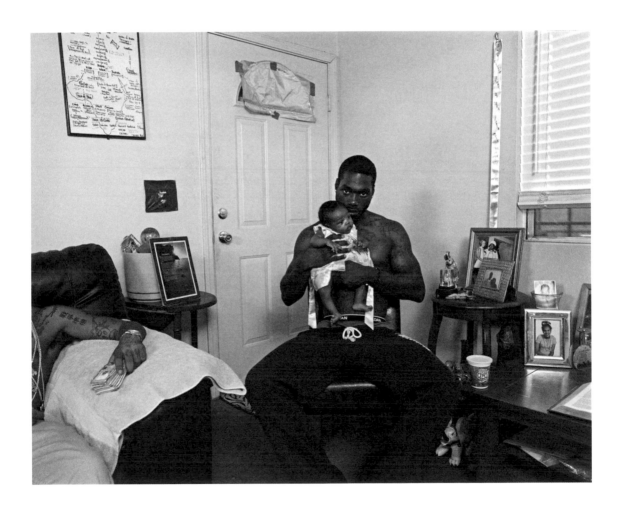

LÊ, AN-MY

Born 1960 in Saigon, Vietnam;
lives in Brooklyn, NY

An-My Lê's photographic practice skirts along the edges of war without directly involving front-line combat. A self-described landscape photographer, Lê finds history and historical memory in the ground beneath her feet. Born in Saigon in 1960, she witnessed firsthand the violence that divided Vietnam; she immigrated to the United States as a political refugee in 1975. In her early series *Small Wars* (1999–2000), Lê photographed reenactments of the Vietnam War in the forests of Virginia and North Carolina. For her next project, *29 Palms* (2003–04), the artist immersed herself in a U.S. Marine Corps training site in California's Mojave Desert, where recruits practice before being sent to Afghanistan and Iraq. The black-and-white prints in these two series are deliberately composed, molding the forest and flatlands into mise-en-scènes. The formalism of Lê's compositions in many ways results from her choice of technology: she uses a 5-by-7 view camera to produce detailed negatives through long exposures. While *Small Wars* depicts the theatrical afterlife of war, *29 Palms* shows the elaborate staging involved beforehand.

For nine years beginning in 2005, the artist traveled around the world with the U.S. Navy on mostly noncombat missions, resulting in her photographic book *Events Ashore* (2014), published by Aperture. In 2013, she installed fifty-two photographs in the U.S. Coast Guard's new headquarters in Washington, DC, her first commission, after traveling to various Coast Guard stations and training centers. Lê's work about living with the individuals who compose the armed forces—within their structures and infrastructures—is intentionally ambiguous. She refuses to condone or condemn the military, in particular the people who fight as its members.

The Silent General, Lê's new series for the Whitney Biennial, filters rehearsal and reenactment through the lens of cinema, moving from the film set for a Civil War–era movie to various monuments of Confederate generals in New Orleans. One photograph shows two Iraq War veterans taking on the roles of Confederate soldiers in the Civil War, wearing makeup intended to amplify their existing wounds; behind them we can glimpse cranes, ladders, and other filmmaking equipment. In *The Silent General*, Lê captures sets as artfully arranged as many early photographs of Civil War battlefields, reminding us of the fictions nestled in war's documentation.

—CI

Film Set ("Free State of Jones"), Maroon, Chicot State Park, Louisiana, 2015. Inkjet print, 40 × 56½ in. (101.6 × 143.5 cm)

Film Set ("Free State of Jones"), Battle of Corinth, Bush, Louisiana, 2015. Inkjet print, 40 × 56½ in. (101.6 × 143.5 cm)

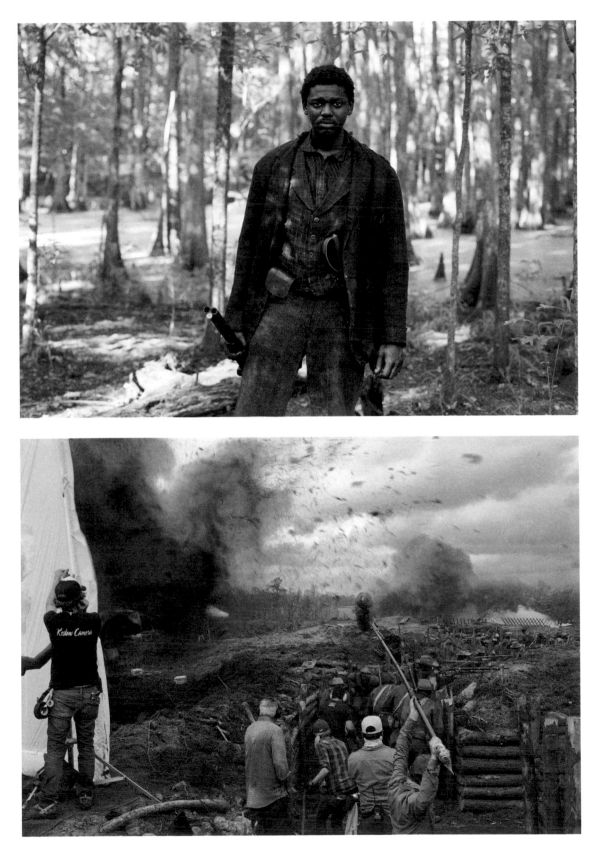

LEDARE, LEIGH

Born 1976 in Seattle, WA;
lives in New York, NY

Leigh Ledare's work—which takes the form of photography, film, performance, text, and archival installations—explores sexuality, subjectivity, and the network of relationships between artist, subject, and viewer. In *Pretend You're Actually Alive* (2008), photographs of the artist's mother, Tina Peterson, a former ballerina turned exotic dancer, are displayed alongside ephemera from her life, constructing a complex archive representing her various social positions—mother, daughter, aging woman, sexual subject—that otherwise might seem irreconcilable. At the same time, the project registers Peterson's shared authorial agency and attempts at self-definition, what Ledare describes as the subject "weaponizing" the artist for other ends.

Similarly, in the series *Personal Commissions* (2008), Ledare serves as a blank canvas onto which expectation and desire are projected. The artist responded to personal ads placed by women—"surrogates" for his mother, who herself had sought out sexual partners in local newspapers—and asked them to pose and photograph him in their homes according to what they assumed to be his fantasies and preferences. For the series *Double Bind* (2010), Ledare invited his ex-wife, Meghan Ledare-Fedderly, to a remote cabin to participate in two intense photo sessions. For the first, Ledare photographed her over the course of several days; for the second, as an intentionally strange revisiting, Ledare-Fedderly returned to the same location to be photographed by her new husband, Adam Fedderly. Ledare arranged the resulting photographs into a series of diptychs that paired images from the two

sessions, creating a comparative structure that emphasizes the degree to which the photographs were affected by the different relationships underpinning them, only to expand that structure through the inclusion of collaged elements appropriated from porn and mass media, a strategy that implicates the viewer's biases and projections as well.

For his film *Vokzal* (2016), Ledare shot footage of the area connecting three Moscow train stations, examining the charged interpersonal dynamics inherent within public spaces shared by diverse social groups. As the artist describes, the film "foregrounds the projective processes undertaken by individuals passing through, working in, loitering around, or policing this public zone," as each person attempts to negotiate his or her relationship to the space and its inhabitants.

—RW

Still from *Vokzal*, 2016. 16mm film, color, sound; 58 min.

LEVENTHAL, DANI

Born 1972 in Columbus, OH;
lives in Columbus, OH

Dani Leventhal describes the creation of her moving-image works as a process of "accumulation and excision." In videos such as *Sister City* and its companion piece *Platonic* (both 2013), Leventhal collects and chisels moments, stories, and images, placing them within loose constellations rarely unmarked by the specter of death. Leventhal shoots her own footage, often involving individuals who are close to her, but treats the resulting images almost as a bank of found material to be manipulated and recontextualized through montage. Her cutting is intuitive, not systematic. Micronarratives of birth, aging, awkwardness, and pain gradually take shape without ever fully congealing, as Leventhal allows her images to breathe even as she transforms their tenor through assemblage. The textures of the everyday are refracted through an intimate sensibility that dwells in the vulnerability of our fleshy bodies, our need for care and communion—and our cruelty.

Leventhal frequently turns to animals—dead and living, domesticated and wild—as part of her exploration of how bodies, of whatever species, inhabit the world. She pays no mind to traditional hierarchies, allowing not just horses and cats into her bestiary but roadkill and anemones, too. A similarly egalitarian ethos pervades her organization of the many fragments she brings together in these lo-fi, diaristic works. The utterly commonplace might stand next to a fleeting moment of beauty or a recounted episode of brutality—all are accorded equal status under Leventhal's gaze. The fragile bodies and relationships between people that appear on-screen find themselves redoubled by the delicacy of the accords between Leventhal's images and sounds: a snake fiercely devouring a mouse cuts to a child in a superhero costume; a luminous jellyfish is accompanied by asynchronous sound, in which a woman asks incredulously, "How can someone say there's no God?" In other hands, the combination of radically heterogeneous materials can figure as a violent leveling of specificity. Leventhal, however, brings a tremendous sensitivity to the unlikely connections she forges, creating force fields of affinity and difference that extend across human, animal, and environment.

—EB

Stills from *Strangely Ordinary This Devotion*, co-directed with Sheilah Wilson, 2017. High-definition video, color, sound (work in progress)

MADANI, TALA

Born 1981 in Tehran, Iran;
lives in Los Angeles, CA

Tala Madani injects her lyrical figuration with
unsettling themes that confront the radical
dimensions to which desire and shame condition
human behavior. The majority of Madani's paint-
ings, drawings, and animations revolve around an
abject scenario that features one or more of her
hallmark characters: bald, portly, middle-aged
men clothed in varying degrees. In the painting
Ding, Boom! (2012), one of these men, wearing
only his underwear, appears nine times in succes-
sive phases of blowing a mucus bubble and then
climbing inside it to assume a fetal position. This
allegory of a grown man's self-imposed return to
his mother's womb evinces the artist's flair for
innovating regressive rituals in a world of men
without women.

Bodily fluids again run amok in the animation
Music Man (2009), in which a towering, brawny
man forces his meek counterpart to vomit bile
onto a blank musical score and, once satisfied
with the splattered notations, stuffs his compan-
ion into his boxer briefs to simulate an erect
penis. Madani's distinct approach to anima-
tion allows this perverse scene of fraternal bond-
ing to retain the apropos fluidity and disorder of
her paintings: the approximately minute-long
video comprises more than 2,500 still images,
each hand-painted with loose and expressive
brushstrokes on wood, captured on camera,
and then wiped away to prepare for the next
image. Departing from this masculine universe
of cultish sadomasochism, *Abstract Pussy* (2013)
depicts a silhouetted phalanx of miniaturized
explorers creeping toward the exposed crotch
of a seated young girl; the lead creeper holds

up a pole bearing a Kandinsky-esque painting
and points toward the girl's genitalia as if to
intimate its shared illegibility with the abstract
design, a playfulness that belies the work's trans-
gressive approach to issues such as childhood
sexuality and pedophilia that are often too taboo
to explore artistically.

For her first solo museum exhibition in the
United States, at the MIT List Visual Arts Center
in 2016, Madani exhibited the entirety of *Smiley
Has No Nose*, a body of work that displaces the
smiley face from its now-ubiquitous technologi-
cal screen presence and maps it onto and around
actual bodies to experiment with its power and
properties as an icon. In *Projections* (2015), a
seated group of dejected gray men are spotlit by
three overhead projectors that cast neon smiley
faces onto their naked bodies. Madani converts
the religious symbolism of being bathed in light,
awakening her figures not to the enlightenment
of God but instead to the sterile shorthand of
contemporary communication: the emoticon.

—EC

Shitty Disco, 2016. Oil on linen, 55 × 44 in.
(140 × 112 cm)

McARTHUR, PARK

Born 1984 in Raleigh, NC;
lives in New York, NY

For several years, Park McArthur has engaged
a primarily sculptural way of making art that
includes municipal parking signage; large blocks
of polyurethane foam; thick, bed-sized sheets of
paper made with super-absorbent diaper poly-
mer; rubber bumpers installed at loading-dock
height; and latex prophylactics piled inside
stainless-steel containers. Although varying
in material, form, and process, these artworks
simultaneously receive and resist their surround-
ings—a quality McArthur thinks of as absorption
that connects to the lived conditions of access
and accommodation. These conditions also
inform other works composed of personally and
socially inflected items, such as pajama pants,
portable ramps, and a personal computer.

For the work included in the 2017 Whitney
Biennial, McArthur considers again the form and
design of signage. Previously, in *Private Signs*
(2014) and *Liabilities* (2015), the artist re-created
the shapes of restricted parking signs without
their directive text, as flat fields of color. At the
Whitney, highway signage is rendered in the
single hue used to indicate sites of historical
significance or natural phenomena in order to
ask after the literal grounds upon which commem-
oration and official designation are performed.

—PM

Detail of *Às vezes você é ambxs/Sometimes You're Both*,
2016. Twenty-five plinths (stainless steel and latex rubber),
34 × 19 × 33 in. (86.4 × 48.3 × 83.8 cm) each. Installation
view: *Incerteza viva: 32ª Bienal de São Paulo*, September 7–
December 11, 2016

MENDEZ, HAROLD

Born 1977 in Chicago, IL;
lives in Chicago, IL, and Los Angeles, CA

Memory, Harold Mendez reminds us, is an accretion of matter. Mendez unearths and transforms materials that bear traces of the past as he works to show how the construction of history is complex and contested. His work insists on the materiality of archives, whether personal or collective, and on visibility's inherent complications. "With regards to violent and traumatic histories," Mendez has written, the conditions of their visibility are "veiled," mediated by a series of screens and layers of in- or under-visibility. "How can we render what's invisible or make a case for its impermanence to be permanent (even if it's only in thought or memory)?"

In works shown in 2015 at the Institute of Contemporary Art in Philadelphia, Mendez drew from archives in Medellín, Colombia, related to that country's histories of violence and civil war. The artist selected images that allude to the difficulties inherent in representation, such as a photograph of a mirror with an empty reflection; printed these images on paper; and affixed the sheets with gel medium to a metal plate. He then washed, scrubbed, and scraped away the paper to leave traces of the image adhering to the metal, in a labor-intensive process he likens to archaeology. Mendez makes frequent use of natural pigments, such as cochineal, a carmine dye made from insects native to South and Central America, suggesting how the traces of life and landscapes, of animal and vegetal matter, persist in the materials of visibility.

Writing about Mendez's work, the poet and critic Fred Moten asks: "What if we could detach repair not only from restoration but also from the very idea of the original? . . . Then, making and repair are inseparable, devoted to one another, suspended between mend and edge." Seen this way, Mendez's objects suggest the need to return to history, to engage in the work of reparation and suture, while at the same time revealing their own seams and abandoning the notion that there is a "true" history to be recovered. Focusing instead on the materials and acts of revision that make such labor possible, Mendez's recent sculptures employ standardized materials of construction, such as concrete or prefabricated metal units, and recast them as sites of mysterious signification. In one work, *but I sound better since you cut my throat* (2016), a found metal pole leans against the gallery wall with a fragment of a tree trunk that grew around it hanging from its middle, the trace of a strange attachment between the natural and man-made. In another, *American Pictures* (2016), an altarlike assemblage becomes a space for the ritualistic scattering of carnation petals. Rather than closing the loop of signification, Mendez's work leaves his objects' meanings indefinite, suspended in a history that continues to unfold.

—NR

but I sound better since you cut my throat, 2016.
Reclaimed galvanized steel, wood, and chain-link
fence, approx. 180 in. (457.2 cm) long

MOYER, CARRIE

Born 1960 in Detroit, MI;
lives in Brooklyn, NY

Carrie Moyer's paintings revisit the history of modernist abstraction, combining elements of Surrealism, hard-edge, and Color Field painting with the immediacy of agitprop and graphic design. Working with acrylic paint, which Moyer embraces both for its material versatility and its popular connotations, the artist explores the full range of possibilities inherent to the medium, juxtaposing thin, luminous veils of poured paint in vivid hues, often mixed with glitter, alongside precisely outlined areas of flat, opaque color.

In the early 1990s, Moyer channeled her artistic training and design background into queer and feminist activism, cofounding the public art group Dyke Action Machine! with photographer Sue Schaffner. Informed by her research into the history of propaganda and protest imagery, Moyer's paintings of the late '90s and early 2000s often incorporate fragments of political iconography into otherwise abstract canvases: *Meat Cloud* (2001), for instance, features the silhouetted heads of Marx, Lenin, and Mao hovering over a pale pink ground that merges with amorphous pools and drips of red and orange.

In Moyer's work of the past decade, overtly political images have given way to a broader range of forms and influences, including the abstracted anthropomorphic figures of prehistoric and archaic art, the "central core" imagery of the feminist art movement of the 1970s, and the poured and stained canvases of Helen Frankenthaler. However, Moyer's design work remains integral to her approach to composition: the artist typically begins work on a painting by creating small

collages from cut paper in lieu of conventional preparatory sketches, using the bold, graphic shapes derived from the collages as a scaffolding for areas of watery poured acrylic.

The paintings in Moyer's most recent series, *Sirens*, play with variations in color saturation and surface texture to create a sense of ambiguous spatial depth, heightened by the artist's use of abstract forms loosely suggestive of architecture and landscape. In *Sala de Dos Hermanas* (2015) and *Belvedere* (2016), Moyer frames the radiant poured passages with austere archways, rendered with matte Flashe pigment. *Intergalactic Emoji Factory* (2016) features a rainbow gradient bursting from a glittery band of black, equal parts comic and ethereal, while *In a Cool Blaze* (2015) sets a fiery burst of orange and yellow against a field of icy blue.

—RW

In a Cool Blaze, 2015. Acrylic and glitter on canvas, 72 × 96 in. (182.9 × 243.8 cm)

Intergalactic Emoji Factory, 2016. Acrylic and glitter on canvas, 72 × 96 in. (182.9 × 243.8 cm)

MÜLLER, ULRIKE

Born 1971 in Brixlegg, Austria;
lives in Brooklyn, NY

Ulrike Müller's most recent series of abstract paintings, *Others* (2015), deftly assails modernist precedents: a lurid figuration arises from the meticulously crafted compositions of geometric forms, suggesting that libidinal forces have perhaps always been present, albeit marginalized, in the history of modernism. The portrait-sized, enamel-on-steel paintings recall historical episodes when artists such as Marcel Broodthaers and László Moholy-Nagy embraced this technique for its industrial origins in sign making, hiring fabricators to create works that ultimately critiqued commodity production; Müller, however, takes another tack, honing her enamel works step by step in her studio, thereby emphasizing the technique's handicraft possibilities. Combined with the artist's seductive palette, the enamel's lustrous surface softens the hard-edged contours of her geometric shapes, twisting masculine paradigms of modernist abstraction with craft-based sensuality, in a manner similar as well to the artist's woven rugs. In *Rug (gato de cochinilla)* (2015), for example, a field of abstract forms frames the face of a black cat, cross-pollinating the masculine cliché of schematic design and painting (the artist might hang the rug on a wall to induce such an association) with the stereotyped feminine sentiments accompanying domestic animals and weaving.

A similar sense of fostering a polymorphic notion of identity that departs from essentialist models informs Müller's collective practice as well. After locating an inventory list describing a collection of feminist T-shirts from the 1970s onward at Brooklyn's Lesbian Herstory Archives, Müller distributed descriptions of individual shirts to a hundred fellow artists, inviting them to interpret the words in their own work, such as one description that read: "A graphic of the island of Lesbos with icons depicting different sites and tourist activities." The resulting collaboration, *Herstory Inventory* (2012), revisits the history of feminist iconography, yet it refutes any mandate for a cohesive aesthetic, encompassing a range of diversified lesbian and queer imagery that includes responses to the ACT UP logo, S&M graphics, and stereotypically girly illustrations abounding in rainbows and flowers.

Müller's belief in the generative capacity of collaborative production stems from her involvement, beginning in 2005, in the feminist, gender-queer New York–based art collective LTTR. In addition to sponsoring performances and events, LTTR published journals that included artworks, images, and texts in an irreverent manner reminiscent of early 1990s Riot Grrrl zines, enacting a self-described "purposeful critical promiscuity" that might well be said to also apply across Müller's individual work.

—EC

Installation view of *Ulrike Müller: The old expressions are with us always and there are always others*, Museum moderner Kunst Stiftung Ludwig Wien, Vienna, October 10, 2015–January 31, 2016

NGUYEN, JULIEN

Born 1990 in Washington, DC;
lives in Los Angeles, CA

In the worlds of Julien Nguyen's paintings, frames and bodies compel each other in an uncanny symbiosis. Frames made from metal, concrete, or fabric are often fitted around Nguyen's canvases, but these only signal the significance of frames as omnipresent devices of conceptual inquiry within the picture plane itself, where they manifest as borders and architectural structures that organize and confine bodies or body parts. This recurrent trope of spatially directed spectatorship prompts a slippage between the frame as object and the figure as subject, and it simultaneously asks the viewer to consider the framing structures that populate art history and our present-day reality, as these can be symptomatic of the invisible ideologies that frame, or enforce, particular ways of seeing and experiencing the world. Nguyen's protagonists themselves often strive to negotiate forms of subjectivity within shifting social and political structures, as in *I know why the caged bird sssings* (2016), where the youthful nubility of framed male figures clashes with the performative nobility of their "grown-up" counterparts in uniform.

Blending references to numerous historical periods with allusions to contemporary media culture, Nguyen's work observes ways in which visual articulations of power and resistance have evolved across centuries, from the grandiose decorative flourishes of imperial Byzantium to the paradigmatic construction of rational perspective from the Renaissance, which collides with the stylized artifice and lack of clear focal points favored by French Mannerists. Simultaneously, Nguyen examines the aestheticized personas of current figures such as Congresswoman Nancy Pelosi and filmmaker Kathryn Bigelow, both of whom appear mighty but melancholic, their work at once critical of and participatory in the violence perpetuated by the culture to which they contribute. Nguyen's work throws into relief the biopolitical consequences of Americans' eagerness to intertwine entertainment and governance: too often, the systemic nature of disenfranchisement is overshadowed. The artist's use of multiple materials and collage techniques reflects the ways in which the language of media and politics pervades our everyday lives. This language often works to uphold stereotypical forms of identity based on biological and social categories, which his figures' gender ambiguity and euphoric displays of homoeroticism actively resist.

In several works, phantasmagoric, hybrid creatures pose as classical statuary against monochromatic grounds. Like exquisite corpses absurdly suspended in temporal limbo, they ultimately adhere to no particular era or style. Instead, they evoke the combinatory nature of Nguyen's reference points, which continually relate to the ways in which power circulates through the visual culture of our globalized present.

—JD

Homework, 2016. Oil on panel with concrete frame, 30 × 40 in. (76.2 × 101.6 cm)

NGUYEN, TUAN ANDREW

Born 1976 in Saigon, Vietnam;
lives in Ho Chi Minh City, Vietnam

In 1978, Tuan Andrew Nguyen's family was among the tide of "boat people," as they became known, who fled Vietnam in the 1970s and '80s, often by way of perilous ocean voyages across the South China Sea. While Nguyen himself immigrated to the United States, his current video is set on Pulau Bidong, a tiny Malaysian island that served as home to tens of thousands of displaced Vietnamese until 1991, when the United Nations High Commissioner for Refugees forcibly repatriated the inhabitants who still remained. Today, the island has returned to a picturesque natural state, but reminders of its tumultuous past persist in the form of gravestones, memorials, and statues constructed by its refugee population.

In Nguyen's video, this complex history serves as inspiration for an abstract narrative featuring an unnamed man and woman set in a dystopian future. The man has lived alone on the island for decades, having escaped the 1991 repatriation by hiding; the woman, a naval officer, washes ashore in a flotation device after witnessing a nuclear explosion. The music that accompanies is a remix of "Biển Nhớ" ("The Sea Remembers"), a song originally written by the famous Vietnamese composer and pacifist Trịnh Công Sơn, which was played for refugees when they arrived at or left Pulau Bidong. Along with the crumbling monuments that dot the island's undergrowth, the song's refrain of *ngày mai em đi* ("tomorrow you depart") haunts the story as a reminder of the plight of the island's historical inhabitants. Nguyen's video weaves these imaginary and historical elements together to create a modern-day allegory of displacement and dislocation.

Like much of Nguyen's previous work, both as a solo artist and with The Propeller Group collective, the artist's current video engages with the politics of Vietnam's recent past. Yet rather than take a didactic approach to history, Nguyen draws on the cultural production of individuals and communities, ranging from the informal memorials and rituals of refugees decades ago to the hip-hop and graffiti made by Vietnamese teenagers today. In tracing the legacies of recent events and traumas via their representation, Nguyen's work invites a reassessment of history through the lenses of cultural exchange and the construction of individual identity.

—FJP

Production photograph for ultra-high-definition video, 2017 (work in progress)

DE NIEVES, RAÚL

Born 1983 in Morelia, Mexico;
lives in Brooklyn, NY

On the evening of November 11, 2014, the sold-out premiere of *The Fool*, a four-act opera, took place in the imposing interior of ISSUE Project Room in downtown Brooklyn. With its vaulted ceilings, the space supplied ample acoustics for a string ensemble and chorus of voices that accompanied five characters, two of whom were played by the opera's originators, artist Raúl de Nieves and musician Colin Self. The actors wore colorful costumes and navigated a set anchored by two bedazzled panels. The mise-en-scène bore the signature marks of de Nieves, in particular the sculptural shoes and handmade garments that make frequent appearances in his performances with the art-rock band Haribo. *The Fool* brought together the artist's interest in cycles and spectacles of sound, storytelling, apparel, and nature.

About a month after the opera's debut, de Nieves's shoes appeared again at ISSUE, where the lobby had been transformed into a pop-up shoe store, which subsequently served as a stage for a one-night audio installation. Although viewers could try on the footwear—used shoes painstakingly encased in tiny plastic beads—these goods appeared less functional than fanciful. Exuberantly sprouting vinelike tendrils but also heavy with plastic and glue, de Nieves's shoes insist upon the simultaneity of the natural and artificial, the organic and ornamental. At once ready-made and handmade, these sculptures require an immense amount of labor, reflecting the artist's commitment to craftsmanship and the manual modes of making that he witnessed as a child growing up in Mexico.

Featured in fashion magazines and art galleries alike, de Nieves's footwear flirts with cycles of consumption and the desire for fetish objects. His 2016 exhibition *El Rio*, at Company Gallery in New York, explored life-and-death cycles through iconographies of religion, fashion, and nature. Viewers navigated a hallucinatory landscape populated by saintlike figures in robes, taxidermy birds speckled with pearls, paintings depicting Saint George defeating the dragon, faux stained-glass windows, and biomorphic forms emerging like monsters from the ground. Part church, part nightclub, part tomb, the exhibition refracted the modes and materials of de Nieves's roving practice, and danced around our desire to arrest death by petrifying life.

—CI

Somos Monstros, 2016. Cloth patches,
fabric, and mannequin, 79 × 26½ × 18½ in.
(200.7 × 67.3 × 47 cm)

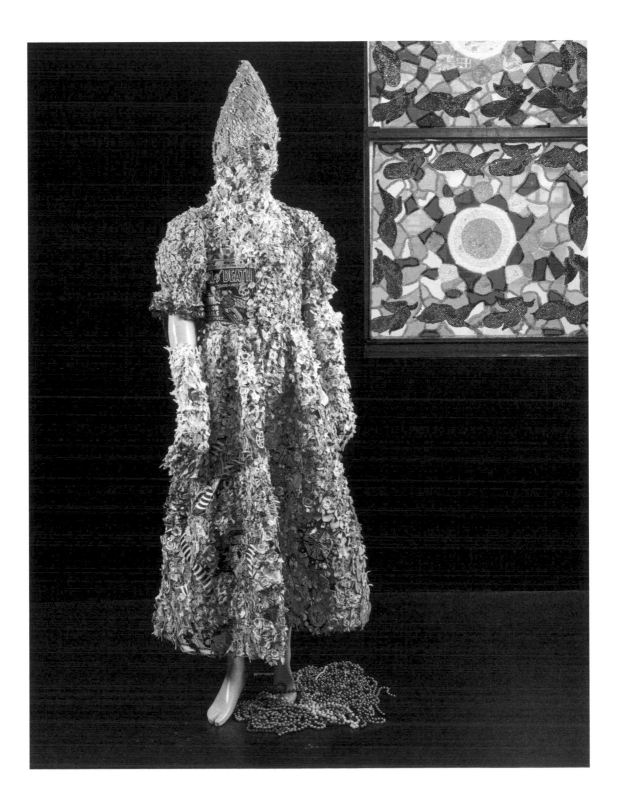

NISENBAUM, ALIZA

Born 1977 in Mexico City, Mexico;
lives in Brooklyn, NY

Aliza Nisenbaum's subjects have a palpable presence in her paintings, which she always composes from life. Her work's resounding relationality arises directly out of the fundamental openness with which she approaches the medium. Engaging a radical politics of care, Nisenbaum's practice converges acts of attentive viewing with what she calls "political witnessing" of individuals, most of whom are undocumented immigrants who have oriented themselves to new, often socially inconspicuous lives. Nisenbaum met many of her portrait subjects as she taught art classes at Cuban-born artist Tania Bruguera's Immigrant Movement International, a community space in Flushing, Queens, and she developed close friendships with several of them. With its insistence on the mutual sharing of both physical and affective presence, Nisenbaum's portraiture issues a call to examine the civil capabilities of painting when one's visibility is at stake, not only in the realm of day-to-day social interactions but in the bureaucratic eyes of the state. By situating invested attention, shared experiences, and close relationships at the foundation of her project, the artist creates representations that transcend any political rhetoric that generalizes or depersonalizes immigrants' experiences.

MOIA's NYC Women's Cabinet (2016) extends the reaches of Nisenbaum's engagement with issues of political visibility. Each of the women depicted, all immigrants themselves, were chosen in 2015 to work with the Mayor's Office of Immigrant Affairs as Women Leader Fellows based on their demonstrated commitment to advancing the status of immigrant women and girls (the group included

Nisenbaum). Through painting their portrait, the artist insists on the importance of making visible women who occupy what are often relatively invisible positions of administrative influence.

Nisenbaum's still lifes, particularly the series illustrating handwritten correspondence between her and a close relative serving time in a correctional facility, offer yet another challenge to the conditions created by structural regulation of human visibility. By representing a form of communication that strongly evokes an investment of time and the intimacy of touch, the artist makes tangible her relationship with her correspondent, an individual otherwise sustaining extreme circumscription in relation to the public realm. Nisenbaum's meaningful bonds to her subjects resonate throughout her canvases, linking her personal investments in the people themselves to the materiality of her finished works. Her deliberate, weighty brushstrokes and focused blending of tones become painted indexes for the attention, communication, and absorption that foster her process. Her practice thus becomes a form of resistance to systemic constraints endured by those less visible.

—JD

MOIA's NYC Women's Cabinet, 2016.
Oil on linen, 68 × 85 in. (172.7 × 215.9 cm)

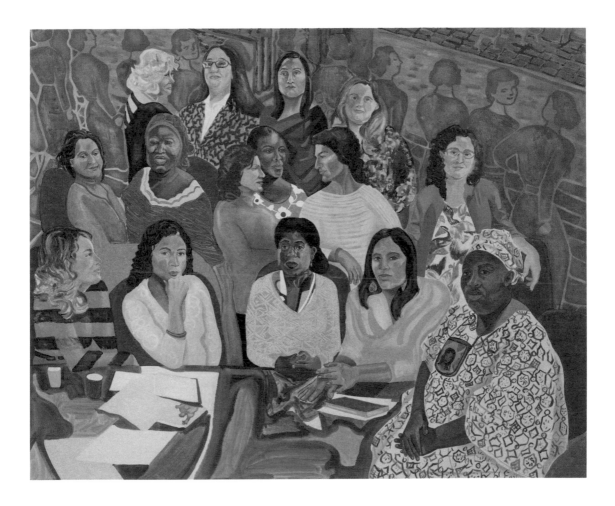

OCCUPY MUSEUMS

Founded 2011

Emerging out of Occupy Wall Street in 2011, Occupy Museums is a largely New York–based group—consisting of Arthur Polendo, Imani Jacqueline Brown, Kenneth Pietrobono, Noah Fischer, and Tal Beery—that focuses scrutiny on the relationship between art institutions and neoliberal capitalism. Through protest actions, conferences, communiqués, and creative projects that imagine a more equitable art world, they make visible how museums and art fairs are privileging profits over people. Occupy Museums draws attention to how today's art world echoes the economy at large: wealth is concentrated in the hands of a tiny minority while the vast majority of artists are consigned to lives of perpetual precariousness.

In 2013, the group and collaborators launched *Debtfair*, a "series of experimental market-actions" to highlight—and potentially redress—the crippling debt many artists are incurring. A platform for artists to share personal accounts alongside their artwork, *Debtfair* addresses the reality that artists are frequently assuming "extreme risk individually"; for example, leveraging their educations with scant chance of economic reward in an oversaturated, exclusionary system. *Debtfair* counters the anonymity of statistics by creating a market that reflects "the fluctuating relationships of artists' time, development, creative production, exploration, community, and sustainability under increasing financial burdens."

In collaboration with Art League Houston, Occupy Museums mounted a *Debtfair* exhibition in 2015, cutting out sections of wall to display works by local artists-in-debt between the exposed studs. Artists were packaged in "bundles"—filtered by categories including type of debt, lending institution, or details shared (such as mentioning "fear" or "anxiety" in describing debt)—that could be purchased for the cost of the artists' monthly loan payments with interest accrued according to rates designed to reiterate debt's extractive reality. *Stress, Fear and Anxiety Bundle* (2015) was priced at $9,550.54 to include "an additional 13% daily compounded interest increase for 11 days, reflecting the percentage of Americans on antidepressants recorded in 2012 . . . sales to be split among bundled artists via direct payment to their respective lending institution." In revealing the social and economic infrastructures suppressed by the white-cube gallery space, the installation recalled the interventions of institutional critique–oriented Conceptual art, for example Lawrence Weiner's *A 36" X 36" REMOVAL TO THE LATHING OR SUPPORT WALL OF PLASTER OR WALLBOARD FROM A WALL* (1968). *Debtfair* continues this tradition of drawing attention to the material and human substratum of the art world yet innovates new forms of critique that respond to the "speculative" capitalism of today.

—ND

Final Notice: Debtfair Manifesto, 2016/2017.
Digital photocollage, dimensions variable

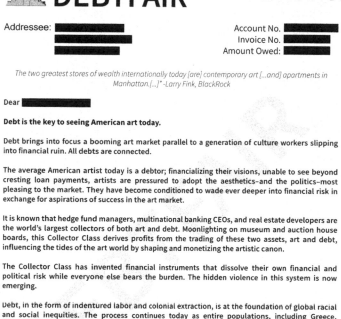

🏛 DEBTFAIR　FINAL NOTICE

CHASE
JPMORGAN CHA
TENANT LEASE
PO BOX 659749
SAN ANTONIO.

Addressee: ▇▇▇▇▇
▇▇▇▇▇▇▇
▇▇▇▇▇

Account No. ▇▇▇▇
Invoice No. ▇▇▇
Amount Owed: ▇▇▇

The two greatest stores of wealth internationally today [are] contemporary art [...and] apartments in Manhattan.[...]" -Larry Fink, BlackRock

Dear ▇▇▇▇▇▇

Debt is the key to seeing American art today.

Debt brings into focus a booming art market parallel to a generation of culture workers slipping into financial ruin. All debts are connected.

The average American artist today is a debtor; financializing their visions, unable to see beyond cresting loan payments, artists are pressured to adopt the aesthetics–and the politics–most pleasing to the market. They have become conditioned to wade ever deeper into financial risk in exchange for aspirations of success in the art market.

It is known that hedge fund managers, multinational banking CEOs, and real estate developers are the world's largest collectors of both art and debt. Moonlighting on museum and auction house boards, this Collector Class derives profits from the trading of these two assets, art and debt, influencing the tides of the art world by shaping and monetizing the artistic canon.

The Collector Class has invented financial instruments that dissolve their own financial and political risk while everyone else bears the burden. The hidden violence in this system is now emerging.

Debt, in the form of indentured labor and colonial extraction, is at the foundation of global racial and social inequities. The process continues today as entire populations, including Greece, Argentina, and Puerto Rico, are forced to sell off their futures to vulture fund partners at 1000% return on investment. The Collector Class extracts value and reaps returns from securitized public resources, education debts, credit card debts, municipal debts and mortgage debts. All over the world, people have become debtors before citizens. Debtors before artists. Debtors before people. We believe that this world will not find balance until reparations are paid.

While elites join debts together into bundles to securitize profits, debtors see themselves as increasingly isolated, lost in one-sided financial precarity. And yet, unexpectedly, there lies before us an opportunity to locate ourselves in this global struggle. We are united in seeking economic justice and building a culture industry that works for us and our communities, not against us. And we are also united because all of our debts are connected. The time is now for we debtors to leverage our collective power.

WWW.DEBTFAIR.ORG

UNTS¨
E
R!

.. up to 20%
old)

.. up to 10%
nters)

.. up to 10%
at-fault accidents

.. up to 25%

may be
FOR INQUIRY CAL!　personalized attention you deserve.
Call me today at (718) 899-8985 or stop by my office to start saving now.　RENTERS

☒☒ ☒ ☒☒ ☒ ☒☒ ☒☒☒ ☒ ☒☒ ☒ ☒☒☒☒ ☒ ⬯○ ○○ ○○○○○○○

POPE.L aka WILLIAM POPE.L

Born 1955 in Newark, NJ;
lives in Chicago, IL

Working across mediums and with inveterate irreverence, Pope.L aka William Pope.L unabashedly tackles hot-button issues endemic to America, provoking scrutiny of how language, nationality, class, and race signify as well as conflict with notions of the individual and the collective. In the endurance-based tributary of his practice—a kind of Body art and Conceptual street performance of the type associated as well with artists such as Chris Burden, Vito Acconci, and Adrian Piper—Pope.L has devoted himself to, in his own words, "perform social struggle." Initiated in 1978 and with more than forty performances to date, his legendary *Crawl* pieces entail the artist dressing in costume, such as a Superman ensemble or business suit, and dragging himself on hands and knees along a city street. These physically and mentally strenuous feats, conceived for group performance but often realized solo, instill viewers with a visceral awareness of the individual body's relationship to its own sense of loss and daily dislocation in the commercial urban environment: the vertical stature and steadfast stride that exist in opposition to the horizontal debilitation and proximity to the ground that most often denote illness, homelessness, and marginalization.

"The body is also a thinking organism," says the artist, whose work excites unexpected sensations such as smell and touch through his selection of tactile and pungent materials like mayonnaise, manure, and peanut butter. For *Claim* (2014), installed at the Institute of Contemporary Art in Philadelphia, Pope.L created a grid of 688 slices of bologna, each slice affixed with a small black-and-white portrait, many blurred to the point of illegibility. Pope.L claimed the number was equal to a proportion of Philadelphia's population of 688,000 Jewish residents, yet demographic data recorded that year tallied the Jewish population at approximately 250,000, proving the artist deliberately distorted statistical fact and, as he ultimately explained, even culled portraits "with no consideration of who might be Jewish and who not." Pope.L's intentional fabrication was, he says, "A blatant challenge to what we call knowledge and how this so-called knowledge is used to construct a picture of certainty via the phantom of accuracy. A picture of certainty is still a representation, and a representation is always a shadow of the thing it claims to portray."

—EC

Claim, 2014. Paint, pencil, sliced bologna, and 688 black-and-white photocopies, 16 × 36 ft. (4.9 × 11 m). Installation view: *Ruffneck Constructivists*, Institute of Contemporary Art, University of Pennsylvania, Philadelphia, February 12–August 17, 2014

POSTCOMMODITY

Founded 2007

The ambitious multimedia projects Postcommodity has produced over the course of the past decade challenge economic and geopolitical processes that, often buttressed by colonial precedents, neglect the experiences of Indigenous peoples. Raven Chacon, Cristóbal Martínez, and Kade L. Twist, the collective's current members, aim to create productive new dialogues in the face of institutional and nationalist practices that prioritize the interests of a globalized market over the self-determination of local communities.

For four days in October 2015, Postcommodity's two-mile-long installation *Repellent Fence* intersected the U.S.–Mexico border near Douglas, Arizona, and Agua Prieta, Sonora. It consisted of twenty-six balloons, each ten feet in diameter, tethered to the ground about four hundred feet apart and floating approximately fifty feet in the air. The artists have referred to the piece as a "suture" joining lands and people across a border that, while intended to demarcate sovereign nations, also artificially divides territory occupied and traversed by generations of Indigenous people. The work's execution was the culmination of eight years of planning and collaboration among many individuals, institutional organizations, local communities, and governments on both sides of the official border. Its discursive structure reflects the border region's role as a locus for a diverse flow of socioeconomic and cultural exchange, a quality often overshadowed by binary political discourse.

A Very Long Line (2016) similarly resists polarizing dialogues by conceptually redefining the space of the border. In each portion of the immersive four-channel video installation, the camera moves laterally, as from the perspective of a passenger in a car whose speed fluctuates rapidly. Shots juxtaposing different types of fence constructions along the border create a viewing experience that constantly vacillates between obstruction and transparency, emphasizing the divisive yet filterlike presence of the barriers. A discordant soundtrack reinforces the installation's sensorial asynchrony, untethering the discontinuous image sequences from any measurable temporality. In the face of political rhetoric that tends to generalize the border as a single entity enmeshed in a set of "known" legal issues, this project imparts spatial, visual, and aural uncertainty, highlighting the fragmented, material precariousness of the border and, in the process, evoking the impact of that precariousness on the lives of surrounding populations. Beyond its status as the site of an ongoing immigration crisis, the border possesses a history inextricably linked to cultural displacement and estrangement. Through historically informed frameworks, Postcommodity's projects underscore the extraordinarily complex, multifaceted range of viewpoints and interchanges among the border region's Indigenous and non-Indigenous residents, both past and present.

—JD

Still from *A Very Long Line*, 2016. Four-channel digital video, color, sound; looped

PUPPIES PUPPIES

Born 1989 in Dallas, TX;
lives in Roswell, NM

In an age of participatory mass surveillance and art-world celebrity, Puppies Puppies is an artist-persona who maintains an anonymous, fluid identity. Puppies makes heavy use of readymades, trolling the pop-culture subconscious, the internet, and the biopolitically manipulated body to devise sculptures, performances, installations, and videos that speak with and against the sterile, grotesque, franchised materiality and iconography of everyday contemporary life.

In Puppies's oeuvre, the artist is sometimes an evil wizard (Lord Voldemort from *Harry Potter* or Sauron from *Lord of the Rings*), a puerile but lovable weirdo (Shrek or SpongeBob SquarePants), a wayward corporate mascot (KFC's Colonel Sanders), or a young pup who pees in the gallery. These mascots seem to function as both personal totems and public allegories—even if the person inhabiting them is not always the same as Puppies's originator, and even as the precise meanings of these allegories within the artist's practice can be nebulous. Scatology is one aspect of Puppies's broad aesthetic lexicon, which connects the individual body to the collective body shaped by fast food, industrial agriculture, and Big Pharma. Corn syrup advertisements, processed-food packaging, morbid cigarette-box warnings, Purell dispensers, Xanax-themed performances, and electronics plugged into raw meat evoke marketized economies of bodily production, control, pleasure, and contamination.

In contrast to the familiar detachment and nudge-nudge-wink-wink nature of much art that features middle-to-low-brow pop imagery and internet-sourced kitsch, Puppies's work feels marked by a peculiar sincerity. The artist's identity may be shrouded, but Puppies draws intimately from the artist's own life and proclivities for materials and content. (A Minion-costumed Puppies even made a marriage proposal to their partner as part of one show.) For Puppies Puppies, it would seem that dark pessimism doesn't diminish real love; that nihilistic gag humor doesn't exclude ambivalence that is raw and open-ended; and that the saturation of life with corporate products doesn't preclude (even as it alters) forms of creative expression, forms that perhaps treat these products as a cultural commons and personal language.

—ND

Liberty (Liberté), 2016, Performance, Galerie Balice Hertling, Paris, July 7, 2016

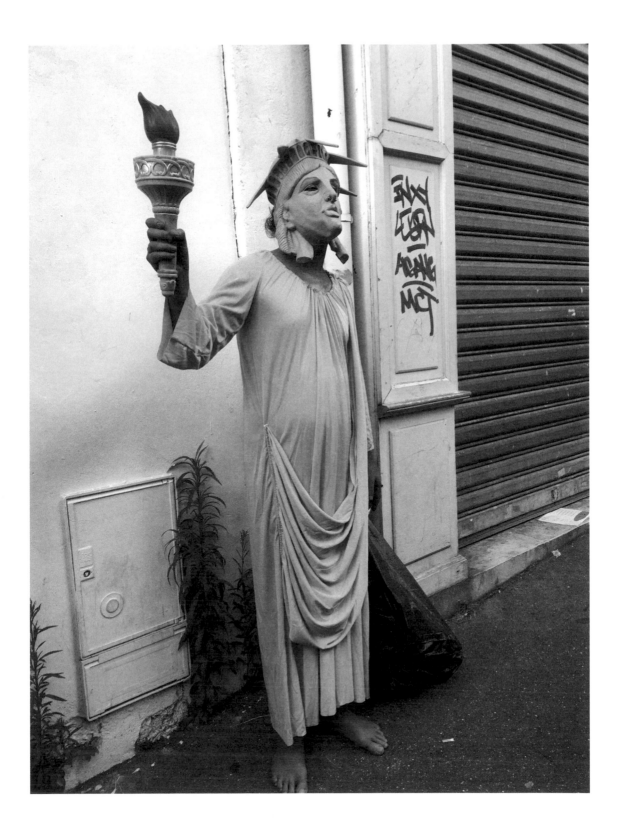

RAZA, ASAD

Born 1974 in Buffalo, NY;
lives in New York, NY

As a producer of exhibitions, Asad Raza has staged complex, interactive works of art by other artists. More recently, Raza has begun to explore this capacity to facilitate encounters between people, objects, and physical space in his own work. For *The Home Show* (2015), for example, he invited artist friends to contribute to an exhibition held in his small one-bedroom apartment in Lower Manhattan. Some provided finished works while others employed Raza's own possessions and daily routines as raw material (creating, for instance, a ritual Raza performed every morning in his bathroom; a still life of groceries in the artist's freezer; a "dream-inducing" toothpaste; ikebana), while Raza himself, rather than remain behind the scenes, served as both tour guide and host. Like the artists with whom he has often collaborated, Raza disrupts the boundaries that have conventionally delineated the artwork, the exhibition, and the artist.

At the Whitney, Raza again explores what he calls "an intersubjective collaboration," but here in relation to the much broader publics of the museum. Within a zone populated with living trees and a collection of objects, most gathered from the everyday lives of a group of New Yorkers who are participating in the work, these "hosts" perform various activities, such as offering food, speaking to visitors, or enacting immaterial artistic structures, thus shifting "between explanatory, performative, and sociable modes of behavior," as Raza explains. In keeping with the artist's interest in oral history and ritual, the work of art emerges collectively and over time, in the form of dialogues elicited by objects and in the shared culture that develops among the participants during the run of the exhibition. Raza's work not only reconfigures the dynamic between viewer and art object but also produces new kinds of social relationships between individuals within the space of the museum.

—FJP

Installation view of *The Home Show*, New York,
November 19–December 20, 2015

REAVES, JESSI

Born 1986 in Portland, OR;
lives in New York, NY

Jessi Reaves makes sculptures that function as furniture: chairs, tables, and sofas that are preposterously assembled from foam, sawdust, plywood, plexiglass, and auto parts—some- times even adorned with sheer fabrics, leather, and glass—and are meant to be used, lived with, and cared for. After receiving her bachelor of fine arts in painting from the Rhode Island School of Design, Reaves worked part-time as an uphol- sterer. "People used to bring me chairs to re-cover that had been sitting in the same place, in the same house, for so long that they had faded based on the relationship to the windows," says the artist. "It was like they had absorbed the architec- ture into their surface, which seems ideal to me."

Inspired by this sense of memory physically mani- fested in such chairs, Reaves pursued what she refers to as "ideological revision": her process of altering furniture to expose the historical ideol- ogy of a particular object, its designer, and the time period in which it was made. For *Maraschino Fairy* (2014), the artist sheathed a Josef Hoffmann cane chair in a translucent pink silk slipcover. Her feminine embellishment gives an erotic charge to the otherwise unadorned and structural char- acter of this Viennese Secessionist chair as well as undermines the machismo that permeates the male-dominated design industry. In 2016, Reaves fabricated variations of Isamu Noguchi's 1948 coffee table by replacing the shaped pieces of interlocking wood that support the kidney-shaped glass top: for one, she created a gnarled base of sawdust and cedar chips, painted in a pewter color, and for another, she chiseled a crude support from black and blue Jeep Cherokee fenders. Her brute

treatment and serial derivation of this iconic coffee table snub its modernist roots by disregard- ing protocol to use refined materials and to retain the singularity of Noguchi's original design.

Reaves's improvised methods manifest her nuanced view of craft as both masterfully executed and homespun. On several occasions the artist has mixed studio sawdust with glue, but instead of employing this "woodworker's trick" to repair imperfections, she applies it as deco- rative flourish, affixing lumpy forms to other- wise smooth surfaces. In another logic-bending exercise, *Life is getting longer/baguette chair* (2016), Reaves wrapped the structural bones of an armchair with upholstery foam, expos- ing what is traditionally concealed. Her transfor- mation of the entrails of couches into their skin yields misshapen forms that could, at a glance, be mistaken for curbside castaways or an earnest DIY attempt gone awry.

—EC

Idol of the Hares, 2014. Oak, polyurethane foam, silk, cotton, aluminum, and ink, chair: 38 × 28 × 48 in. (96.5 × 71.1 × 121.9 cm); ottoman: 18 × 28 × 12 in. (45.7 × 71.1 × 30.5 cm)

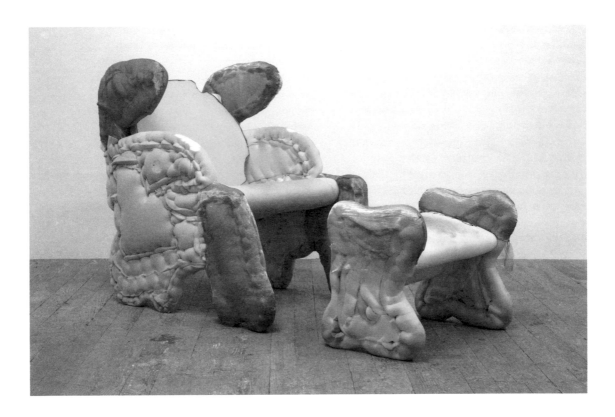

XXXXXXXXXXXXXXXXXXXXXXXXXXXO OOOOOOO

RIEPENHOFF, JOHN

Born 1982 in Milwaukee, WI;
lives in Milwaukee, WI

When he was twenty-two years old, John Riepenhoff founded the Green Gallery in Milwaukee. He borrowed the name, not without gumption, from Richard Bellamy's influential 1960s New York gallery, thus aligning his city with a burgeoning art center. The speculation proved true: since its start in 2004, the gallery has moved from the attic of the artist's home into a large space on the city's East Side now run jointly with Riepenhoff's gallery partner and cousin, Jake Palmert. Beyond championing the artists the Green Gallery represents, Riepenhoff has become something of an ambassador for Milwaukee, promoting the Midwestern city as an important hub for progressive, risk-taking art practices.

Riepenhoff's own output as an artist merges with his role as gallerist, resulting in projects such as *The John Riepenhoff Experience* (2006– ongoing), an intimate gallery—roughly the size of a large cardboard box—for the display of miniature artworks selected by the artist or guest curators. He has said about this project: "The name was a comment on ego in the art world. I like to think of a gallery as larger than the identity of the gallerist who started it, so I made the smallest gallery I could and named it after myself." Riepenhoff returns to the issue of ego in his body of work *Handler* (2009–ongoing), comprising papier-mâché sculptures of legs in sturdy work pants, modeled on the artist's own, and used as easels to support two-dimensional works by other artists. The stance of the legs and their ostensible purpose—to temporarily hold a painting or drawing while it is being judged by a viewer—is a tribute to the work of the art handlers responsible for the physical movement of art, although in this case they are portrayed as more or less invisible behind the artwork.

Riepenhoff exposes the power structures that maintain the status quo in the contemporary art market without subverting them. Residing in the geographical margins, in "flyover" country, he has contributed to the American art scene over the past decade as both participant and outsider. The difficult position he holds as both astute critic and active player comes across forcefully in the *Handler* sculptures, which reveal the exploitation of art-world workers while capitalizing on their labor.

—CB

Handler, 2015. Papier-mâché, fiberglass, wood, wire, cloth, and shoes, 50 × 19 × 14 in. (127 × 48.3 × 35.6 cm), with artwork by unidentified artist, title and date unknown, acrylic on wood, 94½ × 48½ in. (240 × 123.2 cm)

ROSADO-SEIJO, CHEMI

Born 1973 in Vega Alta, PR;
lives in San Juan and Naranjito, PR

Chemi Rosado-Seijo's art projects are entertaining diversions—in concept. Actualized, they demonstrate the radical thinking, willpower, and patience required to bring individuals together in the understanding that they belong to a larger community.

In 2002, Rosado-Seijo began an ongoing collaboration with the inhabitants of El Cerro, a working-class community in Naranjito, Puerto Rico. Struck by the informal, haphazard nature of their homes, which seemed to spring up organically from the earth, the artist proposed that they paint their homes green, to complement the architecture's relationship to its natural surroundings. It was a strange but inspired idea that has had surprising impact. "Through the process of painting, the neighbors met and visited one another," Rosado-Seijo has recalled. "In some cases, neighbors that hadn't visited each other in fourteen years met again."

Rosado-Seijo's contribution to the Whitney Biennial, *Salón-Sala-Salón* (*Classroom/Gallery/ Classroom*), is the second iteration of a project first realized in 2014, when he transformed one of the galleries at the Museo de Arte Contemporáneo de Puerto Rico in the Santurce district of San Juan into a classroom. He next invited the young students at the Escuela Rafael María de Labra next door to the museum's classroom for daily Spanish class and a workshop once a week. Meanwhile, works from the museum were exhibited at the school. In Santurce, Rosado-Seijo has recounted, "The museum became a more active place, full of adolescents every day from 8 a.m.

to 2:30 p.m. Math, science, and Spanish teachers used the art on view to teach their curriculums. The museum lost its sepulchral silence and became a school again, which for me was a surreal experience." The social energy and curiosity of the students activated the museum to function differently, while the contemporary artworks on view at the school were recontextualized as tools for pedagogy. Like many of Rosado-Seijo's projects, *Salón-Sala-Salón* is an experiment that involves well-acquainted people interacting in unexpected circumstances. In breaking from their habits and routines, communities are revealed to themselves.

—CB

Documentation of *Salón-Sala-Salón (Labra)* (*Classroom/Gallery/Classroom [Labra]*), Museo de Arte Contemporáneo de Puerto Rico (MAC), San Juan, Puerto Rico, August–December 2014

XXXXXXXX XXXXXXXXX XXXXXXXXX XXXXXXX OOOOOOO

ROWLAND, CAMERON

Born 1988 in Philadelphia, PA;
lives in Queens, NY

Cameron Rowland received a bachelor of arts
in studio art from Wesleyan University in
Connecticut in 2011. Rowland has had solo exhi-
bitions at Artists Space, New York; Fri Art,
Fribourg, Switzerland; and ESSEX STREET, New
York. The artist has participated in group exhi-
bitions at the Albright-Knox Art Gallery, Buffalo,
New York; MoMA PS1, New York; Punta della
Dogana, Venice; La Biennale de Montréal; and
the Okayama Art Summit, Okayama, Japan.

—CR

Social Impact Bonds marketize social services as well as their recipients. As instruments of austerity, they restructure social services into investment opportunities through government contracts with private service providers.

Social Impact Bonds are initiated between a government agency and a private intermediary organization. A Social Impact Bond contract, also referred to as a Pay for Success contract, indicates "specific social outcomes" to be achieved in a set time period.[1] The intermediary organization selects a nonprofit service provider to design a program in pursuit of the outcomes. The intermediary then works with a financial institution to raise capital for the program by issuing either debt or equity to private investors. At the end of the period, a third-party evaluator determines the success of the program. If the "social outcomes" are achieved, the government repays the investors the principal as well as a return on investment proportional to the presumed public savings. If the outcomes are not achieved, the investors are not repaid.[2]

Social Impact Bonds reorient the focus of social services as they "transfer the financial risk of prevention programs to private investors based on the expectation of future recoverable savings. They also provide the incentive for multiple government agencies to work together, capturing savings across agencies to fund investor repayment."[3] The first Social Impact Bond was realized in 2010 in Peterborough, UK, and was designed to reduce government spending on incarceration by reducing recidivism at HM Prison in Peterborough.[4] The first Social Impact Bond in the U.S. was realized in New York City in 2012 and was intended to reduce recidivism of 16-18 year olds at Rikers Island Jail.[5] The second was realized in 2013 and was intended to reduce recidivism and increase employment of incarcerated individuals in New York City and Rochester.[6] Since 2010, numerous Social Impact Bonds have been initiated throughout the United States, the UK, and Europe to fund various programs that attempt to reduce dependency on the state by reducing recidivism, reducing homelessness, reducing the number of children in foster care, and increasing workforce development.[7]

On June 21, 2016, the House of Representatives passed the Social Impact Partnerships to Pay for Results Act. The Act would provide federal support and oversight to incentivize the implementation of Social Impact Bonds as part of "Social Impact Partnership Projects." Under the Act, a Social Impact Partnership Project "must produce one or more measurable, clearly defined outcomes that result in social benefit and Federal savings."[8] The bill, sponsored by Republican Rep. Todd C. Young of Indiana, garnered bi-partisan support and has been referred to the Senate.

-CR

[1] *Investing in What Works: "Pay for Success" in New York State Increasing Employment and Improving Public Safety* (Albany: New York State Division of the Budget, 2014), 1.

[2] Jeffrey Liebman and Alina Sellman, *Social Impact Bonds: A Guide for State and Local Governments* (Cambridge: Harvard Kennedy School Social Impact Bond Technical Assistance Lab, 2013), 8.

[3] *A New Tool for Scaling Impact: How Social Impact Bonds Can Mobilize Private Capital to Advance Social Good* (Boston: Social Finance, 2012), 5.

[4] Emma Disley and Jennifer Rubin, *Phase 2 Report from the Payment by Results Social Impact Bond Pilot at HMP Peterborough* (London, UK: Ministry of Justice, 2014), 1.

[5] *The NYC ABLE Project for Incarcerated Youth: America's First Social Impact Bond* (New York: City of New York Office of the Mayor, 2012),1.

[6] *Investing in What Works*, 1.

[7] "Social Impact Bonds and Development Impact Bonds Worldwide." Instiglio. Accessed November 10, 2016. http://www.instiglio.org/en/sibs-worldwide/.

[8] Social Impact Partnerships to Pay for Results Act, H.R. 5170, 114th Cong. § 2(c)(2)(B) (2016).

SANTIAGO MUÑOZ, BEATRIZ

Born 1972 in San Juan, PR;
lives in San Juan, PR

Received wisdom might lead one to assume that documentary and performance stand in an antagonistic relationship to one another. In the practice of Beatriz Santiago Muñoz, however, the two are fused together, as the artist deploys an observational style to record staged actions, creating portraits of embodied experience and locality.

Santiago Muñoz often shoots in her native Puerto Rico, probing sites that evidence the island's history and politics in close collaboration with her subjects. More recently, the artist has expanded the geographical reach of her examination of the postcolonial experience, undertaking an ongoing project with Puerto Rican activists in Chicago and filming works such as *Nocturne* (2014) and *Marché Salomon* (2015) in Haiti. Shot over a ten-day period during which the artist recalls "thinking about material and poetic transformation," *Nocturne* captures Port-au-Prince largely at night. Over thirty minutes, the viewer witnesses a typology of performance, from rehearsals of a dialogue by drama students to the recounting of dreams, and the delivery of a song about being arrested by the police. The subjects offer testimonies of pain, anxiety, joy, and the desire for collectivity. In their marshaling of diverse forms of mediation, they propose that strict fidelity to the empirical and objective would fail to communicate the realities of their lives. *Marché Salomon* explores its titular space through a series of handheld traveling shots interrupted by freeze-frames and a voice-over that together recast the bustling, earthly market as a cosmic system. Here, as in *Nocturne*, departures into fantasy and fabulation serve in the production of a truth located beyond the scope of the immediately visible.

Santiago Muñoz takes up the ethnographic tradition of filmmaking but refuses its distanced gaze and scientific origins through performance and collaboration. Whether approaching an Indigenous burial site, a disused military encampment, or the legal representation of political prisoners, her work brings to the fore sensation, affect, and encounter.

—EB

Still from *Prisoner's Cinema*, 2013.
High-definition video, color, sound; 30 min.

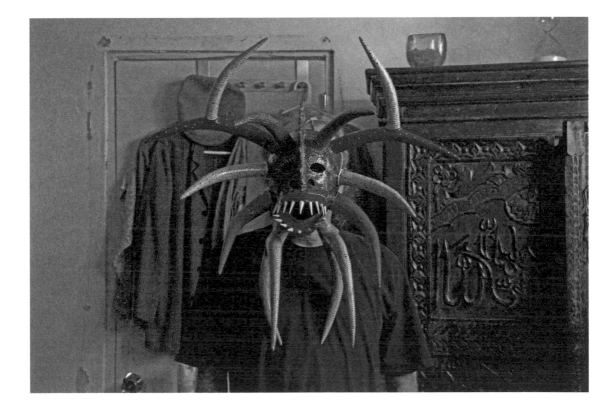

SCHUTZ, DANA

Born 1976 in Livonia, MI;
lives in Brooklyn, NY

Dana Schutz synthesizes a wide range of referents—observations of the everyday, physical sensations both real and imagined, pictorial tropes borrowed from art history—and redeploys them in paint that churns with expansive energy and intense color. At the same time, her paintings are radically enclosed: often organized around self-contained spaces (a boat, a shower) or forms that crowd and define the canvas's edge, they articulate art's status as a world apart, one in which fictive relations can be proposed and tested. Eschewing neat categories—figurative/abstract, real/imagined, figure/ground—Schutz serves up instead a version of painting that privileges experimentation, hybridity, and what the artist has called a "burlesque" sensibility.

Since she began showing her work in the early 2000s, Schutz has been a leading voice in the heterodox world of contemporary painting, joining artists such as Nicole Eisenman, Laura Owens, and Nicola Tyson in forging a new expressive language for painting, and figuration in particular, that is self-knowing without being purely self-reflexive. Schutz's paintings refract human experience with a satirical bent, occasionally bringing in real-world celebrities and politicians, that is amplified by the vulnerability (to loss or violence) or openness (to wonder) modeled by the figures that populate these imagined worlds. The resultant work becomes a medium for the confusion of affects and sensations in paintings such as *Swimming, Smoking, Crying* (2009), where seemingly incompatible experiences are merged by forceful, gestural facture.

The set of paintings that gave title to Schutz's 2015 exhibition at Petzel Gallery in New York, *Fight in an Elevator*, emphasizes compression and enclosure. In the works—one of which is based on the altercation between Jay Z and his sister-in-law Solange Knowles after the Costume Institute Gala at the Metropolitan Museum of Art in 2014—a tangle of bodies is captured between two streaky, reflective planes, the metal doors of the elevator, which press against the surface of the picture. The figures caught within this mechanical frame, barely viewable in the painting's attenuated instant, struggle manically against each other but also against the act of representation itself, threatening to take the picture down with them. Rather than offering an escape, Schutz's works trap their viewers within an unfolding articulation of experience in all of its messy, material conflicts, brought to a hypnotic limit point of containment.

—NR

Fight in an Elevator, 2015. Oil on canvas, 96 × 90 in. (243.8 × 228.6 cm). Whitney Museum of American Art, New York; promised gift of Steven A. Cohen and Alexandra Cohen P.2016.13

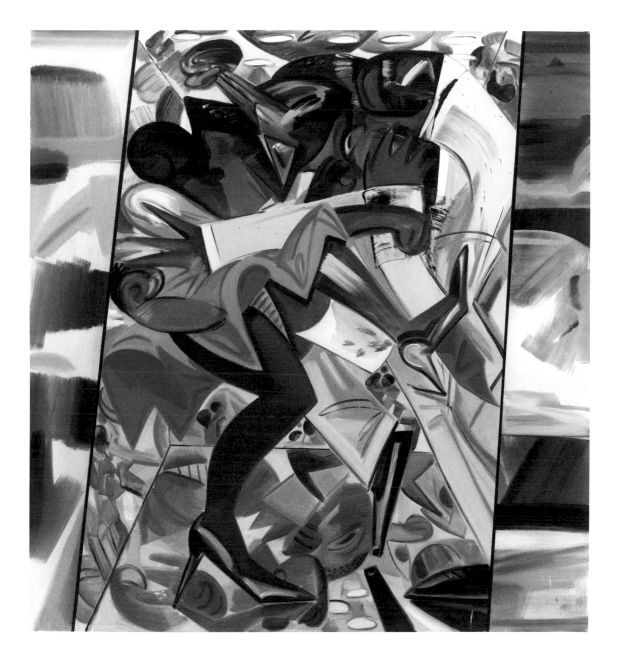

SMITH, CAULEEN

Born 1967 in Riverside, CA;
lives in Chicago, IL

From the rhythms of free jazz to the poetry of Gwendolyn Brooks, from Afrofuturist aliens in New Orleans to fugitive crows in upstate New York, the experimental range of sources, sounds, and spaces embedded in Cauleen Smith's body of work is as expansive as the spectrum of mediums she employs. Trained as a filmmaker in the mid-1990s at San Francisco State University and the University of California, Los Angeles, she is primarily known for moving-image works that challenge standards of traditional narrative cinema, drawing upon improvisational gestures of Black radical aesthetics and politics. Her films channel the insurgent energies and pedagogical legacies of the L.A. Rebellion School, a group of Black filmmakers that emerged in the late 1960s from a community of graduate students at UCLA in the context of Black liberation struggles, the Vietnam War, and the anticolonial politics of Third Cinema. Smith also produces performances, sculptures, installations, and writings, reflecting the unbounded character of her imaginative practice.

Smith's work has often attended to modes of public performance, such as parades and protests against state-sanctioned anti-Black violence. In 2010, she initiated the Solar Flare Arkestral Marching Band Project in Chicago as part of her continuing research into pioneering jazz musician Sun Ra. And in 2015, she organized the Black Love Procession in her neighborhood of Bronzeville, on Chicago's South Side, to present a tender but urgent alternative to what the artist considered to be the problematic nature of a nearby gallery's exhibition, which featured a re-creation of the scene of Michael Brown's murder by a police officer in Ferguson, Missouri, a year prior.

Smith's project for the Whitney Biennial unfurls a new series of banners reminiscent of those carried in the Black Love Procession. Pronouns like "you" and "we" directly implicate the viewer into the affective currencies of the artist's language, which express depths of fear and frustration, rage and resistance, on the flat surfaces of the banners. Phrases like "We were never meant to survive" and "No wonder I go under" unfold like a poem or a fractured sequence of film stills, eschewing narrative clarity and easy polemics for contingency, complexity, and lyrical dissonance.

—CI

Sketches for proposed
2017 Whitney Biennial project

STARK, FRANCES

Born 1967 in Newport Beach, CA;
lives in Los Angeles, CA

Language—our experience of it, its capacity for self-expression, and, in particular, how the words of others inform our own conception of the multiple roles we assume in the world—has long been at the center of Frances Stark's work. While Stark has sampled from any number of like-minded contemplative and autobiographical writers, such as Virginia Woolf, Oscar Wilde, and Henry Miller, her work is just as likely to incorporate the unwitting contributions of anonymous voices as well, as in her 1993 variation on *The Love Song of J. Alfred Prufrock* in which she enlarged a found copy of T. S. Eliot's poem complete with the margin notes of a prior reader. Stark's hour-long film *My Best Thing* (2011) features two animated characters reenacting the artist's online conversations with nameless men in search of virtual sex. That these chats range far beyond their initial prurience to touch upon issues of politics, individual agency, and existentialism suggests the spirit of promiscuity—literary if not literal—that extends across Stark's oeuvre, a sometimes flitting, sometimes deep-digging journey exemplified by the birds that have occasionally served as her avatars (in her collage *A Bomb* [2002], for example, exhibited at Stark's mid-career retrospective in 2016 at the Hammer Museum in Los Angeles, a woodpecker attempts to pry a penciled *A* from an Emily Dickinson fragment).

In her own texts, which include catalogue essays, self-published artist's books, a broad epistolary practice, and a column in the former *art/text* (1999–2001), Stark shrewdly tinkers with literary genres—from the digressive interior monologue to the incisive scholarly commentary—to capture the pastiche spirit of how we communicate and appropriate culture in the twenty-first century, and how that, in turn, helps define who we are, both as individuals and as sociopolitical actors. Her dialogue with writer, artist, and post-punk musician Ian F. Svenonius and her particular fascination with the provocative title essay of his book *Censorship Now!!* (2015) have led to Stark's most recent work. By putting forth Svenonius's ironic/radical argument that censorship, not freedom of speech, might actually empower creative expression by raising the stakes of art's presumed role in society—and doing so in the context of the Whitney Biennial no less—Stark continues her restless, fearless investigations of her own various selves, giving public form to what is often the more private mental toying with potentially explosive ideas, and inviting her audience to do the same.

—EC

Study for painting based on the book
Censorship Now!!, 2016

CENSORSHIP
NOW!!

Frances,
you're #1

103/200

CENSORSHIP
NOW!!

by IAN F. SVENONIUS

SINCERELY,

I F SVENONIUS

⊠⊠⊠⊠⊠⊠⊘ ⊠⊠⊠⊠ ⊠ ⊠⊠ ⊠ ⊠⊠⊠⊠ ⊘ ⊠⊠⊠ ⊠⊠⊘ ◯ ◯◯◯

STOVALL, MAYA

Born 1982 in Detroit, MI;
lives in Detroit, MI

Maya Stovall uses dance to trigger conversations about urban life. A self-described "radical ballerina," she has, for the past four years, been doing anthropological fieldwork in the McDougall-Hunt neighborhood of Detroit, where she lives. Stovall is a fourth-generation "Detroiter." In order to understand the situation of her hometown, so often portrayed as foundering in economic decline, she took to the streets, focusing on a specific social hub: the local liquor store. In communities in Detroit with limited modes of transport, liquor stores often sell groceries, clothing, and electronic goods. They are, in Stovall's words, "one of the remaining viable businesses in many neighborhoods with high levels of disinvestment and abandonment." In front of them, she dances—a mix of ballet and modern dance—then interviews patrons and passersby as they exit, once they've had the opportunity to watch and absorb her presence as contributing to the community rather than taking from it. Stovall records these events on video, editing the footage and adding a soundtrack composed by her husband, Todd Stovall. The result is engrossing: choreographed movement set against the spontaneous reactions of bystanders.

"With *Liquor Store Theatre*, I put my own body on the line; I place myself under surveillance first, before I ask the people I interview to do the same in talking about their lives with me," Stovall has said. "I am forming a method where artist/researcher and participant coexist in a dimension of 'creating' and 'understanding' instead of in fixed roles of 'authority' and 'informant.' The precariousness of my work of dancing

around a liquor store allows participants to see the researcher in a way that challenges relations of representation." The audience addressed is expansive, involving layers of publics, from the locals who experience Stovall's unannounced live performances firsthand to the viewers who later watch the videos online or gather to see them in art spaces.

Stovall's work, equally ethnography and art, documents people at a specific moment in time and in a specific place. Her *Liquor Store Theatre* is an open-ended meditation that raises questions—about socioeconomic status and the use of public space—rather than providing answers.

—CB

Stills from *Liquor Store Theatre, vol. 1, no. 3,* 2014. Digital video, color, sound; 6:32 min.

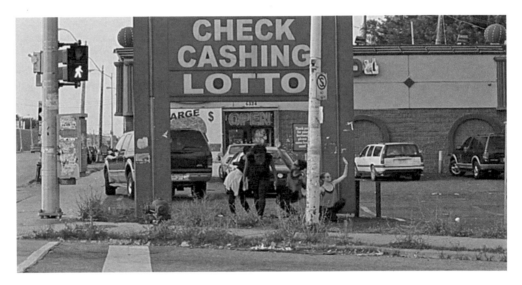

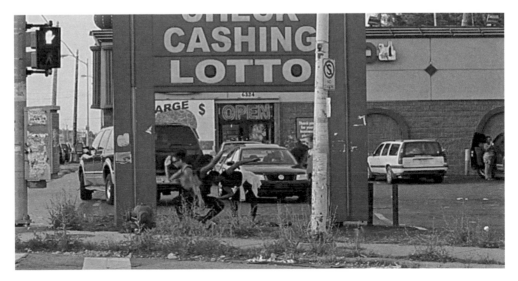

TAYLOR, HENRY

Born 1958 in Oxnard, CA;
lives in Los Angeles, CA

"I paint those subjects I have love and sympathy for," says Henry Taylor, reflecting on his empathic approach to portraiture. The artist's breakthrough 2007 solo exhibition at the Studio Museum in Harlem and his 2012 exhibition at MoMA PS1 both featured his early portraits of patients at Camarillo State Mental Hospital, where he worked as a psychiatric technician from 1984 until 1994. The wide-open mouth of a male figure suffering delusions in *Screaming Head* (1990) nearly exudes the sound of desperation, owing in large part to the artist's capacity to harmonize painterly effect with the sitter's psychological state, which has invited historical comparison to portraitists such as Alice Neel and Edvard Munch.

Among Taylor's more immediate influences was the painter James Jarvaise, who became a mentor to Taylor and encouraged him to attend the California Institute of the Arts. Since his graduation from there, Taylor has developed an expressionist style of painting that explores color and how it can define the details and character of a sitter or scene, while expanding his practice to include installations and assemblage. In *Rock It* (2008), a totemic stack of empty King Cobra malt liquor boxes topped with a black foam mannequin head equivocally fluctuates in its implications, stretching from the humble origins of folk art to the fascination with detritus found in Neo-Dadaism and Pop. "I try to embrace the naive," Taylor has said. "There's sincerity there. But I go from that to Brancusi."

Taylor's more recent portrait subjects range from his intimate circle of family and friends to pivotal figures in African American history, such as Alice Coachman, the first Black woman to win an Olympic gold medal—an exploration that aligns him with contemporary figurative artists like Kerry James Marshall and Barkley L. Hendricks who likewise pave the way for younger generations to reimagine Black identity in the United States. In *Eldridge Cleaver* (2007), Taylor mimics the iconic 1871 composition by James McNeill Whistler of his mother, depicting instead the Black Panther leader in profile sitting in a chair and underscoring how African Americans are marginalized in the art historical canon. In a distinct yet similar vein, Taylor's expanded painting practice moves beyond portraiture to incorporate candid scenes culled from the artist's memories. This is seen in works that counterweigh sensationalist media-driven narratives by foregrounding the everyday experiences and social bonds that contribute foundationally to the formation of Black identity in contemporary America while at the same time transcending racial categorization.

—EC

The Love of Cousin Tip, 2016. Acrylic on canvas, 70 × 96 in. (177.8 × 243.8 cm)

A HAPPY DAY FOR US, 2016. Acrylic on canvas, 60 × 84 in. (152.4 × 213.4 cm)

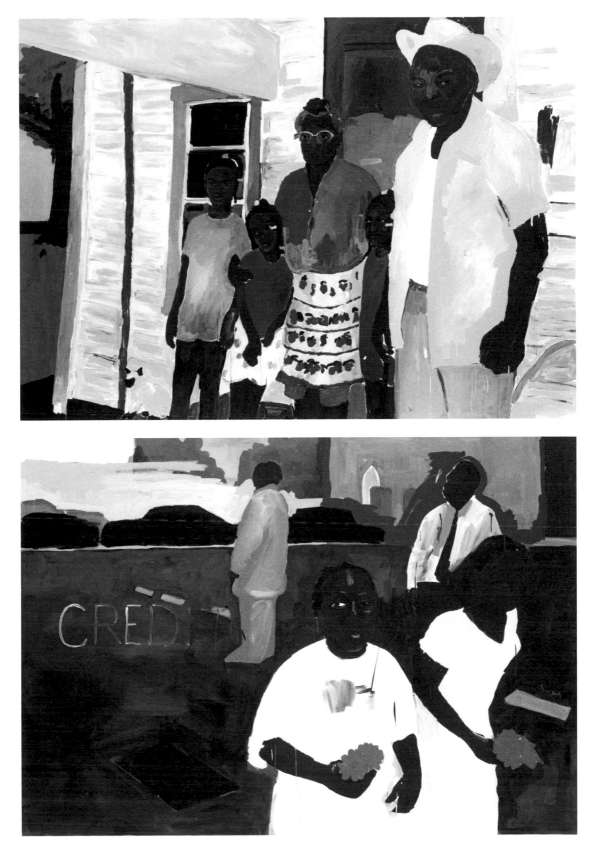

THORNTON, LESLIE

Born 1951 in Oak Ridge, TN;
lives in Brooklyn, NY

RICHARDS, JAMES

Born 1983 in Cardiff, United Kingdom;
lives in Berlin, Germany, and London, United Kingdom

The individual works and collaboration of Leslie Thornton and James Richards take up strategies of assemblage and appropriation to explore the diverse morphologies of media technologies.

A key figure in North American experimental film and video since the 1970s, Leslie Thornton broke with established modes of midcentury avant-garde filmmaking in favor of a more open-ended, antiformalist practice informed by the aesthetics of punk and bricolage. Developed over three decades, her magnum opus, the film cycle *Peggy and Fred in Hell* (1983–2015), follows a pair of television-raised children as they wander through an apocalyptic landscape littered with the detritus of culture. Blending original and appropriated footage as well as abstract and representational imagery into elliptical, episodic structures via multiple moving-image formats (16mm film, analog video, digital media), the project challenges the linearity of narrative and the stability of form. The evolution of moving-image technologies and their complex entanglement in histories of scientific inquiry, colonialism, and nuclear war are traced in Thornton's recent works *Let Me Count the Ways* (2004–ongoing) and *They Were Just People* (2016).

James Richards deploys collage to investigate the ways in which digital technologies enable the infinite malleability of visual and sonic media. His moving-image and installation works mine multifarious sources (films, television, the internet, other artists' works) for particular textures, sensations, and associations. Standards of resolution and fidelity, key designators of professional quality and artistic value, are often flouted by Richards in his effort to find new ways of penetrating the glossy surfaces of digital media, thereby exposing its hidden materialities. *Raking Light* (2014) submits clips from Hollywood blockbusters and experimental works to close inspection, slowing them down, exploring their continuities and contrasts, reveling in their sensuous details.

Thornton and Richards's first collaboration, *Crossing* (2016), was conceived in part as a response to assemblage artist Bruce Conner's iconic CROSSROADS (1976). Whereas Conner's film draws upon archival footage of the 1946 Bikini Atoll atomic bomb tests, *Crossing* collages sounds and images reclaimed from the artists' own works into cryptic structures. A complex soundscape of musical interludes, vocal commentaries, and ambient effects interlocked with original and archival imagery of animals, traffic, nudity, TV shows, and landscapes, Thornton and Richards's material—encompassing a set of enigmatic themes about the body's relationship to science and technology—is shaped into patterned grids and randomized visual passages, drawing upon the noise and excess of audiovisual culture.

—LG

Stills from *Crossing*, 2016. High-definition video, color, sound; 19:10 min.

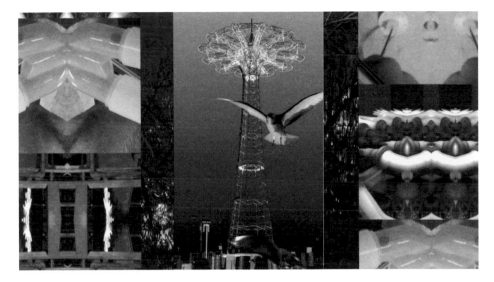

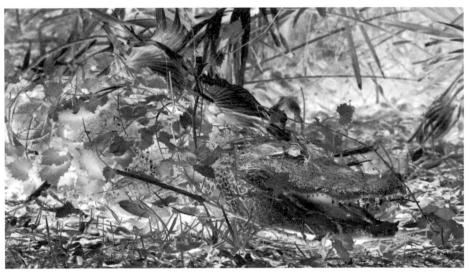

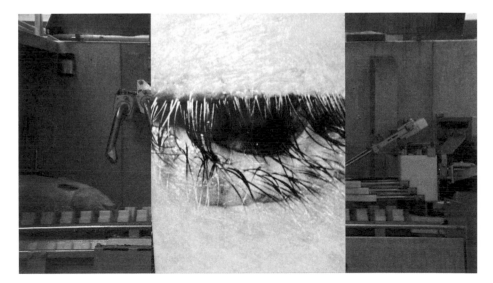

THORNTON, TOREY

Born 1990 in Macon, GA;
lives in Brooklyn, NY

Exploring the relationship between abstraction and figuration, Torey Thornton creates bold, animated paintings and sculptural assemblages that employ a diverse array of mediums and materials, from acrylic, spray paint, and oil pastel to nail polish, corrugated plastic, and foamcore. Typically eschewing a canvas support in favor of slatted wood panels or a padded mattress, Thornton's paintings vacillate between object and image, simultaneously emphasizing the flatness of the picture plane and the work's own eclectic materiality. In addition to his literal incorporation of assemblage elements, the artist adopts a collagelike approach to painting, populating his works with a mix of ambiguous biomorphic forms, graffitiesque scrawls, and cartoonish figures and objects.

Thornton's paintings suspend their components within a purposefully indeterminate pictorial space, playing with unexpected shifts in scale and multiple perspectives, with many works recalling the spatial compression of aerial views or topographic maps. In paintings such as *What Angel Do You Look Towards When You Are Damning Your Tears, Sweet Sis* (2016), floating patches of color, collaged fragments, and frenetic drawing are distributed across a neutral ground, transforming the surface into a network of elusive symbols to be decoded. Other works feature vaguely recognizable forms set against broad expanses of intense, unmodulated color: *Name Your Yellow Lab Cabbie (I Didn't See but OD)* (2015) depicts a yellow taxicab appearing to dissolve into a mustard-colored ground. In *First Cynthia* (2014), a patch of black crossed with yellow lines suggesting a parking lot in the foreground is abruptly interrupted by a tabletop still life, with a distinctly rendered plate of grapes sitting atop a roughly scrawled passage of brown.

Thornton's more recent sculptures similarly play with the variable nature of visual perception, the associations of the materials he employs, and the ways in which these materials are transformed by his handling. In *Bound Be Back Bludgeon (Thanks Oscar)* (2013–16), the artist combines an array of found and ready-made materials—a wood pole, fabric, parts of a bicycle rack, a prepainted purple rock—into a form that recalls a four-legged animal in its pose and proportions yet resists being identified with any particular creature. In *Industrialized Gumbo, Deflate My Float* (2016), a halo of wire radiates out from an irregular form comprising aluminum tape and foil, an ambiguous composition suggesting both a sci-fi landscape and a ritualistic shrine.

—RW

First Cynthia, 2014. Acrylic, spray paint, oil pastel, and charcoal on wood, 54 × 47½ in. (137.2 × 120.6 cm)

UPSON, KAARI

Born 1972 in San Bernardino, CA;
lives in Los Angeles, CA

Kaari Upson's work embraces a loss of boundaries. Diverse mediums—drawing, painting, sculpture, installation, and performance—bleed into one another, while subject and object positions become muddled. A cast-polyurethane sculpture of twisted, sagging sofas is marbled with a painterly patina, as in *Left Brace Erase, Back Brace Face* (2016); in *Four Corners* (2011), drawings emerge from attempts to destroy a human-size doll cast in charcoal.

Upson's interest in intersections applies as much to story as to sculpture: the artist prefers to "crack the narrative open and work in the spaces between." This is particularly true of the Larry Project, in which Upson invented a biography for the absent owner of an abandoned house on her parents' block in her native San Bernardino. Versions of the artist herself entered the fractured story through installations, performances, drawings, and paintings. For her *Kiss* series (2007–08), Upson painted portraits of herself and Larry, then pressed them together so that the images melted into each other, their identities blurred. The doll of *Four Corners*, too, represented Larry, and Upson's destruction of it a symbolic attempt to move past what had become an all-consuming project.

This blurring of inside and out, representation and abstraction, is also at the heart of the artist's more recent work. "I deal with questions of the abject, the in-between, the threshold of the body and its environment," Upson has said. "When something is outside the body it becomes disgusting, but when it's inside it's as natural as blood." Reproduced in polyurethane, silicone, and aluminum, the flaccid forms of upholstered furniture suggest at once the interior and exterior of the human body. *Bodhidharma* (2014), painted an iridescent violet, droops like an easy chair's flayed skin, emptied of both its form and function. Sagging against walls or hanging loosely on them, these objects lose their identity and original purpose, taking on a state that is both abstract and visceral. Their mottled surfaces are membranes that threaten to leak their foul contents at any moment. Upson's drooping structures recall the cast-latex works of Eva Hesse, as well as the soft sculptures of Claes Oldenburg. Yet where Hesse favored a translucent medium, and Oldenburg a glossy Pop aesthetic, Upson's soiled forms bear witness to a dark interior.

—JPF

You Don't Need a Rope to Pinch a Stranger's Butt, 2014. Pigmented polyurethane, 38 × 45 × 54 in. (96.5 × 114.3 × 137.2 cm)

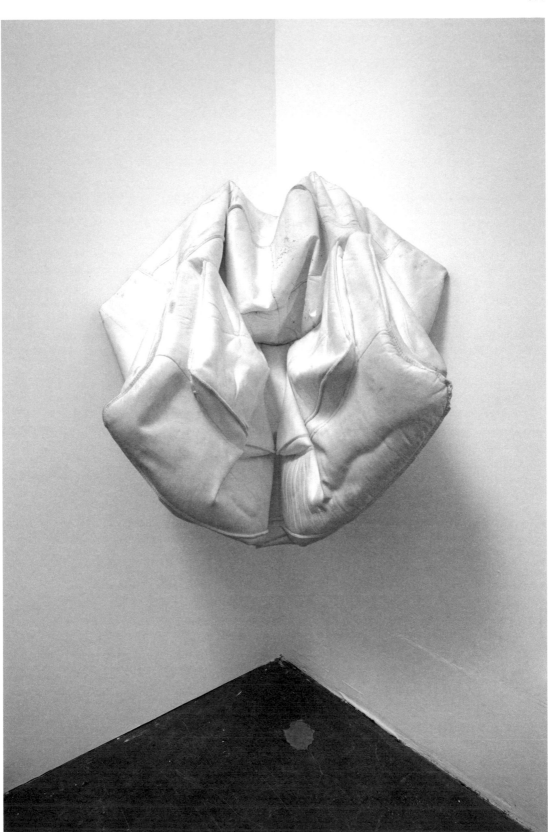

WASHINGTON, KAMASI

Born 1981 in Los Angeles, CA;
lives in Los Angeles, CA

Kamasi Washington is an artist whose music unites diverse audiences. His 2015 release, *The Epic*, is a monumental triple-CD album that harkens to the "spiritual jazz" of John Coltrane, Alice Coltrane, and Pharoah Sanders while evoking the big band, cosmic sound of Sun Ra and incorporating elements of soul, funk, doo-wop, and church music, as well as string and choral arrangements inspired by the likes of Igor Stravinsky. Intimately indebted to jazz history while forsaking the narrow strictures of genre, Washington's music is both reverent and exhilarating.

The son of a saxophone player, Washington grew up between South-Central Los Angeles and Inglewood listening to the hip-hop of N.W.A. He became enamored of jazz after his brother's friend gave him an Art Blakey mixtape, and he subsequently found himself strongly drawn to John Coltrane, especially the posthumously released album *Transition* (1970). Washington pursued jazz intensively at a magnet high school and in his senior year formed the band the Young Jazz Giants with childhood friends. Rather than confining himself to the jazz scene, however, Washington went on tour with Snoop Dogg while studying ethnomusicology at the University of California, Los Angeles. Washington garnered widespread attention for playing on and scoring *To Pimp a Butterfly*, rapper Kendrick Lamar's powerful, searing testament to the African American experience, released a few months before *The Epic*.

Many of the musicians featured on *The Epic* traverse genres, both niche and mainstream. This roster includes Washington's longtime friends and collaborators, such as Thundercat, Ronald Bruner Jr., Brandon Coleman, and Miles Mosley, who are part of a thriving L.A. scene that attracts audiences to the new spirit and energy they imbue into the jazz tradition. Weaving in musical genres like hip-hop and electronic music, Washington's L.A. collective has broken the barrier of the elitism often associated with jazz, making their music accessible to an intrigued new audience.

—ND

Kamasi Washington performing at the Bonnaroo Music + Arts Festival, Manchester, Tennessee, June 10, 2016

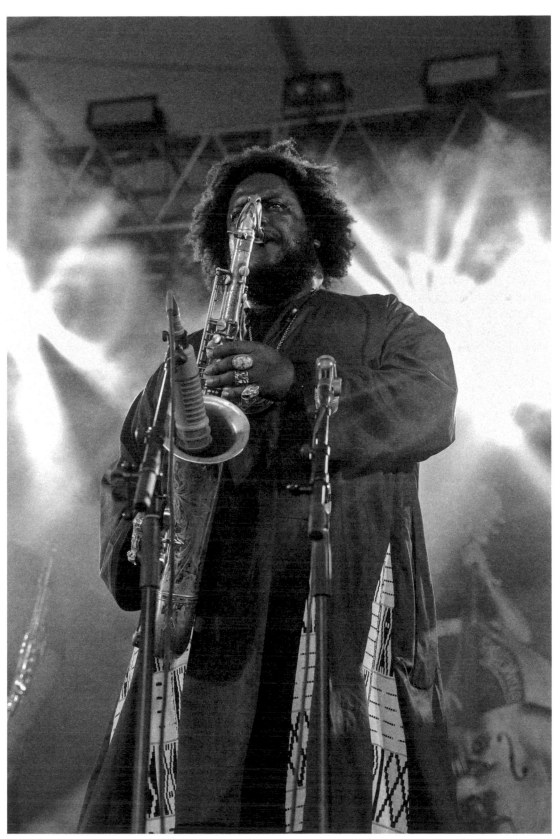

WEINRAUB, LEILAH

Born 1979 in Los Angeles, CA;
lives in Los Angeles, CA, and New York, NY

Leilah Weinraub's film *SHAKEDOWN* (2017) is an intoxicating, dreamlike portrait of Los Angeles's Black lesbian strip club scene, in which a network of female performers attached to a weekly party called Shakedown takes center stage. As the women reflect on their lives and work, a promised land comes into view built around sexual display and the desiring gaze of queer women of color, a utopian community organized and sustained by a Black female microeconomy where money and sex are exchanged in a spirit of ecstatic self-determination. When, after several years, this utopia erodes, the Shakedown dancers are forced to adapt and confront the reality of commodified labor and hourly wages. A West Coast cousin of the mostly male ballroom scene in New York, the subculture Weinraub documents in *SHAKEDOWN* is propelled by female creators notorious in their own community but whose cultural contributions are alternately pirated or ignored by society at large.

Blending together rich visual lyricism with an assemblage of interviews, original recordings of performances, and advertisements in alternative newspapers and on the internet, *SHAKEDOWN* chronicles the personal and professional relationships of the party's dancers and organizers. This group includes Ronnie Ron, Shakedown Productions's creator and emcee; Mahogany, a veteran performer, trans-woman, and grandmother; and Egypt, a single mom and Shakedown's star dancer, among others. Mapping out economies of pleasure that are rarely seen on-screen, Weinraub herself emerges as a desiring participant, rejecting the pose of "neutral onlooker"

in favor of the intimate gaze of a collaborator and confidante.

In addition to her film practice, Weinraub is an artist and executive as well. As chief executive officer of Hood By Air (HBA), the New York–based fashion collective known for their luxury streetwear, Weinraub helped to radicalize fashion by championing what she calls "modern people": the rising class of consumers who subvert traditional markers of race, class, and gender. As a filmmaker, Weinraub has sought to document a new phase in the avant-garde, one led by queer, autonomous communities of color, whose creative output has often been extracted and monetized by mass culture but whose stories have rarely been told on their own terms.

—CG

Still from *SHAKEDOWN*, 2017. Digital video, color, sound (work in progress)

WOLFSON, JORDAN

Born 1980 in New York, NY;
lives in New York, NY

Specializing in video but working across a range of mediums, including sculpture and digital media, Jordan Wolfson mines content and simulates effects from the cultural industries that pervade contemporary life. His dexterity in synthesizing seemingly unrelated subjects attests to his intuitive grasp of the internet and its magnification of such modern-day maladies as disjointed identity and anxiety-ridden thought.

For *Raspberry Poser* (2012), a looped fourteen-minute video set to a soundtrack of Beyoncé and Mazzy Star, Wolfson interweaves the enigmatic journeys of his multiple characters as they move through stock-image backgrounds and taste-fully shot locations: an animated condom filled with cartoon hearts nebulously floats through the streets of New York's posh SoHo neighborhood and occasionally emits its love-filled content; bouncing computer-generated HIV viruses are superimposed onto a virtual tour of the interior of a luxury design store; and a pesky cartoon boy roves through pictorial spaces, such as the paint-ings of Caravaggio and illustrations of Japanese pornography, until strangling and eviscerating himself in a state of euphoria. The artist's meta-dialogue intersperses the video's otherwise musi-cal soundtrack: questions such as "Do you think I'm homosexual? Do you think I'm rich?" disclose obsessive yearning for external validation as well as reflect the societal pressure to abide by cate-gorical distinctions of sexuality and class, here stereotyped to extreme vulgarization.

Wolfson's manipulation of stereotypes to probe contemporary human consciousness surface again in *Colored sculpture* (2016). The artist programmed a colossal mechanized gantry to suspend, contort, drop, and drag, via heavy chains, a marionette-like sculpture that, with the aid of facial recognition technology, makes eye contact with the viewer throughout its pathetic act. Forced into the role of complicit witness, the viewer wrestles with competing emotional responses: bemoaning the abuse of this Howdy Doody–esque character, symbolic of childhood Americana, while acknowledging the schadenfreude evoked by the degradation of a creepy dummy.

Wolfson again interrogates the viewer's collu-sion but with ever more lifelike precision in his latest work, *Real Violence* (2017). Equipped with a virtual reality headset, the viewer is transported to a nondescript urban street where a brutal assault occurs. The shock of the encounter is compounded by the eye contact that the victim maintains with the viewer, his consistent gaze rendering the viewer both spectator and victim.

—EC

Colored sculpture, 2016. Mixed media, dimensions variable

YI, ANICKA

Born 1971 in Seoul, South Korea;
lives in Queens, NY

Since she began exhibiting in 2009, Anicka Yi has been challenging the hierarchy of the senses in contemporary art. "We in the West have been overly dominated by the ocular," Yi has said, and her work activates a broader sensorium that artists, often focused on the retinal alone, have typically left untouched. The sense of smell in particular has been a focus of Yi's objects and installations, which often incorporate scents, whether the faint whiff of Gagosian Gallery (released in her 2015 exhibition at the Kitchen in New York to evoke the "neutral" atmosphere of art-world patriarchy) or of tempura-fried flowers (in which their sweet perfume is replaced with a more ambivalent one). Allied with the uncontained materiality of organic, raw matter, Yi's art is allowed to literally decay, ooze, and disseminate into its surroundings, including the viewer: to smell something, after all, one must physically take in molecules via the nostrils.

Yi embraces the olfactory for the way in which it is "shrouded in mystery, subjectivity . . . and related to long-term memory." If sight is associated with mastery and masculinity, for Yi, odor is coded feminine. Consciously materializing such "feminine" qualities (and, in the case of one installation, 2015's *Grabbing at Newer Vegetables*, literally incorporating bacteria samples collected from one hundred women in the art world), Yi's work offers a pointed critique of aesthetic values and institutions that have excluded women and feminine aesthetics from systems of reward and taste. In her collaborations with scientists, Yi similarly redirects traditionally masculine, positivist forms of inquiry toward subjective and physicalized aspects of knowledge. From this position, the artist's works destabilize distinctions between the organic and the synthetic, as with *Nuit de Cellophane* (2014), in which Yi combined the plasticky reflective materiality of DVDs inserted into the gallery wall with the sticky flow of honey that drips over the discs.

Yi's 2016 video *The Flavor Genome* intervenes at the meeting point of organic matter and scientific inquiry. Shot in Brazil in 3D, the piece produces a speculative, fragmentary fiction from the practice of pharmaceutical bioprospecting in the Amazon rainforest—a quest that joins contemporary laboratory science with the extractive economics of colonialism. From this ostensibly rational form of scientific discovery, Yi imagines a world of "designed chemical personas" that could be derived from the excretions and juices of Amazonian flora and fauna—a vision of hybridity in which the human body (and, indeed, the definition of the human) is rendered porous.

—NR

Stills from *The Flavor Genome*, 2016.
3D high-definition video, color, sound; 22 min.

EXHIBITION CHECKLIST

ZAROUHIE ABDALIAN
Chanson du ricochet,
2017
Multichannel sound installation
Collection of the artist; courtesy
the artist and Altman Siegel,
San Francisco

BASMA ALSHARIF
Ouroboros, 2017
High-definition video, color,
sound; run time unknown
Courtesy the artist; Galerie
Imane Farès, Paris; Momento!,
Paris; IDA.IDA, Paris; and
IDIOMS Films, Ramallah

JO BAER
*Dawn (Lines and
Destinations),*
2009/2011
Oil on canvas
64¼ × 86¼ in. (163 × 219 cm)
Collection of the artist; courtesy
Galerie Barbara Thumm, Berlin

*Dusk (Bands and
End-Points),* 2012
Oil on canvas
86⅝ × 118⅛ in. (220 × 300 cm)
Collection of the artist; courtesy
Galerie Barbara Thumm, Berlin

*Heraldry (Posts and
Spreads),* 2013
Oil on canvas
61 × 61 in. (155 × 155 cm)
Collection of the artist; courtesy
Galerie Barbara Thumm, Berlin

*In the Land of the
Giants (Spirals and
Stairs),* 2012
Oil on canvas
58¾ × 58¾ in. (149 × 149 cm)
Collection of the artist; courtesy
Galerie Barbara Thumm, Berlin

*Royal Families (Curves,
Points and Little Ones),*
2013
Oil on canvas
72¹³⁄₁₆ × 72¹³⁄₁₆ in. (185 × 185 cm)
Collection of the artist; courtesy
Galerie Barbara Thumm, Berlin

*Time-Line (Spheres,
Angles and the Negative
of the 2nd Derivative),*
2012
Oil on canvas
72¹³⁄₁₆ × 72¹³⁄₁₆ in. (185 × 185 cm)
Collection of the artist; courtesy
Galerie Barbara Thumm, Berlin

ERIC BAUDELAIRE
Also Known as Jihadi,
2017
High-definition video, color,
sound; 99 min.
Courtesy Poulet-Malassis
Films, Paris

*The Anabasis of May
and Fusako Shigenobu,
Masao Adachi, and 27
Years Without Images,*
2011
Super 8 film and high-definition
video, color and black-and-
white, sound; 66 min.
Courtesy Poulet-Malassis
Films, Paris

ROBERT BEAVERS
Der Klang, die Welt,
2017
16mm film, color, sound; 4 min.
Courtesy the artist

*Listening to the Space
in My Room,* 2013
16mm film, color, sound; 19 min.
Courtesy the artist

*Pitcher of Colored
Light,* 2007
16mm film, color, sound; 24 min.
Courtesy the artist

The Suppliant, 2010
16mm film, color, sound; 5 min.
Courtesy the artist

As yet untitled, 2017
16mm film, color, sound; 5 min.
Courtesy the artist

LARRY BELL
Pacific Red II, 2017
Laminated glass
Twenty-four panels, 72 × 96 in.
(182.9 × 243.8 cm) each, and
twenty-four panels, 72 × 48 in.
(182.9 × 121.9 cm) each
Collection of the artist; courtesy
Hauser Wirth & Schimmel,
Los Angeles

MATT BROWNING
Untitled, 2016
Wood
Collapsed: 3½ × 3½ × 18¼ in.
(8.9 × 8.9 × 47.6 cm);
expanded: 17¾ × 17¾ × 4 in.
(45.1 × 45.1 × 10.2 cm)
Collection of the artist

Untitled, 2016
Wood
Collapsed: 3½ × 3½ × 18¼ in.
(8.9 × 8.9 × 47.6 cm);
expanded: 17¾ × 17¾ × 4 in.
(45.1 × 45.1 × 10.2 cm)
Collection of the artist

Untitled, 2016
Wood
Collapsed: 3½ × 3½ × 18¼ in.
(8.9 × 8.9 × 47.6 cm);
expanded: 17¾ × 17¾ × 4 in.
(45.1 × 45.1 × 10.2 cm)
Collection of the artist

Untitled, 2016
Wood
Collapsed: 3½ × 3½ × 18¼ in.
(8.9 × 8.9 × 47.6 cm);
expanded: 17¾ × 17¾ × 4 in.
(45.1 × 45.1 × 10.2 cm)
Collection of the artist

Untitled, 2016
Wood
Collapsed: 3½ × 3½ × 18¼ in.
(8.9 × 8.9 × 47.6 cm);
expanded: 17¾ × 17¾ × 4 in.
(45.1 × 45.1 × 10.2 cm)
Collection of the artist

Untitled, 2016
Wood
Collapsed: 3½ × 3½ × 18¼ in.
(8.9 × 8.9 × 47.6 cm);
expanded: 17¾ × 17¾ × 4 in.
(45.1 × 45.1 × 10.2 cm)
Collection of the artist

Untitled, 2016
Wood
Collapsed: 3½ × 3½ × 18¼ in.
(8.9 × 8.9 × 47.6 cm);
expanded: 17¾ × 17¾ × 4 in.
(45.1 × 45.1 × 10.2 cm)
Collection of the artist

Untitled, 2016
Wood
Collapsed: 3½ × 3½ × 18¼ in.
(8.9 × 8.9 × 47.6 cm);
expanded: 17¾ × 17¾ × 4 in.
(45.1 × 45.1 × 10.2 cm)
Collection of the artist

Untitled, 2016
Wood
Collapsed: 3½ × 3½ × 18¼ in.
(8.9 × 8.9 × 47.6 cm);
expanded: 17¾ × 17¾ × 4 in.
(45.1 × 45.1 × 10.2 cm)
Collection of the artist

Untitled, 2016
Wood
Collapsed: 3½ × 3½ × 18¼ in.
(8.9 × 8.9 × 47.6 cm);
expanded: 17¾ × 17¾ × 4 in.
(45.1 × 45.1 × 10.2 cm)
Collection of the artist

SUSAN CIANCIOLO
*RUN RESTAURANT
UNTITLED,* 2017
Installation and performance,
collaboration with
Michael Anthony
Courtesy the artist and Bridget
Donahue, New York

**MARY HELENA
CLARK**
Delphi Falls, 2016
High-definition video, color,
sound; 20 min.
Courtesy the artist

*The Dragon Is the
Frame,* 2014
16mm film, color and black-
and-white, sound; 13:31 min.
Courtesy the artist

EXHIBITION CHECKLIST

JOHN DIVOLA

Abandoned Painting A, 2007
Inkjet print
44 × 54 in. (111.8 × 137.2 cm)
Collection of the artist; courtesy Maccarone Gallery, New York and Los Angeles, and Gallery Luisotti, Santa Monica

Abandoned Painting B, 2007
Inkjet print
44 × 54 in. (111.8 × 137.2 cm)
Collection of the artist; courtesy Maccarone Gallery, New York and Los Angeles, and Gallery Luisotti, Santa Monica

Abandoned Painting C, 2007
Inkjet print
44 × 54 in. (111.8 × 137.2 cm)
Collection of the artist; courtesy Maccarone Gallery, New York and Los Angeles, and Gallery Luisotti, Santa Monica

Abandoned Painting E, 2008
Inkjet print
44 × 54 in. (111.8 × 137.2 cm)
Collection of the artist; courtesy Maccarone Gallery, New York and Los Angeles, and Gallery Luisotti, Santa Monica, CA

Abandoned Painting F, 2008
Inkjet print
44 × 54 in. (111.8 × 137.2 cm)
Collection of the artist; courtesy Maccarone Gallery, New York and Los Angeles, and Gallery Luisotti, Santa Monica

Abandoned Painting G, 2008
Inkjet print
44 × 54 in. (111.8 × 137.2 cm)
Collection of the artist; courtesy Maccarone Gallery, New York and Los Angeles, and Gallery Luisotti, Santa Monica

Abandoned Painting H, 2008
Inkjet print
44 × 54 in. (111.8 × 137.2 cm)
Collection of the artist; courtesy Maccarone Gallery, New York and Los Angeles, and Gallery Luisotti, Santa Monica

Abandoned Painting I, 2008
Inkjet print
44 × 54 in. (111.8 × 137.2 cm)
Collection of the artist; courtesy Maccarone Gallery, New York and Los Angeles, and Gallery Luisotti, Santa Monica

CELESTE DUPUY-SPENCER

Art Party, 2015
Watercolor and gouache on paper
11 × 9 in. (27.9 × 22.9 cm)
Collection of Nino Mier

Asher and Miro, 2015
Watercolor and gouache on paper
9 × 12 in. (22.9 × 30.5 cm)
Collection of Asher Dupuy-Spencer and Ariella Thornhill

The Charmers, 2016
Pen on paper
12⅞ × 10⅞ in. (32.7 × 27.6 cm)
Collection of Sam Sparro

Closing Party (Hit the North), 2016
Oil on canvas
48 × 60 in. (121.9 × 152.4 cm)
Private collection

Don't Look Now / Goodbye Daughters, 2016
Oil on canvas
20 × 20 in. (50.8 × 50.8 cm)
Collection of Wendy Lee

Fall with Me for a Million Days (My sweet waterfall), 2016
Oil on canvas
60 × 48 in. (152.4 × 121.9 cm)
Private collection

Good Morning, 2014
Watercolor on paper
11 × 6 in. (27.9 × 15.2 cm)
Collection of the artist

It's a Sports Bar But It Used to Be a Gay Bar, 2016
Watercolor and gouache on paper
24 × 30 in. (61 × 76.2 cm)
Collection of Cindy and Arnold Schwartz

Matriarchs of the Hudson Valley (1980s–90s), 2016
Pencil on paper
24 × 30 in. (61 × 76.2 cm)
Collection of Wendy Lee

Mercy, Things Are Gonna Slide, 2016
Oil on canvas
48 × 36 in. (121.9 × 91.4 cm)
Collection of Cindy and Arnold Schwartz

NADCP, 2015
Watercolor and gouache on paper
9 × 11 in. (22.9 × 27.9 cm)
Collection of David Kobosa and Frank Maurer

New York Knicks, 2015
Acrylic and watercolor on paper
8¼ × 10¼ in. (21 × 26 cm)
Collection of Mia Romanik

Pink Floyd (Ooooh aah), 2016
Oil on canvas
48 × 64 in. (121.9 × 162.6 cm)
Collection of Donovan and Matthias Vriens-McGrath

St. Tammany Parish, 2016
Oil on canvas
60 × 48 in. (152.4 × 121.9 cm)
Collection of Vinny Dotolo and Sarah Hendler

Trump Rally (And some of them I assume are good people), 2016
Pencil on paper
24 × 30 in. (61 × 76.2 cm)
Collection of Marija Karan and Joel Lubin

Untitled, 2016
Watercolor and gouache on paper
5¾ × 9⅛ in. (14.6 × 23.2 cm)
Collection of Sophie Bielders

Veterans Day, 2016
Oil on linen
85 × 65 in. (215.9 × 165.1 cm)
Collection of the artist

The Yard, 2015
Acrylic and watercolor on paper
11¾ × 8⅞ in. (29.8 × 22.5 cm)
Collection of Cindy Schwartz and Robyn Siegal

RAFA ESPARZA

Figure Ground: Beyond the White Field, 2017
With additional works by Nao Bustamante, Beatriz Cortez, Ramiro Gomez Jr., Joe Jiménez, Eamon Ore-Giron, Gala Porras-Kim, and Dorian Ulises López
Installation with approx. 5,000 adobe bricks
Dimensions variable
Courtesy the artist

KEVIN JEROME EVERSON

Ears, Nose and Throat, 2016
16mm film transferred to high-definition video, black-and-white, sound; 10:30 min.
Courtesy the artist; Trilobite-Arts DAC, Charlottesville, VA; and Picture Palace Pictures, New York

Eason, 2016
16mm film transferred to high-definition video, color, sound; 15 min.
Courtesy the artist; Trilobite-Arts DAC, Charlottesville, Virginia; and Picture Palace Pictures, New York

Fastest Man in the State, 2017
Co-directed with Claudrena Harold
16mm film transferred to high-definition video, black-and-white and color, sound; 10 min.
Courtesy the artists; Trilobite-Arts DAC, Charlottesville, Virginia; and Picture Palace Pictures, New York

Fe26, 2014
16mm film transferred to high-definition video, color, sound; 7:21 min.
Courtesy the artist; Trilobite-Arts DAC, Charlottesville, Virginia; and Picture Palace Pictures, New York

Lost Nothing, 2016
Super 8 film transferred to
digital video, black-and-white,
sound; 3:30 min.
Courtesy the artist; Trilobite-
Arts DAC, Charlottesville,
Virginia; and Picture Palace
Pictures, New York

Sound That, 2014
16mm film transferred to
high-definition video, color,
sound; 11:40 min.
Courtesy the artist; Trilobite-
Arts DAC, Charlottesville,
Virginia; and Picture Palace
Pictures, New York

GCC
*Local police find fruit
with spells*, 2017
Installation
Dimensions unknown
Collection of the artists;
courtesy Kraupa-Tuskany
Zeidler, Berlin; Mitchell-Innes
& Nash, New York; and Project
Native Informant, London

OTO GILLEN
New York, 2015–
ongoing
High-definition video, color,
sound; run time unknown
Courtesy the artist

SAMARA GOLDEN
As yet untitled, 2017
Installation
Dimensions unknown
Collection of the artist; courtesy
Night Gallery, Los Angeles, and
CANADA, New York

**CASEY GOLLAN AND
VICTORIA SOBEL**
Reflections, 2017
Installation
Dimensions unknown
Collection of the artists

IRENA HAIDUK
SERVERS FOR .YU and
Frauenbank, 2017
Router hardware, metal housing,
and objects from former
Yugoslav infrastructures priva-
tized by foreign corporations
Dimensions variable
Collection of Yugoexport

**LYLE ASHTON
HARRIS**
Once (Now) Again, 2017
Installation including:

*Beachwood Canyon,
circa mid 1990's*
MiniDV transferred to digital
video, color, silent, looped;
and four silk panels, 120 ×
45 in. (304.8 × 114.3 cm) each

Blue Snow
MiniDV transferred to digital
video, color, sound; 4 min.

*Ektachrome Archive
New York Mix*
Three-channel high-definition
video, color, sound; looped

for Tommy
Hi-8 film transferred to digital
video, two-channel video,
color, sound; 38 min.

Collection of the artist

TOMMY HARTUNG
*The Lesser Key of
Solomon*, 2015
Ultra-high-definition video,
color, sound; 8:05 min.
Courtesy the artist and On
Stellar Rays, New York

**PORPENTINE
CHARITY
HEARTSCAPE**
Beautiful Frog, 2015
Hypertext
Courtesy the artist

Begscape, 2014
Hypertext
Courtesy the artist

Cyberqueen, 2012
Hypertext
Courtesy the artist

howling dogs, 2012
Hypertext
Courtesy the artist

*With Those We Love
Alive*, 2014
Hypertext
Courtesy the artist

SKY HOPINKA
*I'll Remember You As
You Were, Not As What
You'll Become*, 2016
Digital video, color,
sound; 12:32 min.
Courtesy the artist

Jáaji Approx., 2015
Digital video, color, sound;
7:37 min.
Courtesy the artist

Visions of an Island,
2016
Digital video, color, sound;
15 min.
Courtesy the artist

SHARA HUGHES
Beautiful Truth, 2016
Oil, acrylic, enamel,
and dye on canvas
68 × 60 in. (172.7 × 152.4 cm)
Collection of the artist; courtesy
the artist and Rachel Uffner
Gallery, New York

Cascade, 2016
Oil, acrylic spray paint,
and enamel on canvas
68 × 60 in. (172.7 × 152.4 cm)
Collection of the artist; courtesy
the artist and Rachel Uffner
Gallery, New York

In the Clear, 2016
Oil, acrylic, and dye on canvas
68 × 60 in. (172.7 × 152.4 cm)
Collection of the artist; courtesy
the artist and Rachel Uffner
Gallery, New York

Reaching My Plateau,
2016
Oil, acrylic spray paint, and dye
on canvas
68 × 60 in. (172.7 × 152.4 cm)
Collection of the artist; courtesy
the artist and Rachel Uffner
Gallery, New York

Split Ends, 2016
Oil, acrylic, and vinyl paint
on canvas
68 × 60 in. (172.7 × 152.4 cm)
Hort Family Collection

We Windy, 2016
Oil, acrylic, and enamel
on canvas
56 × 48 in. (142.2 × 121.9 cm)
Collection of Chana and
Cliff Chenfeld

**AARON FLINT
JAMISON**
As yet untitled, 2017
Email footer
Collection of the artist; courtesy
Miguel Abreu Gallery, New York,
and Air de Paris, Paris

KAYA
SERENE, 2017
Installation
Dimensions variable
Collection of the artists;
courtesy the artists and
47 Canal, New York

JON KESSLER
Evolution, 2016
Mixed media with motors,
surveillance camera,
smartphone, and LCD screens
96 × 75½ × 63 in.
(243.8 × 191.8 × 160 cm)
Collection of the artist; courtesy
the artist and Salon 94, New York

Exodus, 2016
Mixed media with motor,
surveillance camera, and
LCD screen
81 × 47 × 66 in.
(205.7 × 119.4 × 167.6 cm)
Collection of the artist; courtesy
the artist and Salon 94, New York

EXHIBITION CHECKLIST

**JAMES N. KIENITZ
WILKINS**
B-ROLL with Andre,
2015
High-definition video, color,
sound; 19 min.
Collection of the artist; courtesy
the artist

Mediums, 2017
16mm film transferred to high-
definition video, color, sound;
run time unknown
Collection of the artist; courtesy
the artist

AJAY KURIAN
Childermass, 2017
Glass, epoxy putty, marble,
retroreflectors, chromed
epoxy, expanding foam, wire,
steel, plexiglass, LEDs, fog
machine, custom clothing,
hardware, and fur
Dimensions variable
Collection of the artist; courtesy
the artist and 47 Canal, New York

DEANA LAWSON
Franmeka, 2016
Inkjet print
Dimensions unknown
Collection of the artist; courtesy
the artist; Rhona Hoffman
Gallery, Chicago; and Sikkema
Jenkins & Co., New York

The Key, 2016
Inkjet print
Dimensions unknown
Collection of the artist; courtesy
the artist; Rhona Hoffman
Gallery, Chicago; and Sikkema
Jenkins & Co., New York

*Kingdom Come, Addis
Ababa, Ethiopia,* 2015
Inkjet print mounted on board
50¾ × 43 in. (128.9 × 109.2 cm)
Collection of the artist; courtesy
the artist; Rhona Hoffman
Gallery, Chicago; and Sikkema
Jenkins & Co., New York

Nicole, 2016
Inkjet print
Dimensions unknown
Collection of the artist; courtesy
the artist; Rhona Hoffman
Gallery, Chicago; and Sikkema
Jenkins & Co., New York

Ring Bearer, 2016
Inkjet print
Dimensions unknown
Collection of the artist; courtesy
the artist; Rhona Hoffman
Gallery, Chicago; and Sikkema
Jenkins & Co., New York

Signs, 2016
Inkjet print
Dimensions unknown
Collection of the artist; courtesy
the artist; Rhona Hoffman
Gallery, Chicago; and Sikkema
Jenkins & Co., New York

Uncle Mack, 2016
Inkjet print
Dimensions unknown
Collection of the artist; courtesy
the artist; Rhona Hoffman
Gallery, Chicago; and Sikkema
Jenkins & Co., New York

AN-MY LÊ
A selection of photographs from
The Silent General,
2015–17
Inkjet prints
40 × 56½ in. (101.6 × 143.5 cm)
or 26½ × 38 in.
(67.3 × 96.5 cm) each
Collection of the artist, courtesy
the artist and STX Entertainment,
Los Angeles

LEIGH LEDARE
Vokzal, 2016
16mm film, color, sound;
58 min.
Collection of the artist; courtesy
the artist; Mitchell-Innes &
Nash, New York; The Box, Los
Angeles; Pilar Corrias Gallery,
London; and Office Baroque,
Brussels

DANI LEVENTHAL
Hard as Opal, 2015
Co-directed with Jared
Buckhiester
High-definition video, color,
sound; 29:23 min.
Courtesy Video Data Bank,
Chicago

Platonic, 2013
High-definition video, color,
sound; 20:29 min.
Courtesy Video Data Bank,
Chicago

*Strangely Ordinary
This Devotion,* 2017
Co-directed with Sheilah Wilson
High-definition video, color,
sound; run time unknown
Courtesy Video Data Bank,
Chicago

TALA MADANI
Shitty Disco, 2016
Oil on linen
55 × 44 in. (140 × 112 cm)
Collection of the artist; courtesy
the artist; Pilar Corrias Gallery,
London; and David Kordansky,
Los Angeles

Tit Shits, 2016
Oil on linen
35 × 25 in. (89 × 63 cm)
Collection of the artist; courtesy
the artist; Pilar Corrias Gallery,
London; and David Kordansky,
Los Angeles

*Three as-yet-untitled
paintings,* 2017
55 × 44 in. (140 × 112 cm) each
Collection of the artist; courtesy
the artist; Pilar Corrias Gallery,
London; and David Kordansky,
Los Angeles

PARK McARTHUR
*Another word for
memory is life,* 2017
Laminated vinyl on aluminum
Two components, 144 × 192 in.
(365.8 × 487.7 cm) each
Collection of the artist; courtesy
the artist; ESSEX STREET,
New York; and Galerie Lars
Friedrich, Berlin

HAROLD MENDEZ
American Pictures,
2016
Reclaimed wrought iron, wood,
crushed cochineal insects,
staples, industrial work mats,
and carnations
72 × 48 × 48 in.
(182.9 × 121.9 × 121.9 cm)
Private collection; courtesy
the artist and PATRON
Gallery, Chicago

*At night we walk in
circles,* 2016
Cotton, enamel spray paint,
watercolor, toner, graphite, and
litho crayon on ball-grained
aluminum lithographic plate
mounted on aluminum sheet
72 × 60 in. (182.9 × 152.4 cm)
Collection of the artist

*but I sound better since
you cut my throat,* 2016
Reclaimed galvanized steel,
wood, and chain-link fence
Approx. 180 in. (457.2 cm) long
Collection of the artist

Elmina Castle, 2016
Inkjet print mounted on
aluminum sheet with artist's
bronze frame
13 × 19 × 2 in. (33 × 48.3 × 5.1 cm)
Collection of the artist
Produced with generous
support from the Robert
Rauschenberg Foundation's
Rauschenberg Residency –
3Arts Residency Fellowship

*These deeds must not
be thought after these
ways; so, it will make us
mad,* 2017
Tri-directional foil, fiberglass,
synthetic rubber, toner,
and pigment
Dimensions variable
Collection of the artist

CARRIE MOYER
Belle Isle, 2016
Acrylic and glitter on canvas
78 × 84 in. (198.1 × 213.4 cm)
Collection of the artist; courtesy
the artist and DC Moore Gallery,
New York

Candy Cap, 2016
Acrylic, glitter, and vinyl paint
on canvas
72 × 96 in. (182.9 × 243.8 cm)
Private collection; courtesy the
artist and DC Moore Gallery,
New York

Glimmer Glass, 2016
Acrylic and glitter on canvas
96 × 78 in. (243.8 × 198.1 cm)
Collection of the artist; courtesy
the artist and DC Moore Gallery,
New York

String Theory + Daisy Chains, 2016
Acrylic and glitter on canvas
96 × 78 in. (243.8 × 198.1 cm)
Collection of the artist; courtesy the artist and DC Moore Gallery, New York

Swiss Bramble, 2016
Acrylic and glitter on canvas
84 × 78 in. (213.4 × 198.1 cm)
Collection of the artist; courtesy the artist and DC Moore Gallery, New York

ULRIKE MÜLLER
Rug (gato chico), 2015
Wool, handwoven in the workshop of Josefina and Jerónimo Hernández Ruiz, Teotitlán del Valle, Oaxaca, Mexico
64½ × 48½ in. (163.8 × 123.2 cm)
Collection of the artist; courtesy the artist and Callicoon Fine Arts, New York

Ten paintings, 2017
Vitreous enamel on steel
15½ × 12 in. (39.4 × 30.1 cm) each
Collection of the artist; courtesy the artist and Callicoon Fine Arts, New York

Twelve works on paper, 2015
Acrylic and papier collé on paper
24 × 18 in. (61 × 45.6 cm) each
Collection of the artist; courtesy the artist and Callicoon Fine Arts, New York

JULIEN NGUYEN
Executive Function, 2017
Encaustic and oil on panel
69 × 63¼ in. (175.3 × 160.7 cm)
Collection of the artist; courtesy the artist; Neue Alte Brücke, Frankfurt; and Stuart Shave/ Modern Art, London

Executive Solutions, 2017
Encaustic and oil on panel
69 × 63¼ in. (175.3 × 160.7 cm)
Collection of the artist; courtesy the artist; Neue Alte Brücke, Frankfurt; and Stuart Shave/ Modern Art, London

TUAN ANDREW NGUYEN
As yet untitled, 2017
Ultra-high-definition video; run time unknown
Courtesy the artist

RAÚL DE NIEVES
beginning & the end, neither & the otherwise, betwixt & between, the end is the beginning & the end, 2016
Paper, wood, glue, and acetate sheets
Dimensions unknown
Collection of the artist; courtesy Company Gallery, New York

Man's best friend, 2016
Yarn, fabric, glue, beads, cardboard, vintage trim, and mannequin
Dimensions unknown
Collection of the artist; courtesy Company Gallery, New York

Somos Monstros 2, 2016
Beads, glue, vintage trim, cardboard, costume jewelry, and dress
Dimensions unknown
Collection of the artist; courtesy Company Gallery, New York

The longer I slip into a crack the shorter my nose becomes, 2016
Yarn, dress, glue, beads, cardboard, vintage trim, and mannequin
Dimensions unknown
Collection of the artist; courtesy Company Gallery, New York

UUU MEE, 2015–16
Plastic beads, artist-worn shoe, glue, and fiberglass
Dimensions unknown
Collection of the artist; courtesy Company Gallery, New York

ALIZA NISENBAUM
La Talaverita, Sunday Morning NY Times, 2016
Oil on linen
68 × 88 in. (172.7 × 223.5 cm)
Collection of the artist; courtesy T293 Gallery, Rome, and Mary Mary, Glasgow

Latin Runners Club, 2016
Oil on linen
75 × 95 in. (190.5 × 241 cm)
Collection of the artist; courtesy T293 Gallery, Rome, and Mary Mary, Glasgow

MOIA's NYC Women's Cabinet, 2016
Oil on linen
68 × 85 in. (172.7 × 215.9 cm)
Collection of the artist; courtesy T293 Gallery, Rome, and Mary Mary, Glasgow

2 Years of Correspondence from Inmate 39807, 2016
Oil on linen
43 × 47 in. (109.2 × 119.4 cm)
Collection of the artist; courtesy T293 Gallery, Rome, and Mary Mary, Glasgow

OCCUPY MUSEUMS
Debtfair Whitney, 2017
Installation and online digital platform
Dimensions variable
Courtesy the artists

POPE.L AKA WILLIAM POPE.L
Claim, 2017
Paint, pencil, push pins, wood, framed document, fortified wine, and 2,755 slices of bologna with black-and-white photocopy portraits
15 × 16¾ × 16¾ ft. (4.6 × 5.1 × 5.1 m)
Collection of the artist; courtesy the artist and Mitchell-Innes & Nash, New York

POSTCOMMODITY
A Very Long Line, 2016
Four-channel digital video, color, sound; looped
Courtesy the artists

PUPPIES PUPPIES
Liberties, 2017
Foam hats and metal rack
Dimensions variable
Collection of the artist; courtesy What Pipeline, Detroit, and Queer Thoughts, New York

Liberty (Liberté), 2017
Performance
Courtesy the artist and Balice Hertling, Paris

Trigger (Glock 22) (permanently disabled by Chipp Flynn), 2016
Metal gun trigger
1½ × 4 × ½ in. (3.8 × 10.2 × 1.3 cm)
Kourosh Larizadeh and Luis Pardo Collection

Trigger (Sig Sauer MCX) (permanently disabled), 2016
Metal gun trigger
1½ × 4 × ½ in. (3.8 × 10.2 × 1.3 cm)
Kourosh Larizadeh and Luis Pardo Collection

Untitled, 2017
Inkjet print on vinyl
17 × 29 ft. (5.2 × 8.8 m)
Collection of the artist; courtesy What Pipeline, Detroit, and Queer Thoughts, New York

As yet untitled, 2017
Metal gun trigger
Dimensions variable
Collection of the artist; courtesy the artist and the Zabludowicz Foundation, London

Two as-yet-untitled works, 2017
Metal gun triggers
Dimensions variable
Collection of the artist; courtesy the artist and Balice Hertling, Paris

⊠⊠⊠⊠○

EXHIBITION CHECKLIST

ASAD RAZA
As yet untitled, 2017
Installation
Dimensions variable
Collection of the artist

JESSI REAVES
A selection of as-yet-untitled benches, lamps, chairs, headboards, shelves, couches, and cabinets, 2017
Plywood, wood, sawdust, wood glue, polyurethane foam, silk, cotton, vinyl, ink, and hardware
Dimensions variable
Collection of the artist; courtesy the artist and Bridget Donahue, New York

JOHN RIEPENHOFF
The John Riepenhoff Experience, 2013/2017
Wood, ladder, latex wall paint, and light
103 × 34 × 18 in.
(261.6 × 86.4 × 45.7 cm)
Collection of the artist; courtesy the artist and Marlborough Chelsea, New York

Handler, 2014
Papier-mâché, fiberglass, wood, wire, cloth, and shoes
50 × 19 × 14 in.
(127 × 48.3 × 35.6 cm)
Collection of the artist; courtesy the artist and Marlborough Chelsea, New York

Handler, 2014
Papier-mâché, fiberglass, wood, wire, cloth, and shoes
50 × 19 × 14 in.
(127 × 48.3 × 35.6 cm)
Collection of the artist; courtesy the artist and Marlborough Chelsea, New York

Handler, 2015
Papier-mâché, fiberglass, wood, wire, cloth, and shoes
50 × 19 × 14 in.
(127 × 48.3 × 35.6 cm)
Collection of the artist; courtesy the artist and Marlborough Chelsea, New York

Handler, 2015
Papier-mâché, fiberglass, wood, wire, cloth, and shoes
50 × 19 × 14 in.
(127 × 48.3 × 35.6 cm)
Collection of the artist; courtesy the artist and Marlborough Chelsea, New York

Handler, 2015
Papier-mâché, fiberglass, wood, wire, cloth, and shoes
50 × 19 × 14 in.
(127 × 48.3 × 35.6 cm)
Collection of the artist; courtesy the artist and Marlborough Chelsea, New York

CHEMI ROSADO-SEIJO
Salón-Sala-Salón (Classroom/Gallery/ Classroom), 2017
Educational collaboration with the Lower Manhattan Arts Academy and instructor Julie Roinos
Courtesy Embajada, San Juan, PR

CAMERON ROWLAND

BEATRIZ SANTIAGO MUÑOZ
Black Beach / Horse / Camp / The Dead / Forces, 2016
16mm film, black-and-white, silent; 8 min.
Courtesy Galería Agustina Ferreyra, San Juan, PR

La cabeza mató a todos, 2014
High-definition video, color, sound; 7:33 min.
Courtesy Galería Agustina Ferreyra, San Juan, PR

Marché Salomon, 2015
High-definition video, color, sound; 15:57 min.
Courtesy Galería Agustina Ferreyra, San Juan, PR

As yet untitled, 2017
High-definition video, color, sound; run time unknown
Courtesy Galería Agustina Ferreyra, San Juan, PR

DANA SCHUTZ
Elevator, 2017
Oil on canvas
144 × 180 in. (365.8 × 457.2 cm)
Collection of the artist; courtesy the artist; Contemporary Fine Arts, Berlin; and Petzel Gallery, New York

Open Casket, 2016
Oil on canvas
39 × 53 in. (99 × 134.6 cm)
Collection of the artist; courtesy the artist; Contemporary Fine Arts, Berlin; and Petzel Gallery, New York

As yet untitled, 2017
Oil on canvas
Dimensions unknown
Collection of the artist; courtesy the artist; Contemporary Fine Arts, Berlin; and Petzel, New York

CAULEEN SMITH
H-E-L-L-O, 2015
High-definition video, color, sound; 11:06 min.
Collection of the artist; courtesy Corbett vs. Dempsey, Chicago, and Kate Werble Gallery, New York

Sixteen as-yet-untitled hanging fabric banners, 2017
60 × 48 in. (152.4 × 121.9 cm) each
Collection of the artist; courtesy Corbett vs. Dempsey, Chicago, and Kate Werble Gallery, New York

Sine At The Canyon Sine At The Sea By Kelly Gabron, 2016
16mm film transferred to digital video and found digital video, color, sound; 7:06 min.
Collection of the artist; courtesy Corbett vs. Dempsey, Chicago, and Kate Werble Gallery, New York

FRANCES STARK
Ian F. Svenonius's "Censorship Now" for the 2017 Whitney Biennial, Spread 1 of 8 (Sincerely), 2017
Mixed media on canvas
79 × 104 in. (188 × 264.2 cm)
Collection of the artist; courtesy the artist and Gavin Brown's enterprise, New York

Ian F. Svenonius's "Censorship Now" for the 2017 Whitney Biennial, Spread 2 of 8 (Censorship Now), 2017
Mixed media on canvas
79 × 104 in. (188 × 264.2 cm)
Collection of the artist; courtesy the artist and Gavin Brown's enterprise, New York

Ian F. Svenonius's "Censorship Now" for the 2017 Whitney Biennial, Spread 3 of 8 (pp. 16–17) (the state, like a rampaging mob boss), 2017
Mixed media on canvas
79 × 104 in. (188 × 264.2 cm)
Collection of the artist; courtesy the artist and Gavin Brown's enterprise, New York

Ian F. Svenonius's "Censorship Now" for the 2017 Whitney Biennial, Spread 4 of 8 (pp. 18–19) (the thrown voice of wall street), 2017
Mixed media on canvas
79 × 104 in. (188 × 264.2 cm)
Collection of the artist; courtesy the artist and Gavin Brown's enterprise, New York

Ian F. Svenonius's "Censorship Now" for the 2017 Whitney Biennial, Spread 5 of 8 (pp. 20–21) (their free speech monopoly), 2017
Mixed media on canvas
79 × 104 in. (188 × 264.2 cm)
Collection of the artist; courtesy the artist and Gavin Brown's enterprise, New York

Ian F. Svenonius's "Censorship Now" for the 2017 Whitney Biennial, Spread 6 of 8 (pp. 22–23) (pornographic mind control), 2017
Mixed media on canvas
79 × 104 in. (188 × 264.2 cm)
Collection of the artist; courtesy the artist and Gavin Brown's enterprise, New York

Ian F. Svenonius's "Censorship Now" for the 2017 Whitney Biennial, Spread 7 of 8 (pp. 24–25) (the market has spoken), 2017
Mixed media on canvas
79 × 104 in. (188 × 264.2 cm)
Collection of the artist; courtesy the artist and Gavin Brown's enterprise, New York

Ian F. Svenonius's "Censorship Now" for the 2017 Whitney Biennial, Spread 8 of 8 (pp. 26–27) (the rocker is reduced to nothing), 2017
Mixed media on canvas
79 × 104 in. (188 × 264.2 cm)
Collection of the artist; courtesy the artist and Gavin Brown's enterprise, New York

MAYA STOVALL
Liquor Store Theatre vol. 1, no. 1, 2014
Digital video, color, sound; 4 min.
Courtesy the artist, Eric Johnston, and Todd Stovall

Liquor Store Theatre vol. 1, no. 3, 2014
Digital video, color, sound; 6:32 min.
Courtesy the artist, Eric Johnston, and Todd Stovall

Liquor Store Theatre vol. 2, no. 2, 2015
Digital video, color, sound; 7:56 min.
Courtesy the artist, Eric Johnston, and Todd Stovall

Liquor Store Theatre vol. 3, no. 5, 2016
Digital video, color, sound; 6:02 min.
Courtesy the artist, Eric Johnston, and Todd Stovall

HENRY TAYLOR
Ancestors of Ghenghis Khan with Black Man on horse, 2015
Acrylic on canvas
104 × 250 in. (264.2 × 635 cm)
Collection of the artist; courtesy the artist and Blum & Poe, Los Angeles, New York, and Tokyo

The 4th, 2012
Acrylic on canvas
Top: 90 × 74 in. (228.6 × 188 cm); bottom: 66 × 74 in. (167.6 × 188 cm); overall: 156 × 74 in. (396.2 × 188 cm)
Collection of the artist; courtesy the artist and Blum & Poe, Los Angeles, New York, and Tokyo

A HAPPY DAY FOR US, 2016
Acrylic on canvas
60 × 84 in. (152.4 × 213.4 cm)
Collection of the artist; courtesy the artist and Blum & Poe, Los Angeles, New York, and Tokyo

The Love of Cousin Tip, 2016
Acrylic on canvas
70 × 96 in. (177.8 × 243.8 cm)
Collection of the artist; courtesy the artist and Blum & Poe, Los Angeles, New York, and Tokyo

Reflecting, 2016
Acrylic on canvas
84 × 72 in. (213.4 × 182.9 cm)
Collection of the artist; courtesy the artist and Blum & Poe, Los Angeles, New York, and Tokyo

THE TIMES THAY AINT A CHANGING, FAST ENOUGH!, 2016
Acrylic on canvas
72 × 84 in. (182.9 × 213.4 cm)
Collection of the artist; courtesy the artist and Blum & Poe, Los Angeles, New York, and Tokyo

LESLIE THORNTON AND JAMES RICHARDS
Crossing, 2016
High-definition video, color, sound; 19:10 min.
Courtesy the artists

TOREY THORNTON
What Angel Do You Look Towards When You Are Damning Your Tears, Sweet Sis, 2016
Acrylic, corrugated plastic, collage, wood, graphite, and nail polish on wood panel
79¼ × 64⅜ × 3 in. (201.3 × 163 × 7.6 cm)
Whitney Museum of American Art, New York, purchase with funds from Liz and Jonathan Goldman 2016.156

Three as-yet-untitled paintings, 2017
Dimensions unknown
Collection of the artist; courtesy Moran Bondaroff Gallery, Los Angeles

KAARI UPSON
90 Degree at 270 Degree, 2016
Pigmented polyurethane and aluminum
62 × 62 × 37 in. (157.5 × 157.5 × 94 cm)
Collection of the artist; courtesy the artist; Sprüth Magers, Berlin, London, and Los Angeles; and Massimo De Carlo, Milan, London, and Hong Kong

Eyelids, 2016
Pigmented polyurethane and aluminum
47 × 63 × 32½ in. (119.4 × 160 × 82.6 cm)
Collection of the artist; courtesy the artist; Sprüth Magers, Berlin, London, and Los Angeles; and Massimo De Carlo, Milan, London, and Hong Kong

Heart Atrium, 2016
Pigmented polyurethane and aluminum
59 × 67 × 61 in. (149.9 × 170.2 × 154.9 cm)
Collection of the artist; courtesy the artist; Sprüth Magers, Berlin, London, and Los Angeles; and Massimo De Carlo, Milan, London, and Hong Kong

In Search of the Perfect Double I, 2016
Pigmented polyurethane and aluminum
79 × 31 × 76 in. (200.7 × 78.7 × 193 cm)
Collection of the artist; courtesy the artist; Sprüth Magers, Berlin, London, and Los Angeles; and Massimo De Carlo, Milan, London, and Hong Kong

In Search of the Perfect Double II, 2016
Pigmented polyurethane and aluminum
93 × 47 × 36 in. (236.2 × 119.3 × 91.4 cm)
Collection of the artist; courtesy the artist; Sprüth Magers, Berlin, London, and Los Angeles; and Massimo De Carlo, Milan, London, and Hong Kong

Snag, 2016
Pigmented polyurethane and aluminum
16 × 57 × 53 in. (40.6 × 144.8 × 134.6 cm)
Collection of the artist; courtesy the artist; Sprüth Magers, Berlin, London, and Los Angeles; and Massimo De Carlo, Milan, London, and Hong Kong

Supplement I, 2016
Pigmented polyurethane and aluminum
41 × 18 × 37 in. (104.1 × 45.7 × 94 cm)
Collection of the artist; courtesy the artist; Sprüth Magers, Berlin, London, and Los Angeles; and Massimo De Carlo, Milan, London, and Hong Kong

Supplement II, 2016
Pigmented polyurethane
and aluminum
36 × 20 × 42 in.
(91.4 × 50.8 × 106.7 cm)
Collection of the artist;
courtesy the artist; Sprüth
Magers, Berlin, London, and
Los Angeles; and Massimo
De Carlo, Milan, London, and
Hong Kong

*Transitional Object
Six-Pack*, 2016
Pigmented polyurethane
and aluminum
52 × 47 × 23 in.
 (132.1 × 119.4 × 58.4 cm)
Collection of the artist;
courtesy the artist; Sprüth
Magers, Berlin, London, and
Los Angeles; and Massimo
De Carlo, Milan, London, and
Hong Kong

KAMASI
WASHINGTON
Harmony of Difference,
2017
Music composition in six parts
Collection of the artist

LEILAH WEINRAUB
SHAKEDOWN, 2017
Digital video, color, sound;
run time unknown
Courtesy the artist

JORDAN WOLFSON
Real Violence, 2017
Virtual-reality headsets, high-
definition video, color, sound;
approx. 3 min.
Collection of the artist; courtesy
the artist; David Zwirner, New
York; and Sadie Coles HQ,
London

ANICKA YI
The Flavor Genome,
2016
3D high-definition video, color,
sound; 22 min.
Collection of the artist; courtesy
the artist and 47 Canal, New York

As of December 23, 2016

CONTRIBUTORS

NEGAR AZIMI is senior editor at *Bidoun* and a 2017 Whitney Biennial advisor. Her writing has appeared in *Artforum*, *Frieze*, *Harper's*, *The New Yorker*, and the *New York Times Magazine*, among other publications. She is a member of the Arab Image Foundation in Beirut.

CHRISTOPHER Y. LEW is Nancy and Fred Poses Associate Curator at the Whitney Museum of American Art and co-curator of the 2017 Whitney Biennial. He oversees the emerging artist program at the Whitney, and has organized many exhibitions at the Museum, including *Jared Madere* (2015–16), *Rachel Rose: Everything and More* (2015–16), *Open Plan: Lucy Dodd* (2016), and *Sophia Al-Maria: Black Friday* (2016).

MIA LOCKS is an independent curator based in New York and co-curator of the 2017 Whitney Biennial. At MoMA PS1 in New York, she organized the exhibitions *Samara Golden: The Flat Side of the Knife* (2014–15), *The Little Things Could Be Dearer* (2014–15), *IM Heung-soon: Reincarnation* (2015), and *Math Bass: Off the Clock* (2015). Locks was also part of the curatorial team for the 2015 iteration of Greater New York.

GEAN MORENO is curator of programs at the Institute of Contemporary Art, Miami, and a 2017 Whitney Biennial advisor. He is also an artist, writer, and founder of [NAME] Publications.

AILY NASH is a 2017 Whitney Biennial advisor as well as co-curator of the 2017 Whitney Biennial film program. She is co-curator of Projections at the New York Film Festival, and a program advisor to the short film section of the International Film Festival Rotterdam. She has organized programs for MoMA PS1, the Brooklyn Academy of Music, and Anthology Film Archives in New York.

SCOTT ROTHKOPF is deputy director for programs and Nancy and Steve Crown Family Chief Curator at the Whitney Museum of American Art, and leads the 2017 Whitney Biennial advisors. He has organized numerous exhibitions at the Museum, including *Glenn Ligon: AMERICA* (2011), *Wade Guyton OS* (2012–13), *Jeff Koons: A Retrospective* (2014), and *Human Interest: Portraits from the Whitney's Collection* (2016–17).

ARTIST ENTRIES

Erika Balsom (EB)
Claire Barliant (CB)
Erica Cooke (EC)
Nicole Demby (ND)
Jeanne Dreskin (JD)
Matthew Evans (ME)
Julia Pelta Feldman (JPF)
Christopher Glazek (CG)
Leo Goldsmith (LG)
Irena Haiduk (IH)
Charlotte Ickes (CI)
Frances Jacobus-Parker (FJP)
Park McArthur (PM)
Nicholas Robbins (NR)
Cameron Rowland (CR)
Rachel Wetzler (RW)

STAFF

Alison Abreu-Garcia
Jehad Abu-Hamda
Stephanie Adams
Adrienne Alston
Martha Alvarez-LaRose
Casey Amspacher
Marilou Aquino
Morgan Arenson
David Armacost
I. D. Aruede
Ahmed Attia
Wendy Barbee-Lowell
Marvada Barthelemy
James Bartolacci
Caroline Beasley
Bernadette Beauchamp
Teo Beauchamp
Harry Benjamin
Caitlin Bermingham
Danielle Bias
Stephanie Birmingham
Eliza Blackman
Ivy Blackman
Hillary Blass
Richard Bloes
Alexandra Bono
Kathryn Bosch
David Breslin
Algernon Brown
Hollister Brown
Douglas Burnham
Rosalee Burns
Thomas Burns
Ron Burrell
Garfield Burton
Anne Byrd
Heddy Cabanas
Pablo Caines

Margaret Cannie
Lydia Cardenas
Mary Carenza
Jane Carey
Amanda Carrasco
Maritza Castro
Christina Cataldo
Inde Cheong
Max Chester
Claire Cheyney-Henry
Virginia Chow
Ramon Cintron
Randy Clark
Ron Clark
Errol Coore
Brenna Cothran
Heather Cox
Kenneth Cronan
Monica Crozier
Caroline David
Regine David
Amanda Davis
Sonia Davis
Monserrate DeLeon
Margo Delidow
Donna De Salvo
Lauren DiLoreto
Michelle Donnelly
John Donovan
Kelly Donovan
Marisa Donovan
Lisa Dowd
Anita Duquette
Kasim Earl
Erica Eaton
Nicolyna Enriquez
Cesar Espinoza
Alvin Eubanks

Katie Fallen
Reid Farrington
Katherine Flores
Seth Fogelman
Lily Foster
Shaniece Frank
Samuel Franks
Denis Frederick
Murlin Frederick
Lauri Freedman
Kyle Freeman
Annie French
Donald Garlington
Anthony Gennari
Ronnie George
Claudia Gerbracht
Sarah Giovanniello
Jennie Goldstein
Lucas Gonzalez
Alex Goodship
Hilary Greenbaum
Peter Guss
Stewart Hacker
Amanda Haggerty
Rita Hall
Adrian Hardwicke
Julie Hare
Lola Harney
Tyler Harris
Tara Hart
Greta Hartenstein
Barbara Haskell
Maura Heffner
Dina Helal
Jennifer Heslin
Megan Heuer
Ann Holcomb
Nicholas S. Holmes

Abigail Hoover
Jacob Horn
Ayyub Howard
Sarah Humphreville
Beth Huseman
Chrissie Iles
Gina Im
Zoe Jackson
Carlos Jacobo
Patricia James
Darnell Jenkins
Jesse Jenkins
Bailey Johnson
Dolores Joseph
Vinnie Kanhai
Anna Kay
Tracy Keenan
Chris Ketchie
Farrah Khatibi
David Kiehl
Thomas Killie
Elizabeth Knowlton
Elizabeth Kobert
Kathleen Koehler
Tom Kraft
Margaret Kross
Melinda Lang
Eunice Lee
Sang Soo Lee
Danielle Lencioni
Monica Leon
Jen Leventhal
Christopher Y. Lew
Ruth Lizardi
Kelley Loftus
Robert Lomblad
Doug Madill
Trista Mallory

Elyse Mallouk
Claire Malloy
Erin Malone
Jessica Man
Carol Mancusi-Ungaro
Louis Manners
Joseph Marode
Anna Martin
Heather Maxson
Patricia McGeean
Caitlin McKee
Michael McQuilkin
Sandra Meadows
Nicole Meily
Nicole Melanson
Sarah Meller
Bridget Mendoza
Conor Messinger
Graham Miles
David Miller
Maureen Millmore
Lana Mione
Christie Mitchell
Matthew Moon
Lorryn Moore
Brancey Mora
Michael Moriah
Victor Moscoso
Lara Moynagh
Maggie Mugharbel
Sung Mun
Eleonora Nagy
Anthony Naimoli
Daniel Nascimento
Ruben Negron
Randy Nelson
Tracey Newsome
Katy Newton

Sasha Nicholas
Carlos Noboa
Jaison O'Blenis
Brianna O'Brien Lowndes
Lindsey O'Connor
Kimie O'Neill
Rose O'Neill-Suspitsyna
Nelson Ortiz
Ahmed Osman
Nicky Ozir
Luis Padilla
Jane Panetta
Joseph Parise
Christiane Paul
Jessica Pepe
Natasha Pereira
Jason Phillips
Laura Phipps
Angelo Pikoulas
Elizabeth Plahn
Kathryn Potts
Eric Preiss
Eliza Proctor
Eric Pullet
Vincent Punch
Christy Putnam
Emma Quaytman
Shama Rahman
Shamelah Rampersand
Julie Rega
Gregory Reynolds
Omari Richards
Emanuel Riley
Felix Rivera
Manuel Rodriguez
Gina Rogak
Clara Rojas-Sebesta
Mariah Rollins

Justin Romeo
Joshua Rosenblatt
Jamie Rosenfeld
Amy Roth
Scott Rothkopf
Sara Rubenson
Emily Russell
Isaiah Russell
Angelina Salerno
Leo Sanchez
Jay Sanders
Ximena Santiago
Galina Sapozhnikova
Lynn Schatz
Meryl Schwartz
Peter Scott
Michelle Sealey
David Selimoski
Jason Senquiz
Leslie Sheridan
Elisabeth Sherman
Adelina Simmonds
Dyeemah Simmons
Matt Skopek
Joel Snyder
Michele Snyder
Stephen Soba
Elizabeth Soland
Laura Solomon
Barbi Spieler
Carrie Springer
John Stanley
Mark Steigelman
Alyssa Steiger
Minerva Stella
Jennifer MacNair Stitt
Betty Stolpen
Gregory Stone

Emily Guzman Sufrin
Emilie Sullivan
Denis Suspitsyn
Elisabeth Sussman
Jocelyn Tarbox
Ellen Tepfer
Allie Tepper
Ashley Thimm
Latasha Thomas
Zoe Tippl
Ana Torres
Stacey Traunfeld
Sofia Trevino
Betsy Tsai
Beth Turk
Lauren Turner
Matthew Vega
Ray Vega
Eric Vermilion
Billie Rae Vinson
Farris Wahbeh
Rebecca Walsh
Jenyu Wang
Anteneque Webb
Adam D. Weinberg
Alexandra Wheeler
Clemence White
George Wisegarver
Ryan Witte
Sasha Wortzel
Sefkia Zekiroski
Lily Zhou
Annmarie Zito
Nicolette Zorn

As of November 15, 2016

PHOTOGRAPHY AND
REPRODUCTION CREDITS

Boldface indicates page numbers.

28 (left) Image courtesy the artist and Petzel, New York; (right) Image courtesy the artist and Hauser Wirth & Schimmel, Los Angeles; photograph by Marten Elder. 31 Image courtesy the artist, Eric Johnston, and Todd Stovall; photograph by Eric Johnston. 32 Image courtesy the artist and Mitchell-Innes & Nash, New York; photograph by Aaron Igler/Greenhouse Media; © Pope.L. 38 (top) LOGO's "RuPaul's Drag Race" used with permission by LOGO. ©2016 Viacom Media Networks. All Rights Reserved. LOGO, all related titles, characters, and logos are trademarks owned by Viacom Media Networks, a division of Viacom International, Inc.; (bottom) Image courtesy Atlanta Contemporary Art Center. 39 Photograph by Stephan Tanbin Sastrawidjaja. 41 Image courtesy the artist and Bridget Donahue, New York. 42 Image courtesy the artist, Rhona Hoffman Gallery, Chicago, and Sikkema Jenkins & Co., New York. 46 (bottom) Image courtesy the artist and Galería Agustina Ferreyra, San Juan. 47 Image courtesy the artist; Trilobite-Arts DAC, Charlottesville, VA; and Picture Palace Pictures, New York. 48–49 Images courtesy the artist and ESSEX STREET, New York; photographs by Adam Reich. 54 (left) Photograph by Sarah Rogers; (right) Image courtesy Roberto Villa; photograph by Roberto Villa. 55 (top) Cole Burston/Toronto Star/Getty Images; (bottom) Dimitrios Kambouris/Getty Images Entertainment/Getty Images. 56 Photograph by B. W. Caney; image courtesy Wikimedia Commons. 57 Official White House photograph by Pete Souza. 58 Image courtesy THE SIMPSONS™ and © Twentieth Century Fox Film Corporation. All rights reserved. 62 Image courtesy the artist and Galerie Imane Farès, Paris. 63 (bottom) Image courtesy the artist; Trilobite-Arts DAC, Charlottesville, VA; and Picture Palace Pictures, New York. 64 (left) Image courtesy the artist and Galerie Imane Farès, Paris. 65, 66 Images courtesy the artist; Trilobite-Arts DAC, Charlottesville, VA; and Picture Palace Pictures, New York. 69 Image courtesy the artist and Galerie Imane Farès, Paris. 75 Images courtesy the artist and Altman Siegel, San Francisco; photographs by Kant Smith. 77 Images courtesy the artist and Galerie Imane Farès, Paris. 79 Images courtesy the artist and Galerie Barbara Thumm, Berlin; photograph by Gert Jan van Rooij. 81 Images courtesy Poulet-Malassis Films, Paris. 85 Images courtesy the artist; Swire Properties, Hong Kong; and Hauser & Wirth, New York and Los Angeles. 87 Photograph by Maegan Hill-Carroll,

Vancouver Art Gallery. 89 Image courtesy the artist and Bridget Donahue, New York. 93 Image courtesy Maccarone Gallery, New York and Los Angeles, and Gallery Luisotti, Santa Monica, CA. 95 Image courtesy the artist and Mier Gallery, Los Angeles. 97 Image courtesy Clockshop, Los Angeles; photograph by Dylan Schwartz. 99 Image courtesy the artist; Trilobite-Arts DAC, Charlottesville, VA; and Picture Palace Pictures, New York. 101 Photograph by Jason Nocito. 105 Photograph by Samara Golden. 109 Photograph by Tom Van Eynde. 111 (bottom) Photograph by Ricardo Amado. 113 Images courtesy the artist and On Stellar Rays, New York. 119 Image courtesy the artist and Marlborough Chelsea, New York. 123 Courtesy the artists; photography by Uli Holz. 125 Courtesy the artist and Salon 94, New York; photograph by Genevieve Hanson. 129 Image courtesy the artist and 47 Canal, New York. 131 Image courtesy the artist and Rhona Hoffman Gallery, Chicago. 133 Images courtesy STX Entertainment, Los Angeles. 135 Image courtesy Mitchell-Innes & Nash, New York, and The Box, Los Angeles. 137 Images courtesy the artist and Video Data Bank, Chicago. 139 Image courtesy the artist and Pilar Corrias Gallery, London. 141 Image courtesy the artist, ESSEX STREET, New York, and Lars Friedrich Gallery, Berlin; photograph by Pedro Ivo Trasferetti/Fundação Bienal de São Paulo. 143 Image courtesy the artist and PATRON Gallery, Chicago. 145 Images courtesy the artist and DC Moore Gallery, New York. 147 Image courtesy the artist and Callicoon Fine Arts, New York; photograph by Stephan Wyckoff. 149 Image courtesy the artist and Neue Alte Brücke, Frankfurt. 153 Image courtesy the artist and Company Gallery, New York. 155 Image courtesy the artist; T293 Gallery, Rome; and Mary Mary, Glasgow. 159 Image courtesy the artist & Mitchell-Innes & Nash, New York; photograph by Aaron Igler/Greenhouse Media; © Pope.L. 163 Photograph by Stephan Tanbin Sastrawidjaja. 167 Image courtesy the artist and Bridget Donahue, New York. 169 Image courtesy the artist and Marlborough Chelsea, New York. 175 Image courtesy the artist and Galería Agustina Ferreyra, San Juan. 177 Image courtesy the artist and Petzel, New York. 183 Images courtesy the artist, Eric Johnston, and Todd Stovall; photographs by Eric Johnston. 185 Images courtesy the artist and Blum & Poe, Los Angeles, New York, and Tokyo; photographs by Sam Kahn. 191 Image courtesy the artist and Ramiken Crucible, New York. 193 Photograph by Kayla Reefer. 189 Courtesy the artist and Moran Bondaroff, Los Angeles; photograph by Cooper Dodds. 197 Image courtesy Sadie Coles HQ, London, and David Zwirner, New York; photograph by Dan Bradica. 199 Images courtesy the artist and 47 Canal, New York.

Whitney Museum of American Art
99 Gansevoort Street
New York, NY 10014
whitney.org

Distributed by
Yale University Press
302 Temple Street
P.O. Box 209040
New Haven, CT 06520-9040
yalebooks.com/art

Printed and bound in the United States
10 9 8 7 6 5 4 3 2 1

ISBN 978-0-300-22309-5
ISSN 1043-3260

This catalogue was produced on the occasion of the 2017 Whitney Biennial, held at the Whitney Museum of American Art, New York, March 17–June 11, 2017, and curated by Christopher Y. Lew and Mia Locks.

The 2017 Whitney Biennial film program was organized by Christopher Y. Lew, Mia Locks, and Aily Nash.

The 2017 Biennial advisors, led by Scott Rothkopf, include Negar Azimi, Gean Moreno, Aily Nash, and Wendy Yao.

The exhibition was coordinated by Maura Heffner, with the assistance of Lindsey O'Connor and Emily Guzman Sufrin.

Whitney Biennial 2017 is presented by

TIFFANY & CO.

Major support is provided by

J.P.Morgan Sotheby's

Major support is also provided by The Brown Foundation, Inc., of Houston and the National Committee of the Whitney Museum of American Art.

Significant support is provided by the Philip and Janice Levin Foundation.

Generous support is provided by the 2017 Biennial Committee Co-Chairs: Leslie Bluhm, Beth Rudin DeWoody, Bob Gersh, and Miyoung Lee; 2017 Biennial Committee members: Diane and Adam E. Max, Teresa Tsai, Suzanne and Bob Cochran, Rebecca and Martin Eisenberg, Amanda and Glenn Fuhrman, Barbara and Michael Gamson, Kourosh Larizadeh and Luis Pardo, and Jackson Tang; the Henry Peterson Foundation; and anonymous donors.

Additional support is provided by the Austrian Federal Chancellery and *Phileas — A Fund for Contemporary Art* and the Cultural Services of the French Embassy in the U.S.

Funding is also provided by special Biennial endowments created by Melva Bucksbaum, Emily Fisher Landau, Leonard A. Lauder, and Fern and Lenard Tessler.

Additional endowment support is provided by The Keith Haring Foundation Exhibition Fund, Donna Perret Rosen and Benjamin M. Rosen, and the Jon and Mary Shirley Foundation.

Curatorial research and travel for this exhibition were funded by an endowment established by Rosina Lee Yue and Bert A. Lies, Jr., MD.